THE BLACK FAMILY WHO BUILT AMERICA

The McKissacks, Two Centuries of Daring Pioneers

Cheryl McKissack Daniel

with Nick Chiles

BLACK PRIVILEGE
PUBLISHING

ATRIA

New York Amsterdam/Antwerp London
Toronto Sydney/Melbourne New Delhi

PUBLISHING

ATRIA

An Imprint of Simon & Schuster, LLC
1230 Avenue of the Americas
New York, NY 10020

For more than 100 years, Simon & Schuster has championed authors and the stories they create. By respecting the copyright of an author's intellectual property, you enable Simon & Schuster and the author to continue publishing exceptional books for years to come. We thank you for supporting the author's copyright by purchasing an authorized edition of this book.

No amount of this book may be reproduced or stored in any format, nor may it be uploaded to any website, database, language-learning model, or other repository, retrieval, or artificial intelligence system without express permission. All rights reserved. Inquiries may be directed to Simon & Schuster, 1230 Avenue of the Americas, New York, NY 10020 or permissions@simonandschuster.com.

Copyright © 2025 by Cheryl McKissack Daniel

All rights reserved, including the right to reproduce this book or portions thereof in any form whatsoever. For information, address Atria Books Subsidiary Rights Department, 1230 Avenue of the Americas, New York, NY 10020.

First Black Privilege Publishing/Atria Books hardcover edition August 2025

BLACK PRIVILEGE PUBLISHING / ATRIA BOOKS and colophon are trademarks of Simon & Schuster, LLC

Simon & Schuster strongly believes in freedom of expression and stands against censorship in all its forms. For more information, visit BooksBelong.com.

For information about special discounts for bulk purchases, please contact Simon & Schuster Special Sales at 1-866-506-1949 or business@simonandschuster.com.

The Simon & Schuster Speakers Bureau can bring authors to your live event. For more information or to book an event, contact the Simon & Schuster Speakers Bureau at 1-866-248-3049 or visit our website at www.simonspeakers.com.

Interior design by Davina Mock-Maniscalco

Manufactured in the United States of America

1 3 5 7 9 10 8 6 4 2

Library of Congress Cataloging-in-Publication Data has been applied for.

ISBN 978-1-6680-3399-9
ISBN 978-1-6680-3401-9 (ebook)

To my fearless ancestors,
whose strength and courage forged a remarkable legacy
that has survived and thrived for more than two centuries.

CONTENTS

PROLOGUE		ix
CHAPTER 1	McKissack & McKissack	1
CHAPTER 2	Two in a Million	19
CHAPTER 3	Hollywood to Tennessee	37
CHAPTER 4	Too Big to Be Small	50
CHAPTER 5	1929 and Back	70
CHAPTER 6	"I Ain't Going into the Black Bathroom"	88
CHAPTER 7	"Financial Clearance"	104
CHAPTER 8	"It's Like We're in Heaven"	114
CHAPTER 9	What It Takes	124
CHAPTER 10	Family Business	136
CHAPTER 11	Sisterly Love	150
CHAPTER 12	The Right Kind of Monument	171
CHAPTER 13	I'm a Survivor	195
CHAPTER 14	Strange Bedfellows	208

Contents

CHAPTER 15 A Whole New Ballgame 219

CHAPTER 16 Back to School 230

ACKNOWLEDGMENTS 237

NOTES 241

INDEX 245

PROLOGUE

It should come as no surprise to hear that the suspicions of America's slaveholding white men were easily activated. Court dockets of the time are full of cases of the enslaved being charged for murdering their masters using such means as poison and arson. Masters could never be absolutely certain that these men and women working in their homes were free of a thirst for vengeance. How could they ever really know what rage might be smoldering behind that fake smile?

And there was always the palpable fear of insurrection. From the seventeenth century all the way through to emancipation, whites were distrustful of any gathering of more than two slaves. In the early eighteenth century, it was illegal in North Carolina for slave owners to construct houses of worship for the enslaved. The North Carolina legislature passed a law later in the century making

PROLOGUE

it illegal for the enslaved to travel at night and to gather in white people's kitchens or even in their own quarters.

"Negroes who violated this law by visiting were to receive forty lashes on the bare back, and those receiving the visitors were to receive half as many lashes. A master, however, could send his slave on an errand; but if he was to be out after night a written pass must be given him," author James A. Padgett noted in "The Status of Slaves in Colonial North Carolina."

It was in this environment that my great-great-grandfather Moses and his crew of builders (themselves enslaved just as Moses was) made their way across the North Carolina countryside, traveling to their various projects.

Slavery in North Carolina took on a wide variety of appearances and practices, largely dependent on the temperament and occupational interests of the owner. Moses's owner, William McKissack, saw himself as a builder, taking advantage of the growing desire among North Carolina residents for homes with shingles and bricks, replacing the old log cabins favored by the early settlers. The early 1800s saw a greater diversity in staple crops, such as corn, tobacco, cotton, and wheat, which resulted in a greater demand for the building of barns, tobacco houses, and warehouses. This undoubtedly gave the enterprising McKissack a market for his services.

McKissack trained his slaves to be expert artisans in areas like carpentry and bricklaying. He must have seen talent and leadership traits in Moses, because word passed down through my family says the young man was promoted as high as foreman of McKissack's building crew. When McKissack sent his builders out across North

PROLOGUE

Carolina and other portions of the South, Moses was in charge. Historical accounts contend that the slaves of masters engaged in nonagricultural occupations tended to have more liberties and be treated more humanely than those who spent their days toiling in the fields. The artisan enslaved were of greater value—worth almost twice as much as field hands—and in much demand.

While entertainments like *Gone with the Wind* and *Roots* have painted a picture in our mind's eye of vast plantations filled with dozens or even hundreds of slaves bent over endless fields of cotton, numerous historical accounts claim that slavery in North Carolina bore little resemblance to these portraits. North Carolina's slavery was smaller in scope—yeoman farmers working their relatively small plots alongside the handful of slaves they might own, if they owned any at all. Such closeness tended to create more humane living conditions for the enslaved.

Sometimes when I visit one of the sites my company, McKissack & McKissack, is constructing now, I try to imagine what it might have been like for Moses to move around the South with his crew 200 years earlier—a slave unaccompanied by his master, nervously trying not to draw the suspicion and ire of every white man he encountered.

While the fears of whites—and the risk of the violence their fears might trigger—were always wafting through the air, the peculiarity of slavery allowed for a wide variance in the treatment of Black people. For instance, slaves in Wilmington were given so many liberties that it wasn't unusual for them to use funds they gained from hiring themselves out to rent houses and tenements for their families.

PROLOGUE

However, by 1823, the North Carolina legislature cracked down on the practice of self-hire, declaring it illegal. More common was the master hiring out his slaves to others who were in need of laborers. According to historian John Hope Franklin, "the newspapers carried advertisements of slaves for hire, and not infrequently the masters sent the enslaved worker into town to earn money during the dull seasons."

"Since many masters in antebellum North Carolina worked side by side with their slaves, they felt that they knew them and had the problem of discipline well in hand," wrote Franklin. "When the slaveholder clamored for more restrictive legislation, it was for the purpose of bringing his neighbor's slaves under the surveillance of the law rather than his own. Under these circumstances, it is not difficult to conceive of a situation in which many slaveholders refused to enforce the law in regard to their own slaves, which resulted in a general laxity of law enforcement over a large area."

In fact, so many slaves were fleeing the more brutal form of bondage practiced in the neighboring states of Virginia, South Carolina, and Georgia that the North Carolina legislature in the early 1800s passed laws more carefully regulating the militia and slave patrols and circumscribing even further the activities of slaves, according to Franklin. But there still were well-known examples of slaves in North Carolina who were given liberties seen by just a tiny number of their contemporaries.

One of the best known of these was George Moses Horton, a slave owned by a farmer in Chatham County named James Horton. George spent much of his time on his master's farm, tending to the corn and wheat crops. But when George desired, his

PROLOGUE

master allowed him to "hire his own time," meaning he paid the master fifty cents for a day of freedom. Beginning when he was about age twenty, he used his "free" time to travel the eight miles from the farm to the University of North Carolina at Chapel Hill. George, who had taught himself to read when he was a child, sold poems to students that he wrote incorporating the names of their sweethearts, charging twenty-five, fifty, or seventy-five cents per piece. He did this for several decades, becoming a beloved figure on campus. He had an especially enthusiastic fan in Caroline Lee Hentz, a novelist and professor's wife, who helped him publish his first printed poem in her hometown newspaper in Massachusetts, *The Lancaster Gazette*, on April 8, 1829. A Raleigh printing press later that year published Horton's *In Hope of Liberty*, which was the first book published in the South by a Black man. In the 1930s, a school for Black children in Chatham County was named after him; after integration it eventually became Horton Middle School. In 1978, North Carolina governor James B. Hunt proclaimed June 28, 1978, as "George Moses Horton Day."

While the practice of hiring your own time wasn't commonplace, there were many other slaves in North Carolina who were granted this "privilege." There is no evidence that Moses McKissack ever hired his own time, but he likely had a great deal of control over his time as the foreman of a crew of enslaved laborers that constructed buildings throughout North Carolina and other portions of the South.

Another sign of Moses's status on the McKissack plantation came in 1820, when he was allowed to marry an enslaved woman named Miriam. A common custom among slaves was for the groom

PROLOGUE

to jump over a broom handle to indicate the union was binding; sometimes the bride and groom held hands and both jumped over the broom. The groom usually offered the bride some sort of gift, such as a toy or brass ring. Historians have written that if an enslaved woman bore no children within two or three years, her master might urge her to take a second husband. If that union also produced no children, she might be obliged to take yet another bedfellow. Because offspring was a way for owners to increase the value of their holdings, enslaved women were encouraged to have numerous children. In this regard, Moses and Miriam didn't disappoint: They had fourteen children. Miriam had already given birth to Wesley, Emily Jane, and William Thomas before Moses II was born on March 25, 1830. But he lived for only about a month before he passed away. Ten years and eight children later, on November 8, 1840, Miriam bore a child they named Gabriel. He soon became known in the family as Moses II.

It's long been a mystery to my family how my great-great-grandfather Moses became cargo on a slave ship heading for America. Born in 1781, Moses was an Ashanti, the dominant group in West Africa throughout the 1700s and 1800s. While the Ashanti Empire acquired its riches through the plunders of war and from trading gold, which was abundant in the region, by the late 1700s the empire had become a major player in the slave trade. Historical records indicate that when the Ashanti conquered groups like the Denkyira and the Dagomba, the Ashanti sold members of these conquered groups to British and Dutch slavers in exchange for weapons and other European goods. Millions of Africans passed through ports in Ghana to be shipped to the

PROLOGUE

Caribbean and the New World, where the demand for labor was intensifying.

But if Moses was a member of the powerful Ashanti, how did he wind up on a slave ship to America at the tender age of eleven?

"There has always been a question in my mind as to how Moses got over here," my father DeBerry McKissack said in 1972 during an interview with a Fisk University student, Mitchell Jerome Harris, who was writing his master's thesis on the history of the McKissacks. "The Ashanti was the tribe in Africa that captured the other tribes and sold them into slavery. So this makes me wonder, how did Moses get captured unless he was a volunteer to come to America?"

However he found his way to that ship, at age eleven the young Ashanti made the unspeakably brutal and dehumanizing journey across the Atlantic—a trip that could take up to three months and was so mortally dangerous for the Africans that sharks routinely followed the ships waiting for the inevitable bodies to be dumped overboard. Some estimates put the mortality rate for the Africans crossing the Middle Passage at 13 percent.

When he arrived in the New World in 1790, the young Ashanti was quickly placed on the auction block in Charlotte, North Carolina. He was purchased by William McKissack, an Irishman who is believed to have arrived in the New World about twenty-five years earlier, a decade before the American Revolution. McKissack bestowed the young Ashanti with the name "Moses"—a nod to his own religious faith and that of the region he'd come to call home. Moses now resided in a state with 100,572 slaves, according to the 1790 census. The number of white inhabitants was about 300,000.

xv

PROLOGUE

Before the start of the Civil War, master McKissack expanded his construction business with the aid of his son, also named William. The young William II married a woman from Tennessee named Maxwell and moved to Tennessee with his bride to start his own family. William II and his wife profited from the custom whereby each family would give the bride and groom the gift of a slave, a common occurrence in North Carolina and across the South. After William II moved to Spring Hill, Tennessee, he eventually brought Moses II (Gabriel), a gift from his father, to Tennessee as well. Years later, Moses II married a young Maxwell slave named Dolly. It's not clear whether Dolly was also a gift to the young couple from the Maxwell family. Moses and Dolly's first child, Almanda, was born in 1871.

In Tennessee, William II continued the family business and trained his slaves in the building trade just as his father had done. Moses II, like his father before him, was made the foreman of a slave crew that constructed buildings throughout middle Tennessee. This was a significant development in my family's history, as it solidified that the construction business was now an inheritance that would pass through the bloodlines.

Amid the lush greenery of the Tennessee countryside, about thirty miles south of Nashville, sits a grand Greek Revival style antebellum mansion. That was the house William McKissack II built in 1845 when he moved to Tennessee—a house that is still standing in 2025, though now fighting a losing battle with grime. Although Moses II was too young to have been involved in its construction, the building does offer a window into the quality of the buildings McKissack and his slaves were constructing—

PROLOGUE

180-year-old buildings that look just as sturdy as if they were finished last year.

By the time Moses II arrived in Tennessee with his master, the state had exhibited a growing strain of antislavery sentiment, particularly in the mountainous eastern regions, where residents had little need and less regard for the institution. Lawmakers had gathered in 1834 for a constitutional convention, where they considered abolishing slavery entirely, eventually backing down because of the vociferous voices of the pro-slavery forces in the west, where the large cotton plantations were king.

The historian William Lloyd Imes noted that killing a Black or mulatto slave in Tennessee was actually deemed a murder, punishable by death—though Imes went on to say he could find no example of a white Tennessean ever indicted under such a charge.

"We do have a case of a famous old slave-holder in a community not far from Nashville being tied to his gate post and severely whipped by his neighbors, because of his brutal murder of one of his slaves," Imes wrote.

Moses II and his crew, under the direction of William McKissack II, erected several buildings of historical significance. One of these was the Maxwell House Hotel in Nashville. Construction began in 1859 but was halted by the outbreak of the Civil War. Historical accounts describe the hotel as being conceived by Colonel John Overton Jr.—he named it for his wife, Harriet (Maxwell) Overton—and designed by architect Isaiah Rogers, but built by "mostly enslaved labor." Those three words found in several historical records represent the only "official" mention of my great-grandfather Moses II's contributions. When

xvii

PROLOGUE

it was officially completed in 1869, the Maxwell House Hotel was Nashville's largest hotel—with five stories, 240 rooms, steam heat, gas lighting, mahogany cabinetry, brass fixtures, chandeliers, ladies' and men's parlors, billiard rooms, barrooms, shaving saloons, and a grand staircase to the expansive ballroom. The still unfinished hotel was put to use by some interesting figures: in Room 10, former Confederate general Nathan Bedford Forrest in 1866 was inducted into the Ku Klux Klan, of which he was named grand wizard; and the first national meeting of the KKK took place there in April 1867. The hotel eventually would host seven US presidents and such dignitaries as Jane Addams, Sarah Bernhardt, Enrico Caruso, Thomas Edison, Henry Ford, Annie Oakley, George Westinghouse, and Cornelius Vanderbilt. During a 1907 visit to the hotel, President Theodore Roosevelt reportedly said the words "good to the last drop" after he finished a cup of coffee—and that became the genesis of the Maxwell House coffee brand that was served at the hotel and the advertising slogan used to market it.

Moses and his crew also built the Giles County Courthouse in Pulaski, Tennessee, which was completed in 1859 and was described on a Giles County website as "constructed of the best materials by the finest workmen available at the time." During the Civil War, the courthouse was occupied by federal troops and had the Union flag flying over it.

Back in Charlotte, North Carolina, Moses I and his wife, Miriam, both died in 1865—Moses on August 26 and Miriam on December 29. As they were both older than seventy-five, it is difficult to state with certainty what the last months of their lives

PROLOGUE

looked like. There were Blacks in places like the South Carolina low country who tasted freedom as early as 1861, when the Union troops arrived. But in other parts of the South, emancipation didn't come until much later, in parallel with the movement of the Union army across the region. There were reports from federal authorities that as late as September 1865—five months after Confederate surrender in Appomattox, Virginia, on April 9— they were still encountering Black people who were unaware that they were free.

While the roads were filled with newly freed men and women trekking long distances in search of a better life or for family and loved ones they had been separated from, conditions were precarious for the sickly and elderly. Many planters left their most vulnerable former slaves to scrape together a bare subsistence as best they could, or to die in hunger and squalor. I truly hope that Moses and Miriam, having borne all those children, had someone to make sure their final days were as pleasant as possible— and that they both tasted freedom long enough to appreciate its sweetness.

After emancipation, Moses II moved to Pulaski and established his own independent construction business, which he called McKissack Contractors. He was part of a wave of Black people starting their own businesses during the period known as Reconstruction. Many of them used the skills they acquired during slavery to go out on the open market and try to make a living. The most common businesses were beauty shops, barber shops, cleaning and pressing services, and shoe repair shops. Whites had long been accustomed to having these services performed by

xix

PROLOGUE

Blacks, so it wasn't difficult for these Black businesses to attract white customers—at least in the early years of Reconstruction. Often, Black businesses offered their services at a cheaper rate than competing white businesses.

These years after emancipation were incredibly exciting, though fraught, scary, and dangerous for the newly freed men and women in the South. For almost three hundred years they had been property with "no rights which the white man was bound to respect," in the infamous words of US Supreme Court Chief Justice Roger Taney in the March 1857 Dred Scott decision. They had been forced to function within the bounds of a system that didn't see them as actual human beings. Suddenly, they were their own agents—within reason—able to go and do as they pleased. Within reason. The momentous shift must have been almost impossibly hard to fathom.

Making matters even more complex for the newly freed, the whites in their midst were harboring resentments of almost immeasurable size, their feelings moving from—in most cases—disregard to outright hatred. This development was recounted in painstaking, devastating detail by writer, journalist, and sociologist W. E. B. Du Bois in *Black Reconstruction in America, 1860-1880*. First published in 1935, this work catalogues the virulence of the hatred whites had for these newly emancipated people. The situation in states like Mississippi, Alabama, and Georgia, with their large Black populations, was ugly and dangerous. While nearby Tennessee, with a smaller Black population, might have been spared somewhat from the worst events of the era, things were bad all over.

PROLOGUE

Du Bois described the dawning of the poor whites' recognition of their new status alongside free Black men:

"It seemed after the war immaterial to the poor white that profit from the exploitation of black labor continued to go to the planter. He regarded the process as the exploitation of black folk by white, not of labor by capital. When, then, he faced the possibility of being himself compelled to compete with a Negro wage worker, while both were hirelings of a white planter, his whole soul revolted. He turned, therefore, from war service to guerrilla warfare, particularly against Negroes. He eagerly joined secret organizations, like the Ku Klux Klan, which fed his vanity by making him co-worker with the white planter, and gave him a chance to maintain his race superiority by killing and intimidating 'niggers'; and even in secret forays of his own, he could drive away the planter's black help, leaving the land open to white labor. Or he could murder too successful freedmen."

So, as they became more successful, freedmen at the same time became more of a threat and a target for poor whites. In many ways, this presaged the racial dynamic that would cleave apart white and Black laborers for generations and mark more successful Blacks as a menace to the white working classes. To illustrate the feelings of the white community, Du Bois turned to the writing of Carl Schurz, a highly educated German immigrant who was decidedly on the side of freedom for the former slaves. President Johnson hired Schurz to travel south and write a report on "the existing condition of things" to help the president make decisions going forward that would be based in fact.

"Wherever I go—the street, the shop, the house, the hotel, or

PROLOGUE

the steamboat—I hear the people talk in such a way as to indicate that they are yet unable to conceive of the Negro as possessing any rights at all. Men who are honorable in their dealings with their white neighbors, will cheat a Negro without feeling a single twinge of their honor. To kill a Negro, they do not deem murder; to debauch a Negro woman, they do not think fornication; to take the property away from a Negro, they do not consider robbery. The people boast that when they get freedmen's affairs in their own hands, to use their own expression, 'the niggers will catch hell.'"

Du Bois's work is full of examples of Black laborers who continued working the fields for their former masters, but when it came time for them to be compensated, the masters refused to pay them. In Mississippi and other Southern states, freedmen were killed on a daily basis by whites. The assistant commissioner for Mississippi's Freedmen's Bureau reported that an average of two or three Black men per day were killed in Mississippi—and those who returned from the war wearing their blue uniforms were a favored target.

"My expectation concerning them is that they are destined to extinction, beyond all doubts," said Governor William L. Sharkey of Mississippi, a Unionist who had opposed secession and was appointed provisional governor in 1865 by President Johnson. "It is alarming, appalling, I think they will gradually die out."

Speaking specifically about Tennessee, Union General John P. Hatch described the hatred he witnessed among poor whites for the newly freed Blacks:

"The hatred toward the Negro as a freeman is intense among

PROLOGUE

the low and brutal, who are the vast majority. Murders, shootings, whippings, robbing and brutal treatment of every kind are daily inflicted upon them, and I am sorry to say in most cases they can get no redress. They don't know where to complain or how to seek justice after they have been abused and cheated. The habitual deference toward the white man makes them fearful of his anger and revenge."

In the midst of this dangerous new world turned upside down came Moses II's move to Pulaski—seventy miles south of Nashville—where he started his own construction business. I consider this perhaps the most consequential move in the history of the Black McKissacks, charting a course the family would follow for the next 150 years. It was one thing to do what the McKissack masters wanted and run a slave construction crew; it was another thing entirely to step out into this new world as a Black business-man reliant on both whites and Blacks to earn a living.

McKissack joined a wave of Blacks who were not scared off by white hatred and endeavored to become entrepreneurs. In his book *The African-American History of Nashville, 1780-1930*, histo-rian Bobby L. Lovett chronicles some of the noteworthy Black businesses that emerged in the years after emancipation: Wil-liam Sumner, Benjamin F. Hadley, and George Trimble's saloon on Capitol Avenue; Henry Harding's expansion of his blacksmith business to include a saloon and boardinghouse; William Sumner's Sumner House Hotel; William Houston's harness shop. Joseph Williams, a former sergeant in the US Colored Troops (USCT), opened a "Counselor's Office" to help USCT veterans get their bonus money. In addition, Black craftsmen formed the Colored

PROLOGUE

Barbers Association in 1865 and the Colored Mechanics Association in 1866.

Because of the hostility that now greeted them from many whites, Black businesses increasingly had to rely on Black customers. The cause of racial solidarity became a motivating force for the Black community to patronize these new Black businesses. While Moses II had some early success in Pulaski finding white customers for his construction business, he gradually began to establish a reputation in the Black community. After organizing in Pulaski in 1866, the KKK would target Black people who showed too much independence, such as by establishing schools or serving in leadership positions. But the growth of the KKK apparently did not deter Moses II in the expansion of his business, possibly because the Black McKissacks had gained the grace of some of the more prominent citizens of the town. In Pulaski, Moses and Dolly saw their family grow to a large brood of seven boys and seven girls. Moses II taught his seven sons the skills of the construction trade, including how to design a building. Two of those sons were Moses III and Calvin. The McKissack construction family was poised to jump into its third generation.

CHAPTER 1

McKissack & McKissack

I was moving around in my house in New Jersey with the drone of the television keeping me company, as it often did when I was home by myself. The television was tuned to NY1, New York's twenty-four-hour news station, our local version of CNN. I was only half listening, preoccupied with my thoughts, when the news anchor said something that halted me in my tracks. I moved closer to the screen.

The anchor announced that real estate developer Bruce Ratner was buying the New Jersey Nets and bringing the basketball team to Brooklyn. *A basketball team in Brooklyn? Wow.*

My next thought came straight from the construction company CEO lobe of my brain: *Where will they play?*

I knew instantly that this project would quickly become the

talk of the city, particularly in the real estate circles where I spent most of my days.

Then I had another thought: *McKissack & McKissack has to get on board.*

That idea would soon become a preoccupation of mine, bordering on obsession.

McKissack & McKissack was on the verge of taking over a string of big projects that would establish us as a major player among Northeastern construction firms: among them an impressive new student center at Medgar Evers College in Brooklyn, the Emergency Response Program contract for the New York City School Construction Authority, and the stunning Perelman Center for Advanced Medicine at the University of Pennsylvania in Philadelphia. I was ready for McKissack to take off into the stratosphere. A major role in the construction of a Brooklyn home for the Nets could be exactly what we needed to breathe the kind of rarified air that my family's company hadn't yet sniffed in our 210 years of existence.

Brooklyn had never really recovered from the psychic wound left by Walter O'Malley in 1958 when he moved the Brooklyn Dodgers across the country to Los Angeles, about as far symbolically as you could get from gritty, working-class Brooklyn. Though the Dodgers played at Ebbets Field in Flatbush, O'Malley had wanted to build a domed stadium in Brooklyn at the intersection of Flatbush and Atlantic Avenues, the borough's two most famous streets, but city officials—namely, the imposing planner Robert Moses—had other ideas. O'Malley fled the city, bringing with him the iconic Jackie Robinson, who had become an instant hero to African Americans

in Brooklyn and throughout the land when he smashed baseball's color barrier in 1947.

The succeeding decades saw Brooklyn plunge deep into despair, abetted by poverty, crime, corrupt politicians, racial unrest, and a sense that the financial and political power centers in Manhattan had little care for the well-being of the millions who resided on the other side of the bridge. But if Brooklyn could have its own sports franchise once again, maybe the team could serve as a positive force in helping to foster community revitalization amid the borough's hardship and suffering.

I didn't know Ratner, but I knew people who knew him. And I also knew many of the Brooklyn players whom I figured would be influential brokers in the development of this enormous project. I had watched my mother, Leatrice Buchanan McKissack, for years wield her considerable charm and influence to build relationships throughout the South that would enable the family business to secure major projects. Mom knew how to get into the rooms where decisions were made, where important things happened. I had learned from the best. And I had been in New York long enough to know that while the accents might be different, New York was also a place where relationships determined the directions in which the money flowed. I pulled out my Rolodex and went to work.

Ratner, who was from a wealthy Cleveland real estate family, happened to be an associate of one of my former bosses, an attorney named Darryl Greene. Greene had been the director of the New York State Urban Development Corporation when I worked there as a summer intern in 1983; he became a mentor to me. The NYSUDC

was a partner in the construction of the Jacob Javits Convention Center, which was being built during the summer I interned. After my graduation from Howard University, when I came to New York in 1986 to work with Weidlinger Associates, I had informal weekly meetings with Darryl. So, it made sense to me when I started The McKissack Group dba as McKissack & McKissack in New York in 1991 to use Darryl as our de facto political consultant and attorney. More than a decade later, I knew my connection with Darryl would be helpful if I was going to attach McKissack & McKissack to the Brooklyn Nets.

Numerous factions in Brooklyn soon rose up in deep opposition to the grandiose plan—and their enmity, if not addressed, could grow into a movement that would squash the multimillion-dollar project before any workers ever donned a construction hard hat. The neighborhoods that surrounded the proposed location of the arena near downtown Brooklyn were diverse and multilayered, representing both the working-class struggles and the middle-class aspirations of the borough. If this thing was going to get off the ground, the planners would need to figure out how to appeal to both groups.

Of the 2.5 million residents of Brooklyn in 2002, African Americans made up slightly more than a third. Black people needed to be deeply involved in this project and would not be shy about announcing that fact. If McKissack was going to make a move, I felt like that was my path. I had to galvanize a coalition of African Americans to help my cause. With McKissack's historical legacy and our growing prominence as successful builders in New York, we were in a unique position.

If not us, then who?

The Black Family Who Built America

That's the case I made when I met with influential politicians including Brooklyn Assemblyman Roger Green, Brooklyn Borough President Marty Markowitz, Brooklyn Assemblyman Al Vann, State Senator Velmanette Montgomery, and State Senator Carl Andrews. My supporters presented the argument to Ratner and Darryl Greene that the Black community needed strong Black involvement in the project—and not just subcontractors but prime Black contractors. Namely, McKissack & McKissack.

Darryl told me that despite the power players I had met with, the most important person I needed to get a blessing from in Brooklyn was the most forceful and effective activist in the borough, a take-no-prisoners Black woman named Bertha Lewis. Smart, savvy and tough, Bertha had turned protest into art. She wasn't universally loved, but she certainly was respected because of her unselfishness. She wasn't driven by ego or seeking attention; like Superman, Bertha was out for truth and justice. As the president of the grassroots Association of Community Organizations for Reform Now (ACORN), Bertha rode next to New York City Mayor Michael Bloomberg on his private jet, advising him about the community's needs. ACORN, through voter registration, had helped to raise the minimum wage in fifteen states, creating the national momentum for an increase in the federal minimum wage. The prevailing thought was that no politician in Brooklyn could be elected to a major post without Bertha's support. As a testament to her influence, *Crain's NY Business* would later choose her as one of the 100 most powerful women in New York in 2007.

When I got to Bertha's office, I sat there for at least a half hour waiting for her. The office was filled with a bunch of what I

would categorize as "around the way" girls, to steal a phrase from LL Cool J—Black girls from some of the tough neighborhoods of Brooklyn who probably wouldn't feel at home in corporate America. Bertha came out looking very Afrocentric, as usual—hair in a wrap, clothed in African fabric. She was so smart and sharp; I could sense how quickly she could read people. When I told her the family history of the McKissacks, she latched on right away. From there, we grew closer. She invited me into her home; I thought of her as a friend. She took me on as a protégé of sorts. She knew I didn't understand the streets of Brooklyn, so she took it upon herself to teach me how to maneuver and exert my influence. She became an invaluable connection for me. Whenever she called, I was there for her to provide whatever she needed. If it was a fundraiser, she could count on a check. I will forever remain indebted to her.

I found out that Bertha and Bruce Ratner had some history. In 1996, after Forest City Ratner opened the Atlantic Center, a shopping mall on Atlantic Avenue in Brooklyn, Bertha and other activists were upset that too few African Americans had been hired to work in the stores. A few weeks before the opening, lines of people—mostly Black and desperate for work—wrapped around the corner under the hot sun. For months Bertha, joined by community members and Rev. Al Sharpton, picketed in front of stores in the mall, telling potential customers not to shop in stores like Old Navy if the stores wouldn't hire people who looked like them.

"What's going on? Why are you doing this to me?" a confused Ratner asked Bertha when he finally met with her.

Bertha explained to him that there hadn't been any community

The Black Family Who Built America

hearings on the Atlantic Center project. Bruce listened and, although it was too late to make any changes, that was the beginning of a strong relationship between Bertha and Bruce.

Bertha said she realized as she got to know him that he was different from other developers, even different from his family members who made up Forest City Ratner. He was dedicated to Brooklyn and had placed a huge bet on the future of the borough. She saw that he was a developer with a conscience.

With my allies pushing for McKissack to have a major stake in the Nets project, I finally got my meeting with Ratner, organized by Assemblyman Roger Green. It would take place in the offices of entertainment attorney L. Londell McMillan, who represented high-profile clients, including Prince and Michael Jackson. Roger told me that rapper Jay-Z, from the same Marcy Houses projects where Londell grew up in Bedford-Stuyvesant, was investing in the project. Roger and Londell were trying to organize a coalition of entertainers to raise one hundred million dollars to invest. Londell invested one million dollars himself. Bruce was looking for more money from Jay-Z, who also invested one million, but Jay-Z gave him the star power that he needed.

With Jay-Z's participation, I knew that the developers would need some level of non-white participation in the project. Forest City Ratner was already getting pressure from Black Brooklyn; now they were using Jay-Z as their main promoter. I thought that bode well for my chances of getting a piece.

During our meeting, Darryl said great things about our firm. I guess Bruce was convinced that we were the real deal because he told me that he wanted me to meet his head of construction, a man

named Bob Sanna. He was old-school New York construction—tough, no nonsense. Ratner was one of the larger developers in town, so Sanna was used to contractors trying to placate him. They had already given Turner Construction Company, my former employer, the deal to build the arena as the prime contractor.

"Cheryl, I just don't know where I can put you as a prime," he said.

"Well, you know, I've been working on real projects for a very long time," I said. "Why don't you give me the railyard?"

In order to clear the space for the arena to be built, the Long Island Railroad storage yard had to be moved two blocks from its original site, and a temporary yard had to be built. I had done some consulting work with the Metropolitan Transportation Authority (MTA), though I was hardly a rail expert.

"Let me think about that," Bob Sanna said.

The meeting had taken place on Thursday. The following Monday, a huge package arrived at my office. I had assumed the developers wouldn't bite, so I was surprised when I pried open the package. The note inside read, *Please, give us a proposal.* I thought, *What am I supposed to do with all of this?* The plans stretched nearly across our conference room, more than 500 pages. We were given a week to submit a proposal. I guessed that they figured the documents would overwhelm me and I would tell them I couldn't do it. But instead, my response was, "Let's figure this thing out!" They wouldn't get rid of me that easy.

One of my employees, Craig Belize, was friends with an engineer at the MTA named Mike Kaleda, whom he thought could be a huge help to us. I knew Mike from my early days working in

The Black Family Who Built America

New York; he had been one of the senior project managers on a job with the New York School City Construction Authority. And I was almost certain that he didn't like me. When I would meet with him, he would barely look at me. I had Craig call him for me. Mike responded that he needed to sit down and meet with me to hear the company's "vision."

During that meeting with Mike, I threw everything at him.

"This is the arena!" I said. "It's going to be the biggest project happening in New York. And you're going to lead this effort."

Finally, after a three-hour-long lunch, I convinced him that McKissack & McKissack was a viable company. I still had no idea whether we were even going to be granted the project. But I was convinced that they were building something big. Mike decided to join McKissack. I was so ecstatic that I called Bob Sanna and said, "Bob, not only do I have the perfect person to do this, but he looks like you, too!" We met their deadline; Mike created an excellent presentation for us.

I think Bob was shocked that we had pulled it together. But he had grown to like me in his own way. He understood that Bruce Ratner needed to do something significant for Black people on this project. And again, if he didn't select me, then who was it going to be?

Before he made a decision, Bob called one of the bigwigs at Turner Construction, Jim McKenna, to get some intel on McKissack. But I knew Jim, too. When I first got to Turner, Jim McKenna was my big brother. As I've learned over and over, so much of success in business—and in life!—is about relationships.

Jim McKenna told Bob, "You need to hire these people as soon

as possible. As a matter of fact, if you think Cheryl needs help, I'm here as the backstop. I will help Cheryl on this project."

After he talked to Bob, Jim McKenna called me immediately and reported on their conversation. The proposal we submitted was for a small portion of the yard, totaling about $230,000.

A few days later, Bob called me at our Manhattan office with three words: "Let's get started."

I started attending the weekly meetings with the other players on the project. One week, Bob said, "We have to do this whole portion of the yard. The engineers are working on it, but we don't have anybody who's gonna do that estimating."

Without any hesitation, I said, "McKissack will do it!"

That became my motto. If I heard anything that needed to be done, I'd say, "We'll do it!" It didn't matter whether we had any idea how to do it or not. I had a talented staff; I knew we could figure it out.

The project just kept growing and growing. We became the construction manager for the entire undertaking to move the rail across the street. We had to take down a bridge, demolish the existing railyard, rebuild the railyard two blocks from its original site, reconstruct the bridge, and build the subway station that entered the Barclays Center. This all had to be completed before they could start on the entertainment and sports arena. The pressure on McKissack was enormous. In fact, ours was a more complicated project than building the actual arena—though it certainly wasn't as sexy. We started out at $250,000, but the price tag for our portion of the development kept increasing, eventually reaching $300 million.

The entire arena development encountered so many delays

The Black Family Who Built America

that there were many times when I thought it was going to be shut down.

To get the land they needed, Forest City Ratner started a lobbying campaign to get Brooklyn officials to support eminent domain—buying community residents' property and relocating them. This was not a politically popular plan and was opposed by most of the elected officials in the borough. There were endless court battles between Ratner and opponents of eminent domain, in addition to gentrifiers in the borough who were concerned that parking spaces would be limited, and those who had safety concerns. The delays inflated the entire project's costs into the billions of dollars.

I sensed that failure was imminent. Ratner considered selling the basketball team and dumping the project. Billions of dollars seemed on the verge of sailing away into the capricious Brooklyn wind.

"The community is already vital," one of the most vocal opponents, Patti Hagan, told demonstrators at a rally. "And guess who revitalized it? All of the folks who have been living here for twenty and thirty years. It's a very vibrant community. The way to destroy it is to bring in something like this, a monstrous project . . . the Manhattanization of Brooklyn."

Bertha Lewis conducted a poll with her ACORN members to determine the organization's position. Originally the project called for 4,500 luxury apartments adjacent to the arena. Bertha didn't care much about the arena, but she did care about affordable housing. She and her team asked Bruce Ratner for a 50/50 program—for ACORN to support the project, half the units should be affordable housing.

"Poor people will always be with us," Bertha told Ratner. "You will not win if you have all the luxury apartments here. Politically and practically, affordable housing will be the engine that makes this project go. We are going to make sure that Brooklyn people that were here when it was the 'Wild Wild West' will get a piece of it."

Within the proposal, she demanded renters be integrated on every floor, people who would be displaced should get first dibs on affordable apartments, ten percent of the units should be set aside for seniors, six hundred units should be affordable condos to purchase, and the apartments should be rent-stabilized for forty years. She asked that Forest City Ratner relocate all renters who would want to return to the neighborhood, and they also should pay the difference in their rent during their absence.

Bruce agreed to everything she asked. Local politicians were reportedly incensed that they had not been invited to negotiate with him.

A Brooklyn resident named Daniel Goldstein, was one of the most vocal residents who opposed the arena. Goldstein, along with longtime resident Patti Hagan, created an opposition group, Develop Don't Destroy Brooklyn.

Goldstein argued that because the Atlantic Yards project sat at the intersection of Atlantic and Flatbush Avenues, it would cause increased traffic and could be a potential terrorism threat. He claimed the stadium was too close to the street to shield it from an attack.

Develop Don't Destroy Brooklyn filed a lawsuit and won. Bruce Ratner appealed it, and then he won. Then Develop Don't

The Black Family Who Built America

Destroy Brooklyn took it to another court to fight some more. This went on for six years. Forest City Ratner was still investing millions of dollars into a project that could very easily be scrapped. In the six-year time span, thirty-five lawsuits were filed against the project.

In 2007, in the midst of the crisis, a scandal hit. James Stuckey, second in charge under Bruce Ratner, left abruptly amid sexual harassment charges. Carl Andrews, a state senator representing Brooklyn, was working as a consultant for the Barclays project. He was also working with Attorney General Eliot Spitzer. In March 2008, after he was elected governor Spitzer was forced to resign when he was exposed for hiring $1,000-per-hour sex workers from an elite escort agency.

At the time, I was fighting my own private battles: I was going through a divorce. My husband Fred worked as a contractor; he was highly intuitive and persuasive and would give me solid advice whenever he attended company meetings. But I found him to be very controlling. Eventually it became unbearable.

In 2008, as we all know, the stock market and the housing market collapsed. The nation plummeted into the full-blown economic crisis dubbed "the Great Recession." Bruce dropped famed architect Frank Gehry and his 1.2 billion-dollar-design price tag for the arena. Bruce took a few clandestine trips to visit arenas in the Midwest to talk to architects. Ellerbe Becket, who designed nearly half the NBA arenas in the nation, signed on as the new architect. Bruce told Beckett he wanted the Brooklyn arena to be as good as or better than other arenas they'd designed in major cities, including Philadelphia's Wells Fargo Center and the Capital

One Arena in Washington, DC. They agreed at half the cost that Gehry had submitted.

When the economic crisis hit, many projects were stopped cold. Everyone expected Ratner to walk away. He was reportedly under pressure from the Forest City family each time he returned to them requesting additional money. He was taking hits from the development community because of the 50/50 housing agreement. They did not want to set a precedent.

The timing for Bertha Lewis's undoing couldn't have been more unfortunate—or fortunate, depending on which side of the argument you were on.

During the 2008 presidential campaign, ACORN, best known for advocating for affordable housing, helped to register more than one million low-income voters. But thousands of registration cards with phony names and addresses had been submitted. ACORN workers reported the suspicious cards, but Republicans seized on the controversy and ACORN was branded a criminal enterprise. Then things really got weird.

In 2009 conservative blogger Andrew Breitbart posted undercover videos in which right-wing provocateurs James O'Keefe and Hannah Giles dressed up as a pimp and a sex worker, appearing to get help from ACORN workers for illegal activity such as child trafficking. There were rumors floating around that Bertha Lewis was having an affair with Bruce Ratner and that they had a love child in the Bahamas. None of it turned out to be true. Congress voted to cut off federal funding for ACORN; President Barack Obama signed off on it.

After an investigation involving the Brooklyn district attorney,

The Black Family Who Built America

it was found that the Breitbart tapes were heavily edited and completely misleading. ACORN employees had not facilitated prostitution. By then Congress had stripped their funding—a move that was later ruled unconstitutional—and Bertha Lewis's reputation was ruined.

In 2010, Congress cleared ACORN of any wrongdoing. A thirty-eight-page report, probing how ACORN used federal funds, stated that the organization "showed no evidence of fraud, lack of oversight or misuse of funds." In fact, the probe showed that ACORN had accounted for $40 million worth of grants that aided poor Americans: combating lead poisoning, housing discrimination, and lack of job training. But it was too late.

People were scared. Many who had worked with Bertha suddenly seemed not to want to talk to her or anyone at ACORN because they felt like they would be next. Only a handful of people stuck by her—and one of those people was Bruce Ratner. Bruce loaned ACORN one million dollars unsecured. Bruce never wavered. He told reporters that he remained loyal to ACORN.

Meanwhile, the project appeared to be dead and stinking. Bruce couldn't find investors in the States. The banks had backed out when the market crashed. Forest City Ratner was still in litigation with opponents while they were authorizing work.

In December 2008, just a few weeks before Christmas, Forest City Ratner called everyone on the project.

"We want everybody off the site by the end of the week. The project is on hold until further notice," Bruce told us.

They told us to stop work. We had to carry our people for a couple of months, which was unnerving for us. We thought the

project would just be over, but Bruce was trying to get funding to finish it. Ratner needed a savior. And one finally came in the form of a good-looking, six-feet, eight-inch-tall Russian billionaire, the exciting bachelor Mikhail Prokhorov.

No one was 100 percent certain how Prokhorov had made his money. But that just added an air of mystery and intrigue to this handsome entrepreneur who seemed to fly in from nowhere to save the day. In September 2009, Prokhorov offered Ratner $200 million for 80 percent of the Nets franchise and 45 percent of the arena. It would take nearly nine months for them to negotiate the deal and for Prokhorov to become a majority owner of the Nets.

Prokhorov's and Jay-Z's pictures were plastered on a giant billboard across the street from the Knicks' home at Madison Square Garden. Brooklyn, and New York City, for that matter, had not seen anything this electrifying in years.

But the court battles weren't over yet. The New York Supreme Court had ruled that Ratner would be able to use the power of eminent domain to move residents out of the area of the new arena by purchasing their property at above-market rates. Opponents to the arena appealed the court decision. If the case was held up beyond December 31, 2009, it would have cost Forest City Ratner another $150 million dollars. Bruce had to break ground by the end of the year to be eligible for tax-free bonds.

On November 24, 2009, the New York State Court of Appeals ruled in favor of Forest City Ratner, and they were allowed to use eminent domain for the project.

We worked on other projects while we waited for the Barclays Arena project. We finished the renovation of the Philadelphia Eagles

The Black Family Who Built America

stadium—Lincoln Financial Field—and the renovations for Harlem Hospital. We opened our Harlem Workforce Development office for the community in 2005.

McKissack & McKissack finally broke ground for the rail project in March 2010, six years after we had begun pursuing a contract.

That project was a game changer for us. From there we won more transportation work and brought more dollars to the company. We showed that we could be the prime contractors for something that big, which allowed us to become prime contractors on other big projects moving forward.

In October 2012, I sat in the audience as Jay-Z took the stage at the newly opened Barclays Center arena.

"This has been a long journey to get here. . . . What's up, Bruce?" Jay-Z said, looking mischievously into the darkened arena for his new friend Bruce Ratner.

It was a day of historic firsts. We had rebuilt Atlantic Yards as a Black-owned construction firm. In April 2012, the Nets officially moved to Brooklyn. There were Black investors in the Brooklyn Nets and the borough finally had a professional sports team.

A collage of pictures that spoke to Brooklyn's history flashed on the jumbotron—the Brooklyn Bridge, Ebbets Field, Al Capone, Jackie Robinson, Jean-Michel Basquiat, Michael Jordan. One of Brooklyn's most beloved natives, Barbra Streisand, still battling her lifelong stage-fright affliction, would come home to perform songs from her new album *Release Me* on the Barclays stage the day after Jay-Z performed. It would be her first public performance in her native borough.

"I've been on many stages. I performed at the Grammys. I tore

Coachella to pieces . . . but nothing feels like tonight, Brooklyn. I swear to God," Jay-Z shouted as old-school gold rope chains bounced off his chest. "BROOOOOOOOOOKLYN!"

The crowd's roaring response pierced the air.

"You know they're waiting for us to fuck up," Jay-Z added, grinning conspiratorially as he looked out at the crowd.

I grinned back at him. I knew exactly what he was talking about. More than 220 years had passed since my great-great grandfather Moses had learned the building trade on the McKissack plantation in Charlotte, North Carolina. The journey of my ancestors to that powerful moment inside the Barclays Center had been an arduous, terrifying trek through some of the ugliest and most challenging trials Black people have ever endured.

Filled with emotion, I had a singular, illuminating thought:

If my ancestors could see me now . . .

CHAPTER 2

Two in a Million

My twin sister Deryl and I were born in Nashville on May 15, 1961, the second and third children of William "DeBerry" McKissack and Leatrice B. McKissack. DeBerry, as everybody called my father, was the grandson of Moses II, son of Moses III. My sister Andrea was eleven years older than Deryl and me, so she always felt more like a mother to us than a sister. Andrea used to tell everyone she broke a mirror when she was eleven and that brought her seven years of bad luck—the bad luck being these two boisterous little girls that she had to care for until she could escape to Howard University at eighteen.

While I wasn't fully aware at a young age what it meant to be a McKissack in Nashville, I did have indications that my family was different from most of the other Black families. About once a month when I was growing up, we would travel to East Nashville

to have dinner at my uncle Calvin's house. Since my grandfather Moses III was deceased, his brother Calvin ran the company and was patriarch of the family. Uncle Calvin lived in a grand colonial house on a street called McKissack's Row—because we owned all the property on both sides of the street and the surrounding areas, houses all filled with McKissacks. Each generation of McKissacks had had many children, so McKissacks were everywhere in that neighborhood. But Uncle Calvin's house was the biggest. At an early age, I began to understand the prominence of the McKissacks in Black Nashville. Most anywhere I'd go in the Black community, people would know who we were.

The dinners at Uncle Calvin's were elaborate affairs. We would all be seated at the impressive dining room table and the meal would be served to us by his staff. Everyone would be dressed up—complete with white gloves for the women and girls. When I saw August Wilson's play *The Piano Lesson*, with Wilson's vibrant, spot-on depiction of Black life and banter, I was transported back to the dinners at Uncle Calvin's. The conversation around the table was wide-ranging, from politics to civic affairs to business to gossip, and often hilarious. At some point, one of the old folks would start complaining about what was wrong with the young folks in the community—surely a conversation that has been repeated at Black dinner tables for generations.

Uncle Calvin was a classy gent—always dressed in fine suits and gleaming, polished shoes—with an air of sophistication and refinement. I'm told the same could be said about my grandfather Moses III, who died in 1952, nine years before I was born. Uncle Calvin died in March 1968, two months before my seventh birthday.

The Black Family Who Built America

I think back on those years with a pang of regret that my children had not been raised with that same wonderful tradition of fancy family dinners every month. There was a lushness, a sophistication, that my sister and I absorbed, taking it all in as naturally as the air we breathed. After dining at Uncle Calvin's every month as a child, and being served by staff while wearing white gloves and the loveliest dresses imaginable, no formal dining situation would ever be too overwhelming for me. Of course, I realize some of that was a function of wealth. I wasn't naïve about the fact that my family had money. But we all know money doesn't always bring with it taste and sophistication.

Deryl and I attended nursery school at Tennessee State University, the HBCU right down the hill from our home. We spent our early years sprouting inside the warm, loving embrace of the Black community. However, that all changed when it was time for us to go to kindergarten. My parents decided that we would attend a school called Peabody Demonstration School. It was part of a local teachers' college originally called George Peabody College for Teachers and eventually shortened to Peabody College. (In 1979, it was absorbed into Vanderbilt University.) The Peabody Demonstration School was attended by the children of the white elite in Nashville; the school began to admit Black students for the first time in the mid-sixties. Deryl and I were among the first, along with two other kids from our neighborhood, Avon and Livette—but they were two years older than we were.

It was the first time we'd been around so many white people, all day long, and we didn't like it. When we got back to our all-Black neighborhood at 3:30, it felt like we were able to exhale.

21

Cheryl McKissack Daniel

From eight till three, we had to put on our game faces and get ready for all the strange moments of discomfort that Black kids confront in all-white environments. I often thought we were there more for the white kids' education than for our own education. We were fascinating to them, in the same way people are fascinated by animals at the zoo. There were cliques of kids who didn't want to have anything to do with us, but there were others who wanted to be around us all the time.

The teachers were very good; I think we got a solid educational foundation at Peabody. They didn't treat us any differently from how they treated the white students. But we were constantly asking our parents if we could transfer to the schools our friends from the neighborhood attended. The answer was always the same: "No!"

My parents were spending a lot of money to send us to Peabody. "It's worth the money for the education you're getting. You'll thank us when you get older," my mother told us, more than once. When we complained about all the white kids and missing our Black friends, my mother would tell us, "You can see your friends when you get home."

Our father would bring us to school in the morning. Sometimes one of my uncles would pick us up; sometimes Avon's mother would pick us up. We hated it when she picked us up because she drove this raggedy old Volkswagen station wagon. When we saw that white wagon with the red trim in the pickup line, we'd get so embarrassed. We'd rush to the car so nobody could see us get in.

I think our feelings of embarrassment were definitely compounded by race. We didn't want to look like we embodied the stereotypes that the white kids likely already had about Black

The Black Family Who Built America

people. We would go to their houses for sleepovers, so we knew how a lot of these white kids were living—huge, stately mansions sitting on estates surrounded by acres and acres of pristine land. Uncle Calvin had a large house, but it was an old colonial-style structure in the city. These were fancy new houses outside the city. Their houses would be filled with the newest and finest of everything—the best furniture, the best stemware. Everything just screamed *money*.

Deryl and I both were very good students. I recently came upon our old report cards and saw nothing but A's. My mother was a schoolteacher up until the time we started school; she insisted on nothing but A's. In addition to our schoolwork, she would give us independent assignments that we had to do. When we came home from school, we would have to read *Time* magazine after we finished our homework, before we could go outside to play. At Peabody, it was always foremost in my mind that we were there representing the entire race. We had to look a certain way, act a certain way. We were around people who didn't really understand Black folks, so we were an embodiment of the entire community, in our little schoolgirl bodies. That definitely weighed heavily on me.

Who am I kidding—it *still* weighs heavily on me.

We lived in a neighborhood of nice but modest homes. My grandparents bought a large swath of land on a hill and sold off plots to various well-to-do Black folks in Nashville—doctors, lawyers, academics from nearby Fisk and Tennessee State. McKissack & McKissack then designed and built most of their houses. They called the neighborhood Geneva Circle, named after my great-aunt Geneva—Calvin McKissack's wife and DeBerry's aunt. The biggest

houses were at the top of the hill; our house was on Batavia Street. As people ascended economically, they built houses higher up on the hill—literally moving on up. When I visited recently, I saw that white people are now occupying many of those houses.

My father was the architect and builder, but he also was very futuristic with the interior touches and the furniture—he built furniture as well. When we sat down to dinner as a family, sometimes he'd start drawing sketches on a napkin, working out a design. Our kitchen, which was next to the main entryway of the house, was very modern. It was a ranch-style home with all of the rooms off a main hall. There was a formal living room and a large family room. There was a master bedroom and bath for my parents, and two bedrooms for us three kids. Andrea, who was so much older than we were, had her own bedroom, and Deryl and I shared the other bedroom; we all shared the second bathroom. We were enamored of our older sister; she was so beautiful, so artistic. She made her room into a painting; she literally painted pictures directly on the walls. Daddy would help her because he was artistic as well. When we were nine and ten, Deryl and I would spend many Saturdays painting with our father; he would teach us different techniques with the brushes, how to mix paints. He always used acrylic, which was closest to oil, so that he could create colors easily. He also used watercolors. But Andy was the one who really got that artistic gene. Her room was a total expression of her. She had a Chinese motif in the room; she and Daddy built frames that they would mount on the wall around the paintings. It was very clever; my parents' friends would always want to go to Andy's room when they visited to see the latest pieces of art she

had created on the wall. She wound up getting a degree in art from Howard. She later got an engineering degree at Tennessee State.

When she left for Howard, that room became my and Deryl's room. We loved spending time in there, surrounded by all the art. When we were about eleven, my parents built a large addition to our house. They moved into the addition and their master bedroom became our bedroom. I guess Deryl and I could have separated and gotten our own rooms; honestly, that never occurred to us. That's the way it often goes with twins growing up; the connection is so strong that we can't even envision being apart. We were always in cahoots, always up to something, always trying to figure out how to sneak out of the house. I was usually the one in trouble, though—the one more likely to give my mother fits.

Our mother made us dress alike until we were about twelve. We had been trying to appeal to her to let us wear what we wanted, but she wouldn't listen, until we got an assist from an unexpected place—an episode of the television show *Marcus Welby, M.D.* On the show, Dr. Welby talked about the detrimental psychological effects of making twins dress alike. When she heard that, we were able to convince her that we should be able to dress differently because we each have our own style.

At the bottom of the hill sat the John Henry Hale housing projects. Growing up, all of us mixed and played together, no matter how much money your family had. None of us kids looked down on anybody—though my mother wasn't crazy about us hanging out in the projects. When Deryl and I were younger, several girls from the projects said they wanted to "kick the McKissack twins' ass." We didn't know why we had targets on our backs.

When we went outside after we finished our homework and played kickball on the street with the other kids, we would be on high alert. We were never sure if some project girls were gonna show up at any moment, wanting to fight. Ironically, as we got older, I found myself drawn to the projects and those girls, like a bee to honey. Those girls who wanted to kick my ass? Soon I was in their homes eating dinner with them. Between me and Deryl, I was definitely the one with a rebellious streak—which would continue to reveal itself in various ways during our youth. I was more of a tomboy, while Deryl was the more sophisticated one. I think those kids in the projects could see that I didn't act like I was better than them. I had a level of acceptance with them that my twin sister didn't have. I was more like my father in that way, while Deryl was more like my mother. Over the years, that has never really changed—I might wear designer clothes now, but it's not who I am.

We lived not more than 100 yards away from the kids in the projects. I'd ponder the question, *What, if anything, makes us different?* More than once, my mother asked me, "Cheryl, are you hanging out with those people in the projects?"

"Uh, I don't know," I responded—knowing I had just been at their home.

"You better not bring home any roaches!" she said.

Oh no, I did see some roaches when I was there!

"Yes, ma'am," I said.

If we weren't playing in the street outside our homes, we were walking over to Tennessee State to see what was going on. The campus was a source of endless entertainment for us. I don't think it

The Black Family Who Built America

really registered at the time with us that our family had constructed most of the large concrete buildings on the sprawling campus. On the weekends we went to Tennessee State football games, where we would be entranced by the lovely, glamorous majorettes. We were the children of doctors, bus drivers, janitors, hairdressers, builders. We knew we were elite from the standpoint that we owned a lot of property and our family had the only Black design-and-construction business in the state, but I didn't carry that around with me.

My mother's side of the family had a more elite air to them. When she was growing up, her stepfather, Alrutheus Ambush Taylor, was the dean of Fisk University and best friends with Arna Bontemps, the renowned Harlem Renaissance poet and novelist who was Fisk's head librarian. As dean, her father regularly had notable African Americans, including Langston Hughes and Bontemps, dine at their house, so she grew up surrounded by worldly intellectuals. It was a very different kind of prominence than the McKissacks had—and, in fact, my mother felt like she was from more impressive stock than my father. Her father had a PhD from Harvard, while the McKissacks were contractors who worked outside with their hands.

As a young woman, she once brought a big, beautiful cake, complete with fancy decorations, to DeBerry's house. This woman who knew which fork goes with each entrée in a formal dinner stood by in horror as my father's five brothers came by and grabbed pieces of cake with their hands. She thought they were barbarians. DeBerry's family was building Fisk University with their hands, while her father was trying to build minds—a reflection of the debate between W. E. B. Du Bois and Booker T. Washington about the best path to Black progress.

Despite these differences between their families, after my mother and my father had been married a number of years, they thought about the circumstances of their meeting and figured that the older adults in their lives actually might have planned their courtship. My uncle Calvin McKissack, who was also DeBerry's uncle, was a trustee of Fisk at the time—the only Black trustee on the board (most HBCUs were run by whites in the early days)—and worked closely with my mother's father, who was the dean. My mother thought it was strange that her father seemed unusually interested in her developing a deeper relationship with DeBerry, whom she had met at the tennis courts when her father was giving her lessons.

"I was in Nashville at Fisk and DeBerry was in DC at Howard and one night I told my father I had met this fine guy from Texas and I was going out with him," my mother, Leatrice, recalls. "My father said, 'Well, what about DeBerry?' I said, 'What about him? I haven't heard from him.' My father told me he didn't think I should go out with the guy from Texas. 'DeBerry might call,' my father said. I started to get mad and went to my room. Next thing I know, the phone rings. It's DeBerry."

They wound up getting married a few years later, right before they both graduated from college.

My mother definitely wanted to be considered among the elite. And she brought a level of sophistication to the McKissack name. She opened up areas of society that my father wasn't even interested in, such as being on the board of the Nashville Symphony or the fancy Cheekwood Estate, and going to the estate's annual Swan Ball. She was truly a socialite. But I also know it's the McKissack name that made her who she was in society.

The Black Family Who Built America

My father had very few airs about him. He would show up in a suit that wasn't ironed. If a button or buckle fell off before he walked out the door, he'd sit down and sew it back on. He just didn't care. This is a man who walked construction sites all day. He actually cut slits in the sides of his shoes because he had a corn. DeBerry was a humble guy who treated everybody the same. He was an eclectic man who danced to his own beat. Though we lived through some harrowing times in terms of race relations, he still managed to see everybody as just people. Some of his best friends were white. Some of his best business associates were white—and we're still good friends today. My mom used to say my father was part of the good-ol'-boys' network.

For me and Deryl, the most special day of the year when we were growing up was Christmas. It was a magical day for all of the children in our neighborhood. In the weeks leading up to Christmas, Deryl and I would wrap anywhere from fifty to a hundred gifts. They would be color coded, so we knew which family they were for. When Christmas day arrived, after we excitedly opened our own presents, we would load all of the gifts we had wrapped into the car and begin the family Christmas tour. First, we would start on our block and drive the short distance to Livette's house. Her father, a brilliant research doctor, was a bigwig at Meharry Medical College. After we exchanged gifts with them, they would join us as we moved on to the next family we were visiting, usually Tee's family—Tee was a doctor as well. Next we'd all visit Lamar and his wife; they were Deryl's godparents. Eventually we'd end up at Joan and Avon Williamses' house (Joan and Avon were my godparents) at Fisk, which was only about five or ten minutes from where we

lived, but we wouldn't get back home until midnight—overflowing with presents we had gotten during the day.

At every stop, there would be drinking and a whole lot of talking. The men were large and in charge—we'd all sit and listen to them talk about Black folks, white folks, politics, the latest case of Z. Alexander Looby. Looby was a giant in Black Nashville, a civil rights attorney who was always fighting the white establishment to gain justice for Black people. He worked with Thurgood Marshall to gain acquittals for Black men charged in a race riot; he pushed the city to change the charter to create single-member city council districts, which resulted in African Americans being elected to the city council—including Looby himself, who was elected in 1951; he defended students arrested in Nashville sit-ins pushing for desegregation of public spaces, which resulted in his house being firebombed by segregationists in April 1960.

Sitting around at one of these Christmas gatherings, I heard my father declare, "The white man ain't gone get me down!"

More than a half century later, I can still say that those Christmas days listening to them tell fascinating stories and crack jokes were some of the best days of my life. Us kids invariably would splinter off into a room away from the adults and sample the spiked eggnog, giggling all the while. It was about the fellowship, the food, seeing our friends, comparing Christmas presents, listening to our parents. When we got a bit older, we would sneak out and dive into our own foolishness. I liked this boy who lived near Avon's house whom my parents hated, so I would try to find my way over to him. The parents were drunk by now, so they were not keeping tabs on us; we could get away with all kinds of stuff—I had my first

The Black Family Who Built America

kiss and make-out session on Christmas. Ahh, such warm, powerful memories.

We would also use kids' birthdays as occasions for everybody to gather for fun and fellowship. However, it was during one of these birthdays that we were all tragically reminded of the times we were living in, and the ugly racism that was never far away.

I was nine and I was excited about attending my friend and classmate Avon's birthday because I knew his mother, Joan, my godmother, would have a sumptuous spread for us. Joan was the best cook I knew; everybody loved going to her house because we knew our taste buds would be doing a praise dance. She made this cornbread in an iron skillet teeming with sausage and cheese. The first time I tasted it as a little girl, I thought I had died and soared up to heaven—it was literally the best-tasting thing I had ever put in my mouth. Even if it was just a piece of fried chicken, there would be something special about whatever came off her stove.

We were all gathered in the kitchen, sitting at a long table that Avon Sr. had set up. We finished singing "Happy Birthday to You" and little Avon blew out the candles. In the midst of the celebrating, we heard a loud, blood-curdling scream. Everybody got up from the table and rushed outside to see what was going on.

My eyes widened at what I saw outside: an enormous cross engulfed in flames that I felt instantly on my face. The stench of burning wood and gasoline was suffocating. The day hadn't yet turned dark, but the dusk was alight with this monstrous image in the middle of the small patch of lawn outside their house, well over six feet tall and blazing a lifelong memory in each of our souls. A

huge round ball of fire with a burning cross inside—the desecration of the symbol of Jesus by so-called Christians. The mothers were all screaming—my mom was standing next to me and I felt her high-pitched screams all the way down to my toes.

How could this have happened so quickly? The distance from the kitchen to the front yard wasn't long. *How had they managed to plant a cross in the lawn and set it on fire without anyone seeing or hearing them?*

Us kids might have wondered why. The adults likely didn't. Avon Williams Sr. was a prominent civil rights attorney and state senator who was always pressing the white establishment in Nashville to recognize the rights and humanity of African Americans. Whether it was pushing for justice after the police killed another Black man, insisting that Black students be accepted at schools like the University of Tennessee at Nashville, or demanding that Black businesses get a share of the work in the construction of the airport, Avon was a constant figure in the news for having his foot up white society's behind. There's no doubt why local white terrorists would want to send a message to this proud, unapologetic Black man. They must have somehow known we all would be gathered at Avon's house—they were getting the most dramatic bang for their hate-filled buck.

The scene was terrifying, another in a series of frightening moments exploding around us. The killings of President Kennedy, Malcolm X, Martin Luther King Jr., and Bobby Kennedy, and cities across the country, including Nashville, igniting in destructive exhibitions of anger and frustration—the years of my childhood were violent and scary. But none of them had been as close as this. After

that day, I walked around with discomfort and insecurity making a permanent home in my gut.

If they can come here and burn a cross, what's stopping them from killing us?

That thought took up too much precious real estate in my head. I had always felt safe and protected in the Black community, covered, but these terrorists had breached our space. My feelings of protection were gone, crumbled.

I wasn't naïve; I lived in the South. I knew there was always the possibility and threat of racial violence lurking around every corner. I knew there was a great deal of hate out there. Whenever we drove down to Pulaski, where many of my father's brothers and their families still lived, he would always be on high alert, worrying about being pulled over by cops. He'd make sure he hadn't been doing much drinking before he got behind the wheel. When someone offered him another drink and he declined, I knew why. In Pulaski, he wasn't going to drink like he did on Christmas, when we were confined to our neighborhood.

I was shaking as I stood next to my mother and Deryl. After screaming, she rushed us back inside, as did the other mothers. Our fathers went into Dad mode—angry, protective, running into the street to look around, their outrage and frustration stamped on their faces.

We never found out who burned the cross—it wasn't the style of the KKK to claim credit for their terrorist acts. They much preferred to hide in the shadows like cowards.

The birthday party was effectively over. There wasn't much energy to continue celebrating Avon when such ugliness had been

thrown in our faces, reminding us of who and where we were. No matter our successes, our money, our prestige, we were still Black in America.

Though there were reasons to fear the world, I need to stress that our childhoods nevertheless were filled with an abundance of joy. Much of it came at the hands of our father.

"He absolutely lost his mind when I gave him twin babies," my mother remembers. "He probably spent more time with his girls than I did. Sometimes they'd be in the back seat, and one of them would say, 'Daddy, can you see?' And they'd try to put their hands over his eyes while he was driving in the morning when he was bringing them to school. And on Saturday, he would take them all day. After they were potty-trained, all I had to do was to get them dressed. Oh, the places they would they go.

"They'd come home and say, 'Mom, guess where we went today?' I said, 'I have no idea.' They said, 'Daddy took us to a movie!' I'd find out he'd take them to see some risqué movie. They were sitting on each side of him, so he'd reach out his arms and cover their eyes for certain scenes. Honey, their dad was exposing them to everything."

My father often would take us to construction sites on Saturdays. We were always surrounded by construction, buildings being designed and erected. We both started tracing at a very early age. By the time we were twelve or thirteen, we had traced a full set of documents for a residential building in Nashville. Growing up, we got T squares and Leroy lettering sets for presents.

Some of my most vivid memories are of the wild parties my parents would have as we got older. Many of them took place out at Old Hickory Lake. (It was called Old Hickory Lake in honor of

The Black Family Who Built America

President Andrew Jackson, who purchased a property there known as the Hermitage and owned hundreds of slaves. Jackson's nickname was Old Hickory, which he acquired during his time as a military leader of Tennessee troops.) We had a cozy little two-bedroom lake house that sat on twenty acres of land. My father's brother and his wife had a much bigger house next door because they lived on the lake full-time. My father had his yacht docked in Nashville; almost every weekend we would sail to the lake, which was about twenty-five miles from Nashville.

On Saturdays, we would pack up the car in the middle of the afternoon. Before we headed to the lake, my father had stops to make: We would go to the market for fresh corn; we would go to Counterpoint, for the world's best barbecue sandwiches; we would buy lemon meringue and chocolate meringue pies; we'd buy alcohol. After a half day of errands, finally we would get to the lake. Sometimes we would go straight to the marina and board the yacht. My father would guide the yacht over the Cumberland River, which snakes around Nashville for miles before widening when it gets to Old Hickory. By the time we'd get to the lake it would already be 8 o'clock. It was time to party.

My father and his brothers and cousins built a large, screened pavilion at the crest of a hill on their property. The pavilion had a firepit in the middle, around which were picnic tables and chairs. They would bring tons of food and liquor into the pavilion— by 10:00 p.m. the party would be in full swing. Robbie, one of my mom's best friends, and her husband owned a liquor store, so the adults were never going to run out of libations. They would party until the wee hours of the morning. There were many evenings

when we were young adolescents where there would be as many as one hundred people there, including at least twenty-five kids in our age range. The parties were wild. Legendary. I can clearly recall the night when Robbie got drunk and decided she was going to strip—she thought she was wearing a swimsuit under her clothes, but forgot that she had skimpy underwear on. Us kids saw way too much that night!

Our lives revolved around our large family and even larger group of friends. There was much love and warmth that flowed between us. These were folks who worked really hard, establishing businesses, fighting hard to have our humanity, our skills, our worth, recognized by white society. And when they were done fighting for the week, they wanted to party just as hard. It was a wonderful, supportive, loving childhood—which gave me the strength and the confidence I would need in the coming years as I blazed my own path in the cutthroat construction business.

CHAPTER 3

Hollywood to Tennessee

The challenge for Black businesspeople in the later part of the nineteenth century was figuring out how to grow with a customer base that was largely Black. The businesses that were able to rely on the patronage of whites struggled to hold on to those customers in an environment where white society had little interest in fostering Black success—and in many cases was virulently opposed to Black progress.

Pulaski, Tennessee, was a popular destination for freedmen and -women because the Union Army set up a camp there to help house them, feed them, and give them jobs. The army also set up education classes for them in Pulaski, teaching them how to read and write.

Moses II managed to gain construction jobs from white patrons in Pulaski, even in the midst of rampant white racism. Pulaski is where the children of Moses II and Dolly attended public school.

Moses III, born on May 9, 1879, spent eleven years in public school at the Pulaski Colored High School. In his early years, he worked on his father's construction projects and gained firsthand experience in various building techniques. By the time he was eleven, Moses III was working with a local Pulaski architect named James Porter, from whom he learned how to make construction drawings and whom he also helped with building construction. He stayed with Porter until he was sixteen, when he was hired to supervise the construction of the Vale Rolling Mill, the ice plant and storage building, and the Riverburg Mill. He also constructed houses in Pulaski, Mount Pleasant, and Columbia, Tennessee.

In 1905, Moses III moved from Pulaski to Nashville, where he saw his construction-and-design business really take off. He already had a major job in hand when he arrived in Nashville—to build the residence of Granbery Jackson, dean of the Architectural and Engineering School at Vanderbilt University. It's likely that McKissack had developed quite an esteemed reputation in Tennessee if the company was hired by the white head of the architecture program at one of the top schools in the South. Other faculty members were impressed with Moses's skills and hired him to design their residences in the upscale West End area of Nashville. While he was working on these projects, Moses completed an international correspondence school architecture course.

The 1907 Nashville city directory listed McKissack as a "contractor" with offices at 1001 Eleventh Avenue, North, but the following year he moved his office to the Black business section of the city at 413 Fourth Avenue, North. This was a time when the Black community was trying to figure out the most effective path

The Black Family Who Built America

forward for continued progress and self-determination. After the disappointments of the Reconstruction period following emancipation, there was an increased emphasis placed on economic development and less on political activism. August Meier wrote in *Negro Thought in America, 1880-1915* that the Black community widely believed if they achieved high moral character and an imposing economic position, they would impress whites so favorably that they would be freely accorded their rights. Organizations including the National Negro Conference were created to promote these ideas.

Part of this movement was imploring Blacks to patronize Black businesses, which would help create a Black capitalist employer class that would be in a position to provide Black people with jobs so they wouldn't be reliant on whites for their economic well-being. As a builder engaged in projects across Nashville, Moses III stepped solidly into this role, employing large numbers of Black men to help him build.

At the Fourth Conference for the Study of Negro Problems held in Atlanta in 1899, the following resolution was adopted:

The mass of Negroes must learn to patronize business enterprises conducted by their own race, even at some slight disadvantage. We must cooperate or we are lost. Ten million people who join in intelligent self-help can never be ignored or mistreated.

I'm struck by how little the Black community's rhetoric has changed in the last 125 years when it comes to patronizing Black businesses—often with the same air of desperation.

In 1906, one year after Moses moved from Pulaski to Nashville, Booker T. Washington visited Nashville to speak at Fisk. In the

February 8, 1906, edition of the *Nashville Banner*, a story on his speech included the following:

"The congregation not only taxed to fullest seating and standing capacity, but one hundred, both colored and white were turned away. Mr. Washington, founder of Tuskegee, spoke on the need of colored people to be educated. He stressed the need of education of the hands as well as the head. Mr. Washington emphasized the need for colored people to help themselves and need of the colored community to patronize colored business."

While many Blacks were pushing their entrepreneurial ambitions, most Black people still were dependent on whites for their economic survival. This often meant that they had to carefully calibrate their demeanor in the company of whites, to ensure that they projected the proper deference. This also meant that they felt the frequent sting of white hostilities.

"To promote racial loyalty among white workers, bosses refused to hire black women and relegated black men to unskilled, physically demanding work away from the factory floor," Jennifer Ritterhouse, George Mason University historian, wrote in "Daily Life in the Jim Crow South, 1900–1945." "Whites had also pushed black men out of trades like carpentry and masonry after emancipation and had prevented them from entering new occupations such as electrical work and plumbing. Apart from doing unskilled physical labor, often on an irregular basis, black men living in urban areas found employment mainly in service work for white families or as porters, bellhops, elevator operators, and delivery boys. To make an adequate income, many had to leave their wives and children to find jobs in the countryside, in lumber and turpentine camps or on railroad

The Black Family Who Built America

construction crews. Meanwhile, the majority of black women had to work for wages to make ends meet and typically had few options other than domestic work in white homes."

Moses McKissack III saw his reputation boosted considerably in 1908 when he received his first major commission—to design the Carnegie Library on the campus of Fisk University. The following detailed description of the library's design is included in a successful application for the structure to be included in the National Register of Historic Places, filed with the National Park Service in 1984:

"The building has not been significantly altered and is listed on the National Register as part of the Fisk University Historic District. This two-story brick building was designed in a restrained Neo-Classic style with a stone columned porch, a stone belt course and a large hipped roof of clay tiles and bracketed eaves. The interior contains a two-story light well which provides illumination into the building."

The application, which was approved by the US Department of the Interior in January 1985, when four McKissack buildings officially became national historic sites, states that the Carnegie Library "stands as one of the first major structures designed by a black architect in the country." Moses was chosen to build the Fisk library while his younger brother Calvin was a student at Fisk. Born in Pulaski in 1890, Calvin attended Fisk from 1905 to 1909. He likely worked alongside Moses on the library construction during his final year at Fisk and after he graduated.

It was an interesting time for Fisk, a school established in 1866, just seven months after the end of the Civil War. While Nashville's Black community certainly felt great pride in Fisk—considered one

Cheryl McKissack Daniel

of the top schools for Black students in the country—the community also felt alienated from the university. Fisk was seen as a school of the Black elite, supported by a large concentration of fair-skinned "mulattoes" who, in the view of many Blacks, had segregated themselves into an exclusive clan. Overseen by white leaders, Fisk was considered by many to be an institution willing to accommodate the constraints of Jim Crow rather than fight the system. Booker T. Washington, who served on Fisk's board of trustees—in addition to being married to a Fisk graduate and sending his own children to Fisk—said in 1911 that Fisk intended to train students who could live within the confines of Jim Crow in order to "make progress for the Negro race."

This perspective was vociferously opposed by W. E. B. Du Bois, who had graduated from Fisk in 1888—and went on to earn a doctorate from Harvard, becoming one of the first African Americans in the country to earn a doctorate. Du Bois, whose daughter attended Fisk, wanted the school to train students who would aggressively and openly fight the oppression of African Americans. When Fayette A. McKenzie, a white graduate of Pennsylvania's Lehigh University, became president in 1915, he quickly aggravated much of Nashville's Black elite with his arrogant personality, leading Du Bois to head an alumni movement to remove him. Du Bois claimed that McKenzie used white speakers to indoctrinate Fisk students against social rebellion.

In 1925, McKenzie was replaced by Thomas E. Jones, a Quaker who was the last white person to preside over Fisk. Over his twenty-year tenure, Jones was intentional about maintaining a strong relationship with the Black community. One strong move in that

The Black Family Who Built America

direction was his decision to appoint a Black dean—Alrutheus Ambush Taylor, my mother's stepfather. Through fundraising and grants from the Carnegie Corporation of New York and other organizations, in 1924 Fisk became the first Negro college with a million-dollar endowment ($18 million in today's dollars). But the benevolence of whites began to wane in the 1920s when Black students at Fisk, Howard, and other colleges increasingly pushed for Black control over their own education. Along with the egregious lack of financial support from the state and federal governments, these changes put HBCUs in a cycle of unremitting financial desperation that they still find themselves trapped in today.

Like his brother Moses, Calvin also received an architecture degree through an international correspondence school course after graduating from Fisk, in addition to doing postgraduate study at Springfield College in Springfield, Massachusetts. After working with his brother for several years, Calvin moved in 1912 to Dallas, Texas, where he practiced architecture for three years. In Dallas, Calvin designed several Black schools and churches. He returned to Nashville in 1915 and took a job teaching architectural drawing at Tennessee Agricultural and Industrial State Normal School for Negroes, which had been established three years earlier, in 1912. (The school's name was changed to Tennessee State University in 1968. Notable alumni include Wilma Rudolph, Oprah Winfrey, and Rep. Harold Ford Sr.) Calvin also taught architecture at Pearl High School, one of two high schools in Nashville for Black students. By 1922, Calvin had joined forces with Moses to form McKissack & McKissack Architects and Engineers.

Between 1905 and 1920, Moses did a significant amount of

building around the Vanderbilt and Belle Meade area, a well-to-do white section of Nashville where many Vanderbilt and Peabody professors and other prominent citizens resided. By May 1905, shortly after he arrived in the city, Moses had already completed four residences in Belle Meade—three brick homes and a wooden frame home. In the same year he got the contract to design the Carnegie Library at Fisk University, he was contracted to build Payne Chapel in Nashville.

In the 1909 city directory, Moses McKissack III for the first time is listed as an architect. He is included with eighteen other architects in the city; Moses is described as a "colored architect."

Between 1908 and 1920, Moses began a slow transition from serving a mostly white clientele to a primarily African American clientele. By 1890, Blacks made up 40 percent of Nashville's population, so it was a smart business move to seek their patronage.

"After 1890 and the ruthless onslaught of legalized racial segregation (Jim Crow), the elite Negro leaders reluctantly drew even closer to the masses," Lovett wrote in *The African-American History of Nashville, 1780-1930*. "After 1900, a highly cohesive elite group of black men concentrated on building an economy and engaging the masses to patronize their own businesses. There indeed was a special place for an elite class in this segregated world where Negro banks and businesses stretched through several blocks of downtown Nashville as well as along a corridor in a north Nashville suburb by 1930. The promotion of businesses led to more wealth and leisure for the elite blacks who promoted progressive reform, social organizations, cultural and literary movements, the idea of a clean and healthy community, and a respectable society among Negroes."

The Black Family Who Built America

In the second decade of the twentieth century, McKissack-designed buildings began to sprout on Black college campuses. In 1912, Moses designed the three-story main campus building for the Turner Normal and Industrial School for Negroes in Shelbyville, Tennessee, about fifty-six miles south of Nashville. He also designed dormitories on the campuses of Roger Williams University in Nashville and Lane College in Jackson, Tennessee. McKissack residences were popping up in all sections of the city—between 1918 and 1922, McKissack designed more than a dozen residences in East and West Nashville and Belle Meade. The houses are all examples of the Colonial Revival style that McKissack favored, which was in the mainstream of architectural theory during the period.

As described in the National Register of Historic Places, the most significant residence Moses designed in this period was the home of Dr. George W. Hubbard, the director of Meharry Medical College. The alumni and trustees raised $17,000 ($258,000 in today's dollars) for the construction. The large Colonial Revival two-story house designed by McKissack in the American foursquare style sat at 1109 First Avenue, South, and featured rectangular porch columns, a fanlight and sidelight at the front entrance, bay windows, and a hipped roof with exposed rafters. Because of its architectural and historical significance, the Hubbard House was listed on the National Register in 1973.

There was a monumental national event in 1915 that also precipitated the need for Black business owners to seek Black patronage—the release of the exceedingly racist film *The Birth of a Nation*.

Sound like a stretch? Let me explain.

When we consider the delicacy of racial dynamics, sometimes it's helpful to look more deeply into the social and cultural currents coursing through people's lives at the time. There's no doubt that this landmark movie had a devastating effect on race relations in the United States for years to come.

D. W. Griffith's three-hour film, based on the novel *The Clansman* by Thomas Dixon Jr., depicts the KKK as saving the South from the ignorant and brutish freed slaves, whom the film portrayed as being primarily interested in sexually preying on white women. Dixon's motives couldn't be clearer. In describing his novel, this is what he wrote:

"My object is to teach the North, the young North, what it has never known—the awful suffering of the white man during the dreadful Reconstruction period. I believe that Almighty God anointed the white men of the South by their suffering during that time . . . to demonstrate to the world that the white man must and shall be supreme."

Though the film's content and message were dishonest and ugly, the film pioneered groundbreaking techniques—such as close-ups, zooming the camera in on faces, and crosscutting, in dramatic Civil War battle scenes—that the world had never seen. It was also an enormous commercial success, the *Star Wars* or *Avatar* of its day. In many ways, *Birth of a Nation* is credited with inventing Hollywood. I don't think it's possible to overestimate how much this phenomenon affected the minds of an impressionable white society still trying to determine what to do about this rising and ambitious Black population in its midst. For whites who may have been grappling with an inclination to welcome Blacks into the fold,

this film offered a scold that such an idea wasn't wise. For whites still nursing outright hatred, Griffith gave them license to kill and purge the so-called "dark menace" for the sake of America. African American writer James Weldon Johnson wrote in 1915 that *The Birth of a Nation* did "incalculable harm" to Black Americans by creating a justification for prejudice, racism, and discrimination for decades to follow.

Indeed, violence surged across the country in response to the film. In 1917, riots in Philadelphia; Houston; Chester, Pennsylvania; and Lexington, Kentucky, resulted in the deaths of approximately two hundred African Americans. Riots in twenty-five cities in 1919 caused hundreds of Black people to die—more than one hundred alone in the Elaine Massacre in Arkansas. Riots in Illinois and Florida in 1920 led to the deaths of nearly one hundred African Americans. The well-known Tulsa Race Massacre in Oklahoma in 1921 killed between one hundred fifty and three hundred Black people.

The Birth of a Nation is three hours of racist propaganda—starting with the Civil War and ending with the Ku Klux Klan riding in to save the South from Black rule during the Reconstruction era.

"[Griffith] portrayed the emancipated slaves as heathens, as unworthy of being free, as uncivilized, as primarily concerned with passing laws so they could marry white women and prey on them," Dick Lehr, author of *The Birth of a Nation: How a Legendary Filmmaker and a Crusading Editor Reignited America's Civil War*, said on NPR.

Lehr pointed out that much of the storyline was accepted as historically accurate by whites at the time. President Woodrow Wilson, a college classmate of Thomas Dixon, praised the movie

and screened it at the White House—reportedly the first film to receive that distinction.

To advertise the film, *Birth of a Nation* promoters sent white-robed horsemen through the streets of New York City to symbolize the heroic Klansmen. Can you imagine what that looked like, the KKK riding through the streets of New York City? Later that year, a Georgia preacher named William Joseph Simmons held a ceremony at the top of Stone Mountain in Georgia to revive the KKK, which had been largely dormant for decades. Membership surged.

To make the film, Griffith had moved from the East Coast to Southern California to take advantage of the weather. After the explosive success of the film, an entire industry followed suit—and Hollywood was born.

"If you plant seeds, what grows from those seeds is going to be based on what you planted. So if you're trying to grow marijuana, you probably shouldn't plant tomatoes. *Birth of a Nation* is a film that represents racism," USC film historian Todd Boyd told NPR. "It is at the foundation of what would become Hollywood. So if this is at the root, then it shouldn't be a surprise when in the last few weeks, there have been discussions about the lack of people of color being nominated for the Oscars. In my mind, this is very much a branch that grew out of the tree that was *Birth of a Nation.*"

In 1920, the state of Tennessee passed a law requiring all architects and engineers to acquire a license in order to keep practicing their trade in the state. Moses and his brother Calvin had been constructing buildings across the South since 1905. Suddenly they were faced with this new requirement. Prior to that, it was sufficient to be a tradesperson with a certificate that read "master builder."

The Black Family Who Built America

Not to be deterred, the brothers carefully prepared for the licensing exam by refreshing their skills through a correspondence course. They appeared before the state licensing board on the scheduled date, but the state administrators balked when they saw that the brothers were Black. They told Moses and Calvin that they couldn't take the exam. Eventually, after a prolonged negotiation, the board allowed them to sit for the exam. Apparently, the administrators, thoroughly indoctrinated with the myth that Black people had limited intellectual capacity, the kind of stuff that was already swimming around but rarely so publicly and openly as *this* time, believed they would fail. It was a tactic similar to those that had been employed for years to keep Black people from voting. But the brothers did not fail. The administrators knew they would face unfavorable publicity if they continued to deny the brothers. The brothers lobbied board member Carlton Brush to speak up on their behalf. He wrote to the other members: "I request you act without regard to color as we have no authority to disqualify any race."

In 1922, my grandfather and his brother received licenses numbered 117 and 118. They became the first African American licensed architects in the state of Tennessee. Despite all their experience, they faced racist resistance. That mindset hasn't completely left us— which is why we still need Minority and Women-owned Business Enterprise (MWBE) set-aside programs.

Their fight to get their license was a powerful emotional touchstone for me, because, nearly a century later, I faced an almost identical challenge from the state of New York.

CHAPTER 4

Too Big to Be Small

Ever since I was a little girl, I had my eyes on New York. There was something about the energy of the place that always intoxicated me. Just as I was starting elementary school, my parents brought me and my sisters to the big city, leaving behind our comfortable home in Nashville and diving into exquisite adventures amid the towering buildings and chaotic traffic. For a week, we went to Broadway plays, fabulous restaurants, shopping sprees on Madison Avenue, and rambles through Central Park. I couldn't believe people got to live in such an exciting place.

One day, I'm gonna work in New York, I would tell myself as I spun around in my frilly dress and absorbed every sight. *I'm gonna work in one of these tall buildings.*

There's an old saying: Be careful what you wish for.

Finally, my dream had come true: I was back in the big city

The Black Family Who Built America

more than thirty years later, hoping to establish McKissack as an architecture company in New York.

And the big city was trying to kick my butt.

My family had been at this for nearly 200 years—building thousands of structures across the United States, establishing the McKissack name as the most prolific Black builders the country has ever seen. Schools, churches, dormitories, mansions, housing complexes, office buildings—McKissacks had built them all. America wouldn't look like America without us. But as I tried to get my business off the ground in the Big Apple, none of that history mattered. Or at least that's how the white folks in New York were acting.

Even though McKissack was more than a century old, we came into New York as an upstart. In the early years, we were helped substantially by a new agency in New York called the New York City School Construction Authority. The SCA was established in 1988 by the state legislature to oversee the design, construction, and renovation of public schools in New York City. Half of the city's 1,400 public school buildings were built before 1949, so they require constant vigilance to keep them from falling apart. The independent SCA was intended to circumvent the interminable civil service system that had hamstrung new school construction in the city for years. We were treated fairly by the SCA's first president, General Charles Williams, a Black man who had spent twenty-nine years in the US Army Corps of Engineers and who was committed to ensuring that women- and minority-owned firms were given access to SCA contracts.

In one of our first SCA contracts, as a subcontractor to a Black

architect out of St. Louis, we had a very good experience. I was excited that the SCA would be a major source of work for McKissack. We went after three more SCA contracts, competing against larger white firms, and we won all three—this time as the prime contractors. This wasn't well received by the white firms; they weren't going to let this go without taking shots at us. A Manhattan-based company called Helpern Architects wrote letters to the head of the SCA, saying we were practicing illegally because we weren't certified as a professional corporation.

In the 1980s the state of New York passed a law requiring that in order to operate an architecture business in New York, 100 percent of the owners have to be licensed architects in New York State. But I couldn't fit that requirement because I hadn't attended architecture school—I was a civil engineer with a master's degree from Howard. I had tried, but when I came to the conclusion that I liked building buildings far more than designing them, I left the program. I knew I was quite capable of running a full-service construction and architecture firm in the city, but the state had other ideas.

My attorney Marc Ginsky came to me one day with an idea. One of my family members had registered a McKissack Company in New York in the 1950s. In addition, my grandfather Moses McKissack and his brother Calvin had registered a McKissack & McKissack Architecture and Engineering firm in Nashville in the 1920s.

"Let's see if we can get one of these companies grandfathered in," Marc said. "Because the law that says all owners have to be architects didn't happen until the 1980s."

When he told me the idea, I had to laugh. I was brought back

The Black Family Who Built America

to one of the most inspiring stories I had heard as a child about the challenges my grandfather and his brother faced in the early twentieth century. How ironic that the practice we would pursue to get my business license was called "grandfathering."

Seventy years after Moses and Calvin got their licenses from Tennessee, the State of New York eventually decided to grant us the license. But it didn't last. We were coming in at the beginning of the state's MWBE program, which required white companies to give 10 percent of their work to minority- and women-owned businesses. Before we came along, the white firms who opposed the program could ignore the requirement, claiming there were no qualified MWBE firms available. Once we were licensed, that was no longer the case. They were so upset by our presence that they lobbied the state to change its mind, claiming again that we were operating illegally. They eventually got what they wanted—our license was revoked.

I was outraged by the state's duplicity. But I wasn't ready to give up. If Moses and Calvin had the fortitude to overcome the ugly brand of racism they faced in the American South in the 1920s, I knew there was no way I could let greedy white folks in New York keep me from my dream of becoming a New York City builder. I had to reassess and figure out my next move. I was horrified that I still faced the same battle my ancestors had, some seventy years later. In America, so-called progress often drops you off right where you started.

While I was doing some drafting work for an engineering firm and trying to figure out what I would do next, I learned of an opportunity to work on a project in Philadelphia as a construction

manager. This meant I'd be overseeing the construction of buildings, rather than designing them. This felt much closer to my passion. I had separated from my first husband, and I had begun dating Fred Felder, who eventually became my second husband. Fred was a contractor and he thought Philly would be a good place for me and my company.

"Listen, [Ed] Rendell is in the mayor's office in Philadelphia, and his president of city council is John Street," Fred told me. "I think this would be a great place for you to open an office."

Philadelphia was about 40 percent Black at the time, while New York was just 28 percent Black. There also were a lot of Black women in leadership in Philly. At the same time, Rudolph Giuliani was now mayor of New York City and was sunsetting all the MWBE laws for the city. We weren't winning any new work; contractors were going out of business. We lost a generation of minority contractors during the Giuliani years. In many ways he was establishing the playbook that Donald Trump would seemingly follow twenty years later.

Fred had a good friend named Bart Blatstein, who was a big developer in Philly; Bart and I really hit it off. He offered me cheap office space in one of his buildings, sharing with Jerry Roller at JKRP Architects. Philly was so much easier to navigate compared to the hustle and bustle of New York. I was used to crazy traffic, but driving around Philly was so different—almost how it felt driving in New York years later during COVID. I also found out I was pregnant with my first child.

The firm pursued our first construction-management project with the School District of Philadelphia. The school board, which was

run by a prominent Black attorney named Rotan Lee, also included two other Black members, and they wanted to help me succeed in Philadelphia. We wound up winning a $9.5 million project as the construction manager to renovate Germantown High School.

We decided to go after a larger project, the $24 million construction of Franklin Learning Center, and we won that one, too. There was a white guy in charge of design and construction for the school district; on the surface, he acted like he was a supporter of McKissack and the MWBE program. Around the time we won the Franklin job, he was killed in a terrible car wreck. He was decapitated. I thought he was one of my champions, so I went to his funeral. I was clutching an envelope containing a check that I was going to give to his wife, because that's what we did back in those days. An attorney for the school district, a Black guy, was watching me closely. He came over and asked, "What are you doing?"

"I'm trying to help him because he was—"

"You don't know?" he said, interrupting me. "He was on the phone trying to get rid of you when he was decapitated."

"What?!"

He told me that when the car wreck occurred, the guy was on the phone actively trying to figure out how to take the contract from McKissack and give it to a white construction firm. It sounded biblical, like God was watching over me when I wasn't even aware.

"I don't even know why you're here," the attorney said.

I slid the check back into my purse.

After the funeral, I went to the Black school board members, asking questions. They all said the same thing.

"He couldn't stand the MWBE program—he was trying to work against all MWBEs."

This has happened to me more times than I care to count—white guys who pretend to support MWBE programs but are secretly working to exterminate them. This guy had to do what the board members told him to do, but he didn't like it. Sometimes they're in opposition because they just don't like Black folks; other times it's because we're not greasing their palms. I can't be sure which it was with the school-district guy, but I heard that he was getting paid under the table by other contractors.

Being the construction manager on a project is about organization and oversight. Before the project is bid out to subcontractors, we give the owner an estimate of what we think the overall budget is and we come up with a construction schedule. Then we take those documents, break them down into bid packages for the various trades, and send those out to the subcontractors. If the subs have questions, they submit requests for information (RFI) that we must answer. Everyone submits their bids on the same date, then we take the bids and level them—meaning we make sure each subcontractor is looking at the documents the same way and didn't miss anything substantial in their bid. Finally, we select the lowest bidders and eventually whittle it down to the one that will do the work. Once we select the subs, either we do a contract with each one of them or the owner does a contract with them. Once construction starts, we oversee the subs to make sure they are doing quality work and that everything in the architectural documents is what's being built in the field. We handle safety issues on the site; if there are unforeseen conditions that require a new design or new documents, we handle

The Black Family Who Built America

the entire change-order process—when a change to the original project must be made, after the contract has been signed, because of unforeseen issues that have arisen.

When construction is done, we teach the owner about all the equipment in the building, we turn over the manuals, hand them the keys, and we're done.

On most of our projects, our staff gets paid an hourly rate. We get reimbursed for the cost of our staff, the people in the field, in the office—whoever is working on the project. Then we put a fee on top of that cost for the entire project. For example, if the project is $10 million, we might charge a 3 percent fee, so the $300,000 is pure profit. If we've given the client an invoice for a lump sum for the entire construction, based on what our subcontractors, or subs, have given us, then we might go back to our subcontractors and try to reduce whatever they say their bid is, to squeeze out a little more margin—all the while keeping an eye out on behalf of our clients because we're responsible for the overall quality. It's risky because we are juggling so many balls in the air.

While this was going on in Philly, I gave birth to my daughter Deryl. I named her after my twin sister because of a funny agreement we made when we were younger. Growing up, she always said she never wanted to have kids. She said she was afraid, or whatever. I think she saw how difficult little kids could be. So, I said, "Well, I'm not afraid. I'm having kids—and I'll have mine and yours!"

About a decade after my first, she did wind up having a daughter of her own, Ahlyah.

I gave birth to Deryl in November 1994. By February, I was pregnant again, and later that year gave birth to my daughter Leah.

When you have two kids back-to-back, people think you're trying to make a baseball team.

"Oh my God, you're pregnant *again*?! For real?"

Fred and I also weren't married yet, mainly because my first husband was giving me such a hard time with the divorce. Anybody who's ever gone through a divorce knows that one party can make the process unnecessarily difficult. When the divorce finally came through two years later, in March 1997, I called my pastor, Rev. A. R. Bernard, leader of the Christian Cultural Center in Brooklyn, who I knew was eager to see me and Fred get married after having two kids.

"Can we get married next week?" I asked him.

We lugged our kids to Brooklyn for the ceremony. My mother flew up from Nashville; my sister Deryl was there. We didn't have a chance to get rings, so I took off my little hoop earrings and we put them on each other's fingers. I was relieved to finally have it done. I was a bit embarrassed that we hadn't married sooner, trying to be out and about in society and in the business world. Pastor Bernard was always so cool about it; he never judged. His attitude was, *I understand why that one had to go. I understand why this one entered. We get it; you don't have to make excuses for our benefit.* We commuted from Philly to New York every Sunday for church. Fred was a born-again Christian. By the time I met him, he didn't drink anymore. So, I stopped drinking, too. At least I did for a decade—until the craziness of my life made me pick up a glass.

Fred grew up in Columbia, South Carolina, at a time when Black people had to walk in the street to make room for white people on the sidewalk. If he didn't move into the street far and fast enough, white kids would throw rocks at him. His father wasn't around; he

The Black Family Who Built America

often had holes in his shoes; his childhood home had an outhouse. You're talking about a Black man who felt acutely all the burdens of being Black in America. But somehow he still managed to thrive, using his smarts, his drive, his impressive people skills. When he was young, he didn't have the opportunity or support system to get a fancy education.

I told him, "Fred, if you had gone to Harvard or somewhere like that, you probably would have been [billionaire] Reginald Lewis before Reginald Lewis."

Fred started his own contracting business, using his great gift of gab to get jobs. He could talk his way in and out of anything. He taught me a lot when it came to how to comport myself as a businesswoman. How to stand firm in who I am, whether I feel it or believe it or not. I have a fifth-generation business, dammit— even if we're still struggling at times and still needing the MWBE program after 100 years in business.

We're not Turner Construction, which was founded in 1902, three years before Moses McKissack founded the company in Nashville. We're not AECOM, which was officially founded in 1990 and became a conglomerate by acquiring other companies with much older histories. We're not Hunter Roberts Construction Group, which was founded in 2005. These companies are valued in the billions and have enormous backlogs. So, what's the difference between those companies and McKissack & McKissack? Do I really need to answer that?

The big money is not deployed with us; the venture-capital money does not flow to us. There's an estimated $69 trillion worth of venture capital in the United States; less than 1.3 percent goes to

firms of color and less than 2 percent goes to women-owned firms. If the nation is going to come close to leveling the playing field, we have to be aggressively intentional about it. Instead, we're going in the other direction, eliminating affirmative action in college admissions and talking about doing the same in the business world.

McKissack is too big to be small, meaning we don't qualify for Disadvantaged Business Enterprise programs (DBEs). But we're too small to compete with the Turners and AECOMs. How do we get into the mainstream?

I had a friend who started a venture capital firm, and he called me because he was interested in helping an Asian woman who started a company specializing in electric vehicle chargers.

"Cheryl, we want to help this woman, but she's an MWBE because she's got the Asian designation and she's a woman. How do we do it?"

I told him it was virtually impossible, because if he owned more than 10 percent of her company, then it wouldn't pass the net-worth thresholds to be an MWBE. But at the end of the day, she's still an Asian woman. Just because she got a big investor, I don't think she should be disqualified. She should still count as an MWBE. As a result, it becomes difficult for companies like hers and mine to scale up. With all these rules, it feels like the system wants us to stay little.

As I became more established in Philly, it was interesting to watch Mayor Rendell operate. He and his chief of staff, David Cohen—who went on to become CEO of Comcast—used deal-making to grow the city. On many occasions, my phone rang and it was Rendell on the other end.

"Cheryl, I hear you just won this project," he said. Translation:

The Black Family Who Built America

I think he wanted me to know I got the project because he made sure I got the project.

"Congratulations," he continued. "Now, there is this Black nonprofit over there in North Philly that I need you to go and visit and help out. Just do whatever they ask you to do."

In that way he was a very smart politician; he connected the dots. I believe he was trying to help the entire city of Philadelphia and not just a few. It seemed his way of doing that was to have the Asians help the Asians, the Blacks help the Blacks, the LGBTQ community help each other. That's how he saw things, and he ran the city accordingly. As a result, the city grew under his leadership.

When John Street came in right behind him as mayor, he was a no-nonsense Black man who was keen on helping the Black community. And it seemed that that led to his administration's downfall. Soon enough, the feds swept into town, poking around to see what they could dig up on the Street team. There were so many FBI agents crawling around Philadelphia that a bunch of us wore pins that read something along the lines of, *If you're a Black elected official, you're under investigation.*

During Street's reelection campaign in 2003, the FBI acknowledged that it had placed listening devices in his office as part of a broad investigation of municipal corruption. Street cleverly used the FBI investigation to his advantage during the campaign, winning reelection with 58 percent of the vote. The FBI probes led to more than a dozen of Street's associates being convicted of crimes, including his older brother Milton Street—but John Street was never charged with anything.

Philadelphia really taught me the power of politics and showed

me how much money talks in politics. As a businessperson in the city, you had to participate in a system where political donations could get you much-needed access. I've been a big supporter of many politicians early in their careers, before many others jumped on their bandwagons. My philosophy is, you never know where they might wind up. So I made it my business to support politicians that supported MWBE progams and minority buiness.

With my construction-management business in a strong place, I decided it was time to give New York another try. I quickly discovered that New York was now a different landscape for business because Michael Bloomberg was mayor—along with his many billions. Bloomberg was so rich that he didn't need to raise money from anybody else for his political campaigns; he had more than enough in his own wallet. That meant New York was now a free place to work. I wanted to do backflips when I discovered that one. "This is terrific!" I said out loud to no one in particular.

As a matter of fact, while he was mayor, Bloomberg gave away money to other people. He gave my church in Brooklyn hundreds of thousands of dollars to help us build a new establishment. He would just go around to Black churches making charitable donations. When he was raising money for one of the Democratic senators in New York, I got an invitation to the fundraiser. I was keen on getting there early. Fred always used to tell me, "Listen, if you go anywhere, be early so you can see what the hell is going on." He was right—when I got somewhere early, I usually got good information. I would always get pissed if I was late anywhere.

When I got to Bloomberg's house on Manhattan's Upper East Side, I was the only person there. The staff left me alone, so I just

The Black Family Who Built America

walked around and did my own sightseeing. I was gawking at all the incredible touches—the green marble going up the walls, the beautiful antique pieces, the stunning furniture, the breathtaking art, the gold this and gold that.

"Hey, how are you?"

The voice came from behind me. I turned around and I was shocked to be face-to-face with Michael Bloomberg. I gathered myself and gave him the rundown of who I was, my elevator speech. I presented to him the whole legacy story, going all the way back to Moses I.

"Wow, that's excellent. Just terrific!" he said. He thought for a second. "I'm gonna have a small business committee, and I want you to be on it."

"Okay, great!" I responded.

By now, a few others were trickling in. One of them was Leon Eastmond, who turned out to be the only other Black person at the event. Leon was President of EASCO Boiler Corporation, a New York–based company that had been manufacturing boilers for many decades. An old-school gentleman, Leon understood how New York worked; anytime there was a political event of note, I'd always find Leon there.

I worked with Bloomberg's people on the Small Business Administration. He had a white guy overseeing MWBE programs; their policies weren't great to me, but they were better than Giuliani's. Bloomberg said all projects that were a million dollars or less had to have MWBE goals. That meant he was committed to helping us, but only on the small stuff.

Years later, when Bloomberg launched his presidential bid, they

asked me to do a commercial for him. I called up Pastor Bernard to get his advice. "I want to be on the right side of this," I told him. "His policies weren't that great, but they were better than what Giuliani was doing."

"Well, it's all in the language, Cheryl," he said. "It's how you use the language. Words are king."

I wound up filming a national commercial for the Bloomberg campaign. It shows me sitting and addressing the camera, as well as walking around at a construction site while my voice is heard in the background. After I explain that McKissack is the nation's oldest Black-owned design-and-construction firm, I say, "Before Mike, we were desperate. There were not a lot of opportunities for Black-owned businesses to compete. Mike saw that, and he leveled the playing field for Black-owned businesses. Over the years we have heard a lot of talk. But Mike came in and he actually did something about it. And that's how Mike will get it done as president."

The thirty-second ad closes with a picture of Bloomberg and the words, *Mike Will Get It Done*. I felt like I was able to keep my truth and still tell the truth. What Pastor Bernard told me that day about speaking my truth is something I've always kept with me. I'm often in rooms where I have to speak my truth. I've learned how to do it in tactful ways, telling a side of the story that people may not always want to hear. It's the key to diplomacy.

When I wanted to make stronger inroads in New York, I called Mom. I left her a phone message telling her that I wouldn't see significant progress in New York until I met Republican Governor George Pataki. She called me back and told me Governor Pataki

The Black Family Who Built America

was going to be having lunch in Nashville with the governor of Tennessee.

"If you can be here, they can seat you next to Pataki," she said.

I went to the governor's mansion in Tennessee—and that's exactly what happened. We had a lot to talk about since we were both there from New York. He told me that when we got back to New York we needed to have a meeting. He introduced me to one of his advisors, who proceeded to ask me about holding a fundraiser for the governor. I understood that these were the ground rules of the game I was now playing.

When I got back to New York, I reached out to about 200 people. We eventually raised close to $50,000 for Pataki's 2002 campaign for governor. Politicians began to include me in the mix for his fundraisers in New York, and I always kept my word and showed up. Gearing up for Pataki's second term, the advisor he introduced me to told me that he thought he could arrange a one-on-one with the governor. I didn't believe him. Then Governor Pataki's advisor called and asked me to meet him and the governor at a restaurant in Manhattan. My husband Fred and I drove from Philadelphia to the 21 Club in Midtown Manhattan. I was expecting it to be another fundraiser dinner with a crowd of people. I was delighted when I discovered I was wrong. When Fred and I showed up, it was just us—me, Fred, the governor's advisor, the governor, and fundraiser Cathy Blaney.

After introductions and light conversation, Pataki cut to the chase and asked me, "Well, what is it that you want?"

"I want you to make me wealthy," I said, verbalizing the first thing that came into my head. The governor fell out laughing.

65

I was also a bit shocked I had said that out loud. We had a great relationship from then on. I developed a good rapport with the Republican Party in New York and made inroads with agency heads and developers across the state. These contacts were all extremely helpful when I went after the Barclays Center project.

In Philly we lived in the Germantown-Lafayette Hills section of the city. My children Deryl and Leah went to grade school about two or three minutes from our home, taking the school bus every morning. When Deryl was six and took the school bus for the first time, I made sure I stayed home that day—because when I was absent, I was really absent, leaving at six in the morning. The bus came at around 7:00 a.m.; she walked out the door like it wasn't a big deal and stepped on the bus. Then she taught her sister to do it. I was getting home so late, by the time Deryl was seven I had enough business in New York to get a studio apartment on Thirty-Third Street and Eighth Avenue, across the street from Penn Station. If I was really, really tired, or I had a late business meeting, I could at least stay there and go home the next day.

I had to rely heavily on babysitters; eventually I moved to live-in nannies. I had one woman from Sierra Leone who I think thought she was my husband's wife. She would get dressed up better than me when we would go out of town and she was watching the kids. When she'd come with the family to dinner, she would want to sit next to him. If my kids needed to go to the bathroom, I would do it myself. I didn't need the nanny to do that, especially since I wasn't with them so much of the time. But I'd come back from the bathroom and she'd be all up on Fred. It was crazy. I don't think anything was happening between them, but she had to go.

The Black Family Who Built America

As a dad, Fred was 100 percent present, but I felt he was too rough on the girls, too strict. He had a lot of old-school ways that I found annoying, like telling them they couldn't walk around the house without shoes on. I wasn't drinking, and I was working constantly. Not a great combo for me. On the weekends, I was doing the grocery shopping, getting their clothes together, all the things mothers have to do. On Sunday nights I'd be so tired. I'd crawl into bed at midnight, knowing I had to wake up at six. *This is just so hard*, I thought to myself.

My sisters and my mother would say to me, "Where's the old Cheryl? She used to be so much fun." They noticed that my personality had changed. One Thanksgiving when we were sitting around the table, my mom was pouring everyone wine and so she poured me a glass because she was used to me drinking.

"Well, I don't drink," I said—though a part of me really wanted to take the glass.

"Now, you used to drink when you were thirteen—and you didn't care what Mom and Dad said. Now you care what this man says?" Deryl said. "How does he have that kind of control over you?"

She was right—I had been feeling he was very controlling. Even with the girls, he believed in disciplining them in ways I did not, such as using switches and spankings. I kept saying to myself, *I hope one day my ship comes in*. I didn't mean it literally; it was just something to say. Early one morning my husband and I were in bed and we heard a distant sound that we hadn't heard before.

"Well damn, that sounds like a ship blowing a horn on the ocean," I said. Later that day I told my girlfriend Priscilla, "You know

how I used to say, 'I want my ship to come in?' Well this morning I heard a ship. So it's coming, it's coming!"

I went to my doctor for a regular checkup, and she seemed concerned. "Your blood pressure is extremely high; you have got to do something about it," she said. "And beyond that, Cheryl, you have this scowl in your head right here."

She pointed to her forehead. "I've never seen that before," she said. "What's going on with you?"

"I'm stressed the fuck out!" I said.

"Well, have you ever considered having some wine?"

"That sounds pretty good to me right about now," I said. "But you know, I haven't been drinking for about ten years."

She looked at me. "Listen. A little merlot never hurt anybody. You're wound so tight. You need something."

Honey, she didn't need to say any more. In fact, I wish we'd had legal cannabis back then. I had to pick my kids up from school at about five o'clock that day because they were doing sports or something after school. I saw that I had some time, so I went straight to the bar.

"What do you want to drink?" the bartender asked.

I shrugged. "I don't know—my doctor said merlot."

"Well, we got merlot, we got cabernet, we got pinot," he said.

"I'll take a cab—*and* a merlot."

Oh my God, it felt so good. I felt like I had retrieved a part of my personality from deep freeze. I still wasn't ready to tell Fred I was drinking again—so I started sneaking. If I was taking the kids out and Fred was working late, I would put some cab in a juice glass. At home I'd take a sip of other people's wine before I served

them, but then when I got to the table and they'd want to pour me some, I'd say, "Oh, no." I was living a lie around my wine. Pretty soon I graduated from wine to apple martinis and cosmos. Next thing I knew, I was straight-up drinking. But I was taking all my liquor over to my girlfriend's house. I got more resourceful and would hide bottles down in my boots. The kids didn't know I was drinking; Fred didn't know I was drinking. The only people who knew were my girlfriends and my sisters and Mom.

I would go to New York to stay the night—not because of work but to drink and hang out. To have a good time. I felt like I had gotten my life back. I felt free and I felt good. My blood pressure went down, just like the doctor prescribed. It was then that it fully hit me—I was being manipulated by my husband, controlled.

One day he said to me, "You smell like liquor."

"Yep! I've been drinking," I said. "As a matter of fact, let me go in here and get a bottle out of one of my boots."

I felt a huge relief, like a weight had been removed from my shoulders. That night I probably had three apple martinis. I know I smelled like liquor.

"Oh, I'm gonna pray for you," Fred said.

"Pray on, honey, pray on. I'm making up for ten years without drinking!"

The marriage lasted just a couple more years.

About seven or eight years later, one night when I was hanging out and drinking with my mother and sister, my sister looked at me and said, "I think you have made up for it now."

Mom agreed.

CHAPTER 5

1929 and Back

By the mid 1920s, McKissack & McKissack had to pivot exclusively to the Black community for business. After 1921, the bulk of Moses and Calvin's projects were Black churches and buildings on HBCU campuses. The rise of a Black middle class in Nashville broadened the opportunities available to them. They constructed the Morris Memorial Building at the corner of Fourth and Charlotte Avenues, which held the offices of the Sunday School Publishing Board, the headquarters of the National Baptist Convention, on the site once occupied by the Old Commercial Hotel. Completed in August 1925, the large four-story building is surely one of McKissack & McKissack's finest designs of the 1920s. An article in the August 17, 1924, edition of the Nashville *Tennessean* newspaper reported that the Morris Memorial Building "will be one of the outstanding affairs of its kind in the country, having

been constructed for a negro organization, by a negro construction company, following the plans of negro architects." It was selected as a National Historic Site by the National Park Service in 1985. On the nomination form to the NPS, the building is described in this way:

"It is designed in the Neo-Classic style with an exterior sheathing of Indiana limestone. Over the main entrance is a large fanlight and Doric motif pilasters are spaced evenly along the first story. Above the first story is a cornice with modillion blocks, metopes and guttae. At the roofline is an elaborate frieze with garlands and wreaths, a modillioned cornice and balustrade. The interior also contains significant detailing with a central light well and a stained-glass skylight which illuminates the first-floor lobby."

When the Morris Memorial Building was finished, Moses and Calvin moved their offices to the first and second floors, where the company headquarters remained for decades. This is where my sister Deryl and I would spend our Saturdays with my father in the 1960s and early 1970s. One of my strongest memories of the office was the smell. We shared an entrance with a soul-food restaurant, Carol's, and the fragrance from the food she was cooking would fill the air inside our offices. Fried chicken, fried fish—there was always something being fried up in there. The food was delicious. It was the kind of spot where you ordered a meat with three, meaning something fried with three sides. You could sit inside and eat or get your food to go. We did both; we were up in Carol's all the time.

One of the churches they built in the 1920s was also chosen as a National Historic Site—the Capers C.M.E. Church at 319

15th Avenue, North, in Nashville, considered one of the firm's best church designs. Capers was the church home of the McKissack family for many years; I spent many a Sunday morning staring up at the large stained-glass windows and counting the sunken panels in the coffered ceiling. Deryl and I would dress every week in our Sunday best—pretty dresses, white socks, white gloves—to join our parents, trying not to fidget as we listened to endless sermons. It felt like we were there all day.

Moses and Calvin became members of the National Negro Business League in the 1920s. The league was started in 1900, with Booker T. Washington as its first president, to push the importance of business development in the Black community. In 1925, Calvin was elected president of the powerful Negro Board of Trade, which had superseded the Negro Business League in importance. Moses was a major stockholder in such prominent Black businesses as the Penny Savings Bank in Nashville and the Universal Life Insurance Company in Memphis—the first Black-owned-and-operated insurance company in Tennessee, formed in 1923. McKissack & McKissack was chosen in 1929 as the architects for the new headquarters of the company, built on Memphis's Hernando Street.

The firm became recognized for its fine work designing in the art deco style, which exploded in popularity in the United States and Europe in the 1920s and early 1930s. Combining fine craftsmanship and rich materials, the style was seen to represent luxury and glamour. Major examples of the style were skyscrapers built in New York City in the 1920s and 1930s including the Empire State Building and the Chrysler Building. Two noteworthy examples

The Black Family Who Built America

of the McKissack expertise in art deco were the CME Publishing House, built in Jackson, Tennessee, in 1931; and the AMEC Publishing House in Nashville.

The firm's membership in the Black business elite brought commendations from many quarters. The family archives include letters written by prominent Black leaders attesting to the popularity and integrity of the firm in Nashville's Black community. The following letter from Ira T. Bryant, secretary-treasurer of the AMEC Sunday School Union, to the president of Fisk University, Dr. Thomas E. Jones, dated November 3, 1930, is a prime example:

"It occurs to me in the great extension program of Fisk University you will from time to time have need for a first-class architect. I am desirous of recommending to you the firm of McKissack & McKissack—reputable, business-like, painstaking and dependable men of my group, who held first class rating in their line of work. They have furnished the brains behind some of the best buildings, not only in Nashville but the South. I am expressing the hope that in giving out such contracts as you will be awarding from time to time, that you will see your way clear to take them along with the others of whatever group, according them the same consideration that merit and efficiency entitles them to."

I find it fascinating to see how these elite Blacks danced around the question of race, talking about "men of my group."

Another letter to Dr. Jones at Fisk on behalf of the McKissacks was written by Hilary Howse, who served as mayor of Nashville for a total of twenty-one years and who was popular among African Americans for measures such as the creation of Hadley Park— the first major city park for Blacks in America:

73

Cheryl McKissack Daniel

"I have been advised that a Science Hall will soon be erected on the campus of Fisk University, and am addressing you this letter in the interest of McKissack & McKissack, Architects and Contractors of our city."

"The firm of McKissack & McKissack has in the past constructed for the City of Nashville a colored Public School Building and Fire Hall, their work has at all times proven entirely satisfactory and have always carried out their contract to the letter. They enjoy the distinction of being thoroughly reliable in all of their dealings, they are a local firm and I will appreciate any consideration shown them when the above contract is awarded."

Despite these letters and several others, the Fisk president (who was white) didn't choose McKissack to build the Fisk Memorial Library or the chemistry building—he chose a local white architect, J. C. Hibbs, and a white builder, Rock City Contractor, for both structures. Though Moses had built the Fisk Carnegie Library in 1908, interestingly Fisk did not hire the McKissacks to build another structure on campus until the 1950s—several years after Calvin McKissack became a member of the Fisk board of trustees in January 1942.

Architect Joseph W. Holman, who was white, and Granbery Jackson Jr., son of the dean of the school of architecture and engineering when Moses moved to Nashville to build his home in 1905, were both instrumental in helping Moses and Calvin receive certification to work in other parts of the South. They both sent letters to the Board of Registration of Architects in Columbia, South Carolina; Auburn, Alabama; Jacksonville, Florida; Atlanta, Georgia; Jackson, Mississippi; and Montgomery, Alabama. Written in the

The Black Family Who Built America

late 1930s and early 1940s, these letters stated that Moses III and Calvin were registered in good standing in Tennessee. Despite these letters, the architectural licensing boards in some states, Alabama and Georgia included, still sent back correspondences questioning the firm's qualifications. Tennessee answered by stating the firm was " . . . somewhat unique in the fact that it is one of the few Negro architectural firms in the country. They have done some creditable work in Nashville, including several large school buildings running into a total cost of several hundred thousand dollars." In 1941 the firm was registered to practice architecture in Alabama and in 1943 licenses were granted in Georgia, South Carolina, Florida, and Mississippi.

The collapse of the stock market in October 1929 pulled the country down into the devastating chasm of economic desperation known as the Great Depression. McKissack & McKissack managed to survive this period, but not without some pain. They were dependent on new building projects from the public and private sectors, but most of these entities were just trying to hold on to what they had, never mind start new projects. Between 1929 and 1932, industrial production in the United States fell by nearly half (with devastating drops also in the United Kingdom, France, and Germany); wholesale prices fell by a third; foreign trade plummeted by 70 percent; and unemployment rose by 607 percent, putting 12 million Americans out of work by March 1933.

During the 1930s, Black communities across the country were ravaged by the depression. They were said to be the "last hired, first fired," with little to no savings to cushion their fall. The low-paying jobs most Black people held either disappeared or were snatched

up by desperate whites. The national Black unemployment rate was an estimated 50 percent in 1932—60 percent in Philadelphia and Detroit, 70 percent in Atlanta in 1934, according to historian Cheryl Lynn Greenberg in her book *To Ask for an Equal Chance: African Americans in the Great Depression*. Although these rates spoke to a despair in the cities, that didn't stop hundreds of thousands of desolate Black Southerners, many of them sharecroppers, from heading north and west during the Great Migration—effectively transforming Northern cities for generations to come. By 1940, approximately 1.75 million African Americans had moved from the South to cities in the North and West.

The economic policies of the Franklin D. Roosevelt administration, though often crafted to allow Blacks to be excluded or discriminated against, offered the African American community a measure of hope. In response, the Black community switched its political support en masse from the Republican Party, which had long been seen as the party of Abraham Lincoln, to Roosevelt's Democratic Party.

"My friends, go turn Lincoln's picture to the wall," *Pittsburgh Courier* editor Robert Vann wrote to African Americans in 1932. "The debt has been paid in full."

More than 70 percent of African Americans voted for Roosevelt in the 1936 election, according to the Joint Center for Political and Economic Studies.

Title II of Roosevelt's National Industrial Recovery Act created the Public Works Administration (PWA) to finance the construction of public works. With its $3.3 billion appropriation, the PWA—which eventually was taken over by the Works Progress

The Black Family Who Built America

Administration (WPA)—was a godsend to the McKissacks. The PWA and the WPA constructed hundreds of badly needed Black schools, recreation centers, and hospitals, in addition to thousands of low-cost rental apartments. In the process, they provided jobs to hundreds of thousands of Black workers with a wide range of skills.

Under the PWA, McKissack & McKissack was hired to build two Black schools in Nashville: Pearl High School and Cameron School. When it was completed by fall 1937, many observers considered Pearl High School the most modern, best constructed, and most well-equipped school for Black high school students in the South. (The Tennessee Historical Commission approved the placement of a historical marker at the site of the former Pearl High School in October 1992.) The McKissacks also designed Washington Junior High School on Nineteenth Avenue, and the Ford Greene School, constructed in 1939. The firm designed a residence for the son of former Tennessee governor Albert Roberts, showing that they still had some access to white patronage.

In 1935, McKissack & McKissack was forced to lay off most of its workforce. The company received a loan of about $125,000 from a local Nashville bank—likely Commerce Union Bank—to help weather the depression.

When the Japanese bombed Pearl Harbor on December 7, 1941, killing more than 2,000 Americans, the traumatic assault pulled the United States into World War II—and, in the view of many economists, effectively ended the Great Depression. McKissack & McKissack didn't know it at the time, but the historic moment also initiated a series of events that resulted in one of the greatest honors the firm has ever received. A year later, the federal government

awarded McKissack & McKissack a contract for $5.7 million to design and build the Tuskegee Army Airfield, home to the Tuskegee Airmen's 99th Pursuit Squadron, in Tuskegee, Alabama. It was the largest federal contract ever awarded to a Black-owned company at the time. The firm employed more than two thousand people— carpenters, cement finishers, brick masons, plasterers, roofers, sheet-metal workers, plumbers, steamfitters, electricians, along with clerical workers, expediters, job superintendents, and mechanical and civil engineers—working nearly round the clock to complete the field in just six months. The total job consisted of constructing administration buildings, barracks, warehouses, school buildings, and hospitals. They also built state-of-the-art hangars designed by Tuskegee student Booker Conley. The McKissack workforce was about three-fourths Black and one-fourth white. Commentators at the time noted that no racial friction occurred among the mixed working men, which was a credit to McKissack's management skills.

In an interview, my father, DeBerry, surmised that the influence of Roosevelt's Black Cabinet likely was instrumental in helping McKissack get the contract. While it wasn't an official White House group, the Black Cabinet—informally led by the iconic activist and educator Mary McLeod Bethune—consisted of several dozen Black leaders who lobbied and advised President Franklin Roosevelt and First Lady Eleanor Roosevelt to make sure African Americans got an equitable share of aid and resources from many of the New Deal programs designed to keep Americans out of poverty. Historians credit the Black Cabinet with establishing the foundation of the civil rights movement that emerged after World War II.

The Black Family Who Built America

My father also believed that McKissack benefitted from the fact that his father and uncle had previously done architectural and construction work at Tuskegee Institute.

After McKissack & McKissack completed the field, the training of the pilots was conducted by Brigadier General Benjamin O. Davis, one of only two Black officers in the army. The men recruited to be part of the Tuskegee Airmen were among the best and brightest the Black community had to offer.

In the book *The Tuskegee Airmen: The History and Legacy of America's First Black Fighter Pilots in World War II*, Airman Roscoe Brown had the following recollection:

"When World War II started, the Black press and the Black community wanted Blacks to be able to fly because in 1925, the military had done a study that said that Blacks didn't have the intelligence, ability, or coordination to fly airplanes. The pressure from the NAACP and the press caused them to start an experimental group that was to be trained in Tuskegee, Alabama, and that's why we were known as 'The Tuskegee Airmen.' They went to colleges and recruited the best leaders and athletes to be Tuskegee Airmen. When I was attending Springfield College in Springfield, Mass., my junior year, where I was valedictorian of my class, I had already earned a commission as an infantry officer when I was 18 because they had R.O.T.C. when I was in high school. I resigned my commission, signed up to be a Tuskegee Airman."

Many of the airmen were from the North and had never been to the Deep South. What they discovered in Alabama was shocking to some. "The trip down was my first real experience of the South," said Airman Charles McGee. "As the train left southern Illinois, you

had to change your location in the car. We knew there were certain barber shops or restaurants to go to in Chicago, but you could feel the change in atmosphere and approach as you entered the Deep South—you knew that whatever happened, the law was not going to uphold whatever your position was. When you were a Black man from the North, you especially had to be careful what you said and did. You learned to be extra careful when stopping to fill up your car, and even avoid some filling stations. To a degree, the southern Blacks were concerned about how a northern Negro was going to act, and a lot of conversations dealt with what you needed to know and where to go to keep out of trouble. One of my classmates happened to be from a well-to-do family who owned a drug store in Montgomery, Alabama, and he helped steer me into the Black community, because you didn't go into the downtown area very much."

By the end of the war, a total of 992 pilots were trained in Tuskegee between 1941 and 1946. Of these, 355 saw combat in Europe. Sixty-eight pilots were killed in action, twelve were killed in training or noncombat missions, and thirty-two were captured as prisoners of war, according to *The Tuskegee Airmen: The History and Legacy of America's First Black Fighter Pilots in World War II.* The Airmen received credit for the following:

- 1,578 combat missions—1,267 for the Twelfth Air Force; 311 for the Fifteenth Air Force

- 179 bomber escort missions; losing bombers on only seven missions, and a total of 27 lost (far under the US Air Force average of 46)

The Black Family Who Built America

- 262 enemy aircraft destroyed (112 in the air; 150 on the ground) and 148 damaged

- 950 railcars, trucks, and other motor vehicles destroyed

- One destroyer put out of action

- 40 boats and barges destroyed

"This country was built on race, racial prejudice, and the efforts of Blacks," Roscoe Brown said. "So Blacks have fought in every war going back to the Revolutionary War. Each time we did that, we thought that if we defended the country and did it with dignity and excellence, the broader community would end segregation. After World War II, that finally happened when in 1948, President Truman signed Executive Order 9981 eliminating segregation in the armed forces. So in a sense we made that progress."

Upon completion of the Air Force base, Moses III and Calvin were awarded the prestigious Spaulding Award, given annually back then to the top Black business in the country, by President Roosevelt. The award was named after Charles C. Spaulding, cofounder and second president of Carolina Mutual Life Insurance Company in Durham, North Carolina, who was known for his accomplishments in recruiting, training, and elevating competent Black business executives. The award was designed to inspire and encourage Blacks to enter into business; awardees were traditionally selected by a committee of Black business leaders.

The McKissack brothers also gained prominence in the 1940s through their work on public housing projects. They designed

several government housing projects across the country—the most notable was the one-million-dollar College Hill development in Nashville. Because of their expertise in this area, President Roosevelt appointed Moses to a White House conference on housing problems.

What we think of as public housing today started during the Depression with Roosevelt's New Deal policies. From day one, these programs were overtly segregationist and racist, initially denying African Americans access to the housing developments. Under the PWA, the government in 1935 constructed the first federal public housing project, Techwood Homes in Atlanta. To build it, the government evicted hundreds of Black families to create the 604-unit, whites-only neighborhood. In the same year, the US Supreme Court ruled that the federal government lacked the authority to seize property through eminent domain—but localities did have this power, which allowed them to act without proper oversight, meaning their policies could be as racist and segregationist as they wanted them to be. When the *Dallas Morning News* did a study in 1984 investigating the conditions of public housing in forty-seven metropolitan areas, the paper found nearly all public housing tenants in those areas were segregated by race, and white housing projects had better amenities.

From the beginning of the nation's social experiment in public housing developments, the McKissacks were there on the ground floor, developing crucial expertise as they moved into property management with College Hill.

While he was building up his business, Moses was also busy building a family with his wife, Miranda. Like his father, Moses III

The Black Family Who Built America

encouraged his sons to pursue an education in architecture and engineering. His six sons—Samuel, Calvin, Winter, Lemuel, Moses IV, and William DeBerry—all obtained degrees in this area and entered the family enterprise.

Samuel McKissack, architectural designer and draftsman, attended Fisk and graduated from Hampton Institute's school of architecture in 1949. He immediately began working for his father and uncle's company as a draftsman, designer, and estimator. He went on to establish the McKissack Brothers Paint Shop; in 1957 he set up his own contracting business in Nashville—Sam McKissack, Contractor, Inc.

Lemuel McKissack, a construction engineer, graduated from Tennessee State University's engineering program in 1938. He established his own real estate company in 1955.

Winter McKissack graduated from Fisk in 1938 and went to Howard University's architectural and engineering school. He started his own architecture business in Nashville, Winter McKissack Architects.

Calvin McKissack graduated from the school of building construction at Tuskegee Institute in 1938 and completed two years of graduate study at Purdue University in civil engineering. He served as assistant superintendent for construction of the Tuskegee air force base. He then served as assistant superintendent for College Hill Realty and Property Development, Inc.

William DeBerry and his brother Moses IV were graduates of Howard University's school of architecture and engineering. Before entering Howard, DeBerry served three years in the US Navy, leaving in 1938 before the United States entered the World War II.

After graduating from Howard University in 1943, he worked for the family firm as an architectural designer.

Moses IV attended Fisk before graduating from Howard. He worked part-time as an architect in the company while he taught at Tennessee State's architecture and engineering school.

In the operations of the company, Moses III managed the construction arm of the business and left most of the architectural work to Calvin. In 1947, they decided to split the company and establish the two parts as separate entities, which would allow them to contract with each other for business and increase profits. Each firm had its own management staff: A board of directors was established with Moses III as chairman of the board and president of the construction company. Calvin was named president of McKissack & McKissack Architects and Engineers, Inc., and vice president of the board. The College Hill Realty and Property Developer in 1952 became the third component in the corporation.

In December 1952, at the age of seventy-three, my grandfather Moses McKissack III died at his home in Nashville after a yearlong illness. In his later years, he had overseen a rapid growth in the volume of the company's business. In honor of his contributions to Nashville, the city named a school after him in 1954, McKissack Elementary School on Thirty-Eighth Street, North. (When my sister Andrea went to elementary school, she attended McKissack, walking in the front door under a sign that heralded her family name, strolling past a large picture in the hallway of her grandfather smiling down on her. I know that was a bit strange but also amazing for her. The school is now McKissack Middle School.) His funeral was held at Capers C.M.E. Church on Fifteenth Avenue,

The Black Family Who Built America

North—the church he built thirty years earlier and of which he and his family were longtime members.

When my grandfather died, my uncle Calvin took over as president of the company. Moses IV became president of the construction company.

Around this time, my father, William DeBerry, and Moses IV came up with a brilliant scheme to construct Black churches all across the country. The budgets of Black churches often did not allow them to employ an architect to do the designing and a contractor to do the building. McKissack & McKissack could offer them a package deal: the company's architects could design the building and then, instead of bringing in their own labor force to build it, the company could employ local craftsman to do the actual building under McKissack supervision. This technique had the added benefit of providing employment to local Black craftsmen—many of whom were usually church members. Because of this flexibility, McKissack became the largest contracting firm for Black churches in the country.

The following are among the vast list of churches built by the McKissacks:

Mount Olive Baptist Church (Nashville, Tennessee)

Clark Memorial United Methodist Episcopal Church (Nashville, Tennessee)

Seay-Hubbard United Methodist Church (Nashville, Tennessee)

Spruce Street Baptist Church (Nashville, Tennessee)

St. Andrews Presbyterian Church (Nashville, Tennessee)

Rock of Ages CME Church (Memphis, Tennessee)

St. John Baptist Church (Memphis, Tennessee)

Metropolitan Baptist Church (Memphis, Tennessee)

St. John Institutional Missionary Baptist Church (Miami, Florida)

Zion Baptist Church (Louisville, Kentucky)

Thirgood Memorial C.M.E. Church (Birmingham, Alabama)

Warren Memorial United Methodist Episcopal (Atlanta, Georgia)

The company had received no work from Fisk since they had built the Fisk Carnegie Library in 1908, but the 1950s saw the McKissacks working continually on the Nashville campus. The company built the Henderson A. Johnson Gymnasium in 1950, the Basic College building in 1952, Scribner Hall in 1954, and Park-Johnson Hall, also in 1954. Stretching all the way into the 1970s, McKissack & McKissack built almost every new building constructed on the Fisk campus.

On the campus of Texas College in Tyler, Texas, the company built the president's home, Wiley Hall, and the gymnasium, among other structures. Other buildings constructed in the 1950s and 1960s include the Infantile Paralysis Center in Tuskegee, Alabama; Riverside Sanitarium and Hospital in Nashville; Hadley Park branch of the Nashville Public Library and Hadley Park Community Center in Nashville; North Carolina Mutual Life Insurance Company

The Black Family Who Built America

branch office in Memphis; and the Universal Life Insurance Building in Memphis.

In March 1968, Calvin McKissack passed away at the age of seventy-eight. As a longtime member of the Fisk board of trustees, his funeral services were held at the Fisk University Memorial Chapel. Upon Calvin's passing, the mantle of leadership of the firm was passed to William DeBerry McKissack—my father.

CHAPTER 6

"I Ain't Going into the Black Bathroom"

When Deryl and I were little, my father was not only an investor in Mahalia Jackson's chain of fried-chicken restaurants, Mahalia Jackson's Fried Chicken, but he actually designed and built the restaurants. When we went to the opening day of the restaurant in Memphis, I was filled with excitement. All kinds of dignitaries were there, and Deryl and I were sporting fancy dresses. So was my mom, who had on a lovely light-pink dress. Mom was stressing us out about our shoes, telling us we'd better not get them dirty—which proved to be quite a challenge because it was muddy outside from the rain that had just fallen.

Mahalia's restaurants were a big deal in the Black community.

"In the black world, Mahalia Jackson's chicken enterprise is a culinary Camelot. A shining, vanished moment," acclaimed writer Alice Randall wrote in the winter 2015–16 issue of *Gravy* quarterly.

The Black Family Who Built America

"A place where black people did the cooking and the eating, the sowing and the reaping. A place where blacks were the owners, managers, workers, and patrons. Such a place existed for a moment."

Randall is author of the *New York Times* bestselling novel *The Wind Done Gone*, which is a reinterpretation of *Gone With the Wind*. She is also a successful songwriter—she was the first African American woman to cowrite a number-one country hit (for Trisha Yearwood). Alice is also my godsister—she is the goddaughter of my parents, DeBerry and Leatrice. She was previously married to my childhood friend Avon Williams Jr.

About Mahalia's restaurant, Alice wrote: "And this is what it looked like; this is how my godfather DeBerry McKissack designed it, according to New York's illustrious black newspaper, the *Amsterdam News*, 'The white brick, carry-out chicken stores look like highly styled, modern churches with their red roofs climbing to high pointed peaks. Flying buttress wings, carrying signs shaped in the elongated oval of cathedral windows flank the stores on either side."

"The very first Mahalia Jackson Fried Chicken franchise opened in Memphis, Tennessee, in 1968, just months after the assassination of Martin Luther King Jr.," Alice wrote. "My own godmother, Leatrice McKissack, wife of the architect, was robbed there the day it opened. She entered the restaurant looking sharp, a twin daughter holding each hand. A purse with credit cards and cash swinging from the crook of her arm. After the official opening, she reached into her purse and discovered her wallet was gone. Ben Hooks and A.W. Willis, lawyers and activists who founded the flagship, called and cancelled the credit cards for her."

My mother was not someone to be trifled with. When Deryl

and I were about three or four, we went with Mom on a memorable trip to downtown Nashville to shop at Harveys, one of the major department stores. While we were in the store, Deryl and I told her we needed to go to the bathroom. But in early 1960s Nashville, Harveys was still trying to force Black people to use a separate bathroom from whites. The popular downtown store had been the subject of dramatic sit-ins by Black activists in 1960 and had officially desegregated its lunch counters on May 10, 1960. But I guess the bathrooms didn't get the memo.

My mother pronounced to us, "I ain't going into the Black bathroom. I'm going to the white bathroom."

There was a rather large, overweight Black woman standing guard outside the bathrooms, I guess making sure the white bathroom didn't suffer the indignity of having black pee in the toilet.

"I deliberately went and asked one of the clerks, 'Where is the ladies room?'" my mother recalls. "She said, 'Oh, right over there.' I said, 'Come on, girls, let's go.' We went into the white bathroom, and this big Black woman came inside. And she said, 'You know you're not supposed to be in here.' I acted like I didn't know who she was talking to. I just ignored her. She came right up to me and I said, 'Okay.' I didn't say another word."

My mother got her friend Laverne to watch us while she went up to speak to Mr. Harvey, the founder. She told him that as much money as Black people spent in his store, it was an outrage that he had us using separate bathrooms. She even went to meet with her lawyer about it. At the time, I wasn't aware of my mother working behind closed doors to push these white folks to act right. She said she tried as much as she could to shield us from such ugliness.

The Black Family Who Built America

It was a turbulent time for the Black community in Nashville. Exhorted by Stokely Carmichael, head of the Student Nonviolent Coordinating Committee (SNCC) and the leading spokesman of the Black Power movement, Black students in Nashville had had enough of racial injustices. By 1968, they were ready to do whatever it took to force change. After the assassination of Martin Luther King, the streets exploded with rage, resulting in days of rioting. We saw up close how the city powers responded—with force.

One morning our dog, Pepe, a feisty little black poodle, started yapping at about 4:00 a.m. My parents got up to see what the commotion was—and looked out the window to see National Guard tanks rolling down our street. They were very upset, wondering why our serene little residential street warranted this extreme show of military force. My family stayed close to home, trying to avoid the tempest roiling around us. At night, well after the state-imposed curfew, the phone rang. On the line was a close family friend, a woman we called Aunt Francis, though she wasn't related. She was a professor at Tennessee State, and she was in trouble.

"'Lea, you got to send your husband over here to pick me up,' she said to me," my mother recalls.

Aunt Francis had barricaded herself in a telephone booth. She was terrified of trying to make her way through streets filled with chaos and raging young people. We lived near the TSU campus, where she was trapped.

"I said, 'What do you mean?'" my mother says. "She said, 'I'm in the telephone booth, and I can't get back to my dormitory'—because she was living in one of the dormitories. I said, 'Oh,

Francis, this is not gonna be easy.' Because the children didn't want their daddy going out there. I didn't want him going out there either. But I said to DeBerry, 'I guess you're going out there to try and rescue Francis out of a telephone booth.' And we were so scared until he got back. It was a scary time. There were guns and explosions and fires everywhere."

When the streetlights came on, nobody was allowed to be outside. To a six-year-old child, it felt like the world was coming to an end.

When we hit our teenage years, my parents decided that Deryl and I were going to have actual jobs, working with Daddy at the office. But that meant we had to endure the wrath of Miss Cross. This unpleasant woman had a personality to match her last name. She was my father's protector—nobody was getting in to see him without her approval. That might have served him well, but, to our adolescent eyes, she looked like the personification of evil. She sat down on the first floor, near the steps that led to his office. And she effectively blocked *everybody* from going up those steps, including his doting daughters. We couldn't stand that lady.

One day when Deryl and I went to work, our big sister Andy was there with us. Andy was not very fond of Miss Cross either.

"I'm sick of this bitch!" Andy said to us.

We nodded in agreement, thrilled that we had our big sister on our side.

"Us, too!" we said.

Andy was well into her twenties, so if she didn't like the woman either, to us that meant Miss Cross wasn't worthy of being liked. The three of us initiated a retribution campaign that summer to

The Black Family Who Built America

pay back Miss Cross for all the anguish she had caused us. We were like a bougie Black girl version of the Avengers.

The first thing we did was to get ahold of a large can of my father's fishing worms. We were used to handling worms because we would go fishing with my father out on Old Hickory Lake. Andy sneaked the can of worms into the office and headed straight for Miss Cross's private bathroom. We followed behind her, trying to suppress our giggles. Andy lifted the toilet seat, hoisted the can, and *blam!* She emptied the whole can inside into the bowl. We peeked into the bowl before she closed the lid; all we saw was a teeming mass of squirming, revolting worms. All three of us fled the building as quickly as we could, practically falling over with laughter. We weren't there when Miss Cross went to the bathroom. I can only imagine the scream that must have echoed across that office.

The next act on our retribution campaign was a bit more public. We made up a flier that read, *If you want to have fun tonight, call this number,* and we wrote Miss Cross's phone number underneath. We made hundreds of photocopies of the flier and posted them all over Nashville. Not very nice, I know. Overkill? Maybe. But we were headstrong teenagers; you couldn't tell us nothing.

Miss Cross had her own way of getting back at us—she would dock our pay if we showed up late to work. Mind you, we were only making about a dollar an hour, so every cent hurt. When we complained, she just stared at us.

"Y'all were late," she said.

We couldn't let it end there: We quit. And got jobs at McDonald's. We would trudge to McDonald's every day in those ugly

uniforms and dread what that day's assignment might be. They had us cleaning bathrooms, doing all sorts of unpleasant stuff. Our father would slowly inch his car past the McDonald's drive-through window, peering in at us—and laughing his behind off.

"He-he-he-he!" We could hear him through the window cracking up when he spotted us. He absolutely loved making fun of us.

One day they had me working the fryer for the french fries, sweating my ass off. This white girl said something sideways to me. I was not in the mood. We wound up having a big argument in the kitchen, next to the fryer. As she turned to walk away, I threw the french fry scooper, hitting her in the back.

We lasted at McDonald's for about a month.

We slinked back to our dad. "We can't do it anymore! Can we please have our jobs back?" we said, begging in our most pitiful voices.

That was around the time that Daddy taught us how to drink.

We were about fifteen when he made the pronouncement while we were sitting at the bar in our house.

"I'm teaching you how to drink today," he said.

He proceeded to pour each of us a big glass of straight Jack Daniel's. Of course, our mother was not around. Deryl and I looked down at our glasses and then glanced at each other with knowing little smiles. We had already been drinking liquor, but our father didn't know that. We lifted our glasses and went to work. We were both just about done with our drinks when our mother breezed into the room.

Her eyes bulged when she saw us hunched over glasses with the big bottle of JD inches away.

The Black Family Who Built America

"What the hell are you doing with my kids?!" she yelled at DeBerry.

Deryl and I were quite drunk by then. It was written all over our goofy faces.

"I'm teaching them how to drink," he declared, as if it were as innocent as teaching us how to catch a football. All my mother could do was shake her head in disgust. Meanwhile, as the Jack Daniel's did its work, Deryl and I struggled to stay upright.

But before you get the idea that Leatrice McKissack was an innocent party in the childrearing chronicles, I have another story.

My mother was entertaining her friend Betty one day, both of them sitting on the couch enjoying each other's company. Betty saw something resting in the corner of the couch. She picked it up and held it aloft.

"Lea, what is this?" she asked my mother.

"I don't know," my mother said. But Betty, who had teenage sons in her house, knew exactly what it was—a joint.

When we got home later that day, we were greeted by our furious mother, who had many questions. Mom was the disciplinarian of the family, and she didn't play.

"So this is what y'all are doing?"

We were about sixteen, and we weren't really into smoking weed at the time. Yes, we had tried it, but it wasn't something we did regularly. We tried to explain to Mom that the joint was probably left there by one of our friends, that it wasn't ours. I couldn't tell if she bought it. Then she said something that shocked us down to our painted toenails.

"Okay, we're gonna sit down and we're gonna smoke it together," she said.

Deryl and I looked at each other, wondering if we had heard her correctly. But Mom was dead serious. She went in search of a lighter. This was happening. *What is Mom going through?*

The three of us sat on the couch and passed the joint around like a trio of giggly teenagers. Once we got over the shock, we thought it was the coolest thing in the world, getting high with Mom. I often wonder what Dad would have done if he had caught sight of that one. Maybe asked for a hit himself?

When Mom hit her late forties, she was slammed by menopause. She had had her ovaries removed, so her body wasn't producing estrogen. The lack of estrogen had a severe effect on her moods—in other words, she turned into a raging, um, rhymes with *witch*. Every two weeks she'd have to get a hormone replacement shot; the shots would cool her out. However, toward the end of the second week, the shot's effectiveness would start wearing off. In her words, she'd start "wilting"—though that word I think is a bit gentle to describe what happened to her. At the slightest provocation, she'd rip your head off. Everyone—Daddy, her friends—would tell her, "Lea, it's time for you to go get your shot."

In the days after Thanksgiving one year, we'd been eating so many versions of turkey—turkey à la king, turkey sandwiches—every night that we were all about to start clucking. Mom was an excellent cook, but as she slid plates of turkey slices with gravy and peas in front of us my dad leaned over and whispered to me and Deryl, "I don't know about you, but I think we should go out for dinner."

The Black Family Who Built America

We nodded enthusiastically in agreement.

Then he added, "But I'm afraid to say it!"

Well, if Dad was scared, we certainly weren't going to suggest it. Mom was just about due for her shot; Dad wasn't trying to incur her wrath. So, we sat there and ate the turkey. And nobody uttered a word.

Like I said before, between me and Deryl, I was the one most likely to get in trouble. I don't know what it was—I just always had a bit of rascal in my spirit. And my taste in men didn't help. I was definitely more attracted to the bad boys.

When I was about fourteen, I started seeing a boy named Jeff Cox. Because our families were fairly close, our parents allowed him to take me out on a date. Jeff had a perm in his hair. He would wash his hair, then roll it up and sit under a dryer like a woman. He wore it long, in a flip. This was the mid-seventies, when most of us were sporting Afros. Not Jeff. You remember what Snoop Dogg's hair looked like when he first came out? Or Katt Williams? That was Jeff. He was a good-looking guy, with a lot of style. But half the time his hair was dirty. So, he'd wear a hat to cover it up.

When he came to pick me up, Daddy answered the door. Daddy brought him into the living room, and Jeff sat down on the couch wearing his hat.

"If I were you, I'd take that hat off because my wife ain't going to like that you have a hat on," Daddy said.

Jeff dutifully removed his hat. My father stared at his head. His hair looked pretty bad.

"I think you better put it back on," my father said.

We went out to a pizza shop. Then Jeff decided we should go

over to his friend's house to hang out. But somehow at his friend's house we all fell asleep. We just conked out. When I finally started to stir, I looked down at my watch. Eleven thirty!

"We gotta get out of here!" I blurted out.

By the time we got back home, it was after midnight. When we pulled up into the driveway, my mother was at the door. She ran out and started beating on Jeff. Then she got to me and started beating on me, too. My father rushed out to grab her and dragged her back into the house.

"Jeff, I think you better go," he said over his shoulder.

When I got in the house, Deryl told me that Mom had hit her, too, just on general principle. As if, as my twin, she was partly to blame. Deryl was sick of me for always causing trouble.

When I was sixteen, I was dating a boy my mother couldn't stand named Darrell. In her mind, he was the prototype of the bad influence. She wasn't wrong—Darrell worked full time and sold weed on the side. But to me, he was all kinds of exciting.

After Darrell's car broke down, I would regularly sneak out of the house early every morning to take him to his day job. In retrospect, I guess that must have been a slow month in the drug trade, since he apparently didn't have the money to get it fixed. Nobody in the house knew I was gone—except Deryl, of course. One morning when I was out, I got into a wreck. I wasn't near the house, either, because Darrell worked in Nolensville, at least a half hour outside of Nashville. I found a pay phone and called Deryl. Luckily by then we had our own private line—my parents had given up on trying to keep their twin teenage daughters from monopolizing the house phone.

The Black Family Who Built America

"Deryl! I had a wreck. Can you go and tell Mom that—"

"Oh, hell no! You call Mom and tell her yourself!"

As I said, Deryl was sick of my troublemaking ways. She actually hung up on me.

I took a deep breath and called the house phone. I tried to explain to my mother why I was all the way in Nolensville.

"I was getting some donuts," I lied.

"Donuts?! What kind of donuts are you getting all the way out there?"

"Krispy Kreme," I said.

"Well, that's right on Charlotte! Why are you all the way in Nolensville?"

My father came out to get me. I had to come clean that I was driving Darrell to work because his car was messed up. My parents were not happy about that.

Digital watches were just entering the market and were instantly a cherished and sacred item among my friend group. I just *had* to get one of the Hamilton Pulsar digital watches with the gold band. I don't remember the exact price, but they cost several hundred dollars. My mother wasn't interested.

"No. I'm not getting you that," she told me with a scowl.

If I couldn't get it from my parents, I had to do it on my own. My measly salary working for Dad wasn't going to get me there. So, I went to Darrell.

"Darrell, I got to get this watch. What can I do?"

"Well, you can sell some weed with me," he said matter-of-factly.

"Oh my God," I said, shocked at first. But after about a half

99

second of deep thought, I said, "Okay." And that's how I ended up selling weed long enough for me to buy my watch.

I wasn't bad at it. My early CEO instincts kicked in. I had a customer base of rich white friends from school that was quite different from Darrell's normal customer base. I made about a thousand dollars selling Darrell's weed. I skipped to the store to buy my watch, grinning all the way.

Darrell lived with a few other guys in a house that was known as the weed spot. I would go there sometimes in my father's Mercedes. One of Dad's friends in the police department pulled him aside and told him, "We have pictures of your car in front of the weed house. With your daughter."

When my father confronted me, I came up with a quick lie.

"Darrell is a really good friend of mine. We're not doing anything. We just visited his friends."

I guess he bought it, because he didn't issue any bans. Not long after, Darrell and I were at the house, when we decided to go get something to eat. There were probably about nine or ten people there when we left, hanging and having a good time. As soon as we left, some dudes pulled up and robbed everybody at gunpoint. We missed it by mere minutes.

One night when we were on our way to a party, Darrell told me he needed to make a stop to pick something up. We wound up at some type of plant where they made beer and sodas; one of his friends worked there. As Darrell was picking up the case his friend set aside, it dawned on me that we were there to steal the case.

Mind you, none of that was enough for me to leave Darrell's

The Black Family Who Built America

gangster behind. I didn't stop dating him until I had gone to Howard. He came up to DC to visit me on campus, and I was immediately embarrassed by his presence. That's when I knew I couldn't see him again.

At my urging, Deryl and I would climb through our window and sneak out to attend parties at Tennessee State.

"Are you sure we should do this?" Deryl would ask.

"Sure! It's gonna be fun!" I'd say.

Our most precarious incident occurred one night after my parents had gone down to the spot where they hung out, a club called Deborah's. The club was only a two-minute drive from the house, but the proximity didn't deter me and Deryl from inviting over all our friends when we weren't supposed to have any company. On this particular night, our parents came back much sooner than we expected. When we heard their car, we were able to scurry and get everybody out the house, using the door in our parent's bedroom that led outside. As the key was turning in the lock, we saw that one guy didn't make it—a big dude named Leonard. He weighed more than three hundred pounds, easily. Leonard wasn't fast enough to reach the bedroom in time.

"You gotta get in our tub!" we told him, pointing to our bathroom.

Leonard moved into our bathroom and stepped into the tub, pulling the shower curtain so nobody would see him.

"Leonard, you're going to be okay," I said.

"I'm-I'm scared to death," he stuttered.

When he got inside, smoking a cigarette, my father shook his head.

"Y'all are just bad," he said. "I saw the cars parked up behind the house."

Deryl and I scurried back to our room. It wasn't the time for a lecture from Dad. We closed the door—and then we heard Dad go into our bathroom! *Why is he going in there?*

He was not allowed to smoke a cigarette in the bedroom he shared with my mother, so he was hiding out in our bathroom to finish his cigarette. Somehow Leonard was able to remain quiet and stock-still while Dad puffed away. Finally, he flicked his cig into the toilet and left the bathroom. We exhaled as we heard him leave. *Whew, that was close!*

We lay down in our beds and listened closely, waiting for Mom and Dad to go to sleep so we could get Leonard out. But while we were waiting, we fell asleep ourselves! Poor Leonard. We woke up when we heard a voice calling out to us.

"Cheryl! Deryl!" he was saying in a very loud whisper.

We both sprang out of bed and rushed to the bathroom. I knew how to turn the volume on the alarm down low enough so that nobody could hear the door beep. I went to the alarm while Deryl went to Leonard. Because the long hall had paintings on both sides, Deryl was afraid Leonard was going to knock one of the paintings to the floor.

"I'm sorry, but you got to get on your knees and crawl," she told him.

She made poor Leonard crawl on his hands and knees down the hall. After I finished with the alarm, I saw his large figure lumbering on the floor. My eyes widened.

When we finally got him out of the house, his muffler probably

woke up the entire neighborhood when he turned on the ignition. My father came running out of the bedroom, shouting, "Who's that?!" To our horror, he ran to get his gun. He walked out the front door holding his gun in the air, like Wyatt Earp or something.

I guess that's why when we left for Howard, my mother looked at me and said, "Girl, you gave me a heart condition."

CHAPTER 7

"Financial Clearance"

When I left Philly and reestablished my business in New York, I was eager for a big project that would announce McKissack was back on the scene in a big way. I was excited when I heard the Dormitory Authority of the State of New York (DASNY) was about to release a Request for Proposals (RFP) for a major construction project at Medgar Evers College in Brooklyn.

Named after the martyred civil rights leader, Medgar Evers College opened in 1970 after a sustained effort by Black activists in Brooklyn to create a public college in the borough that would meet the needs of the local Black community. Dr. Edison O. Jackson, an experienced higher education administrator, was president at the time—a position he had held since 1989. The potential contract was for two structures—a social services building and an academic center of learning—totaling close to $300 million.

The Black Family Who Built America

I had several meetings with Dr. Jackson that went very well. I really liked him. He had roots in the South—born and raised in Virginia—and had gotten bachelor's and master's degrees from Howard, just like me. He was a strong supporter of Black businesses. When I told him the story of McKissack, he was fascinated. I was trying to "prime the pump" by connecting with as many of the Black and brown officials in Brooklyn as I could—Assemblyman Roger Green, Congressman Major Owens, City Councilwoman Una Clarke, Assemblyman Clarence Norman.

Turner Construction brought us on as a partner to go after the contract. Since I'd worked for them after grad school, I had many contacts among the leadership in the company. Turner knew that they had to have significant Black involvement on the project, so they offered us somewhere around 30 percent as a joint venture partner. I was hearing from Black alumni at Medgar Evers that Edison was not going to let that number fly; McKissack needed to be higher.

"Listen, we got to up these numbers if we want to win," I told Turner. I knew we would be competing against all the big contractors in town; we had to come correct. However, I didn't think any of the other firms were partnering with firms of color that had as much inside information as I did, so that gave us an advantage. But I couldn't convince Turner that my information was valid. They raised my percentage to 40 percent, but they wouldn't go higher. I thought 40 was a generous percentage, and I appreciated it. But I still didn't think that would win over Edison Jackson.

Finally, Edison got me and a couple of Turner bigwigs in a room. He didn't hold back.

"I want a Black contractor to build my campus," he said, looking back and forth at us. He paused for effect.

He couldn't have been any clearer. Soon after that meeting, I got a phone call from Jim McKenna, president of Turner. He told me he was trying to figure out how to finagle this deal to give Edison what he wanted. I knew what was really happening behind the scenes: It would be unprecedented for a Black firm to be prime on a major deal like this; they were trying to figure out how to make this happen without establishing such a major precedent in the New York construction world. If they let McKissack be prime, would they be opening a Pandora's box? In other words, would there be a long line of Black companies looking to follow suit on future projects?

We went from being an MWBE firm getting 10 or 20 percent on past deals to now possibly getting 50 percent or more. That would be a major game changer not only for McKissack but for the entire MWBE community of firms. Edison kept making it clear that he wasn't going to back down. But Turner was in a tough position because they were owned by a German conglomerate named Hochtief, which was dictating to Turner that they had to be at least 51 percent on any joint venture they entered. I agreed to let them keep the 51 percent, but have McKissack's name go first on the venture, making it a McKissack-Turner project. My thoughts were that I had gotten them from 30 to 49 percent— I wasn't going to trifle over another two percent. Also, I knew I would be leaning on them and their deep pockets if something went wrong on the project. I should add that Turner deserves credit for being consistently forward-thinking when it came to hiring nonwhite firms.

The Black Family Who Built America

I considered it good policy to enter into a project with a partner who is relatively happy and comfortable with the partnership. It was a bad idea to go into a project with a joint-venture partner who's pissed off from day one. Everyone has to feel like they're okay with what they got—even if they didn't get exactly what they wanted. That's the hallmark of an effective negotiation. I didn't think it was misleading to have McKissack go first even though we weren't quite the majority partner—after all, I'd gotten offers from companies to put McKissack first even though they were only giving us 10 percent. That's the kind of game people tried to play with MWBE companies—use our names to make them look good without giving us the money to go with it.

Still, there were people at Turner who didn't understand why we were getting such a large percentage. One Turner official in particular, Kevin Sharkey, was adamant about it, and we argued.

"You can't do forty-nine percent—you don't have the staff for it!" he told me.

I went right back at him, telling him he didn't know what he was talking about. I understood where Kevin was coming from—so many minority firms don't have adequate resources—but I needed him to give us a fair shot. We stood there, cursing each other out. If we were both dudes, somebody might have thrown a punch. The irony is that over time, as we both discovered that we lived near each other in Westchester, we began to have drinks together and eventually became the best of friends. Our friendship was helped by the fact that McKissack delivered on its promises, which Kevin was glad to see.

Once the deal was announced as a McKissack-Turner venture,

it made the state and the Pataki administration look good to have a Black firm as the lead on such a big project. It was also decided that we would try to have as many MWBEs as possible working on the project; we collaborated with Turner to make sure that happened. Instead of having four major primes, which is a requirement in New York State, we broke it up into smaller packages and had about seventeen or eighteen contracts, allowing us to employ as many minority firms as possible. We oversaw that process. Again, Turner was willing to think outside the box. I sincerely wish there were more white firms like them.

I'm forever grateful to Edison O. Jackson, because none of this would have happened without his stubborn insistence that we be the lead. Being the prime on Medgar Evers took McKissack to a whole new level in terms of our stature in New York. It was a game changer for us. We hired people on that job who are still working for us today as part of our leadership staff. And, moving forward, we were able to compete for projects as a prime by ourselves. It's hard to win a project without the staff and the portfolio of work to show you've done it before. We were chosen to manage the construction of major structures in the next few years, including Harlem Hospital and Lehman College. And I'm sure we would not have been added to the Barclays Center project in Brooklyn a few years later without Medgar Evers. It opened a succession of doors for us and helped us establish important new relationships. And I can't leave out the money: Since Medgar Evers was a $280 million project, McKissack cleared about $13 million in revenue.

It's interesting because I never thought I could be prime on that project until Edison put the idea in my head. But once he did,

The Black Family Who Built America

I ran with it. That's the way it's worked for McKissack—on each big project we reach a new level. We're standing at the edge of a cliff—either we're going to make it or we're going to plunge to the ground below in a spectacular crash. It's never going to be middle-of-the-road, inconspicuous and ordinary.

However, we didn't get out of the Medgar Evers project completely unscathed. One of our employees has been involved in some unsavory activities before we hired him. I found out that when he was working at the School Construction Authority, he was allowing contractors to inflate the price of change orders over the actual amount, and he was likely collecting part of the windfall from them. The story hit the newspapers and we had to endure the embarrassment of having investigators come and briefly shut down the Medgar Evers project while they did a probe. We immediately removed him from the job. While we weren't complicit, it wasn't a good look for McKissack. With so many millions of dollars flowing through these construction projects, it was tempting for greedy and unethical folks to try to find ways to fleece the system. Unfortunately, I don't think that will ever change.

In addition to DASNY, I relied on the NYC School Construction Authority as a place where I thought we would be treated fairly as we went after big deals in the city. That was largely due to General Williams, as I discussed earlier. I would take a look at the upcoming projects for the two agencies, then I would go to a bigger company like Turner or Skanska or Parsons Brinckerhoff and see if they were interested in working together—with McKissack helping them reach their MWBE targets. But once General Williams was gone—moved aside, I think, because he was not playing well with

the big white firms—it became more difficult for us to get treated fairly.

In the early 2000s, we won a staffing contract with the SCA. That meant we were in charge of providing professional staff for the authority's construction projects. Typically, the SCA would employ a small staff in-house and use outside consultants to fill the rest of their needs, usually dozens of additional people. For example, if the SCA is going to do a billion dollars of construction this year, they're going to need at least ten project managers, fifteen superintendents, and six estimators. The company who holds the SCA staffing contract will go out and find people for each of those positions—and charge the SCA a sizable rate for each position filled. The SCA would give these staffing contracts to about three different firms. They are very desirable contracts for firms because they can be very lucrative, with little risk attached because you're not building anything.

I had a guy at McKissack who had worked many years for the SCA and also run staffing contracts for a large construction-management firm. It was a perfect setup for us. We were shortlisted, did our presentation, and won the contract—beating out a half dozen very large white firms. We were ecstatic, giving one another high fives around the office. But then we got a call from the SCA.

They told me that though we had been awarded the contract, now we had to undergo something they called "financial clearance." I had never even heard that term before.

"What the hell is 'financial clearance'?" I asked.

"Well, we need to look at your financials to see if you can afford to hire this many people," the SCA guy told me.

The Black Family Who Built America

It sounded highly suspicious to me. We had been working with SCA for a number of years under General Williams and never had to undergo a financial clearance. Why now under the new guy? I had no choice but to agree. We had a $2 million line of credit from our bank sitting untouched, so I didn't think we'd have any problem passing this kind of scrutiny. The line of credit alone was enough to get us a thumbs-up. We surely didn't have the kind of cushion the big white firms had, but I figured we were good.

I was stunned when the SCA came back and told us that we had not passed the financial critique.

"You've got to be kidding!" I said.

I put out calls to my allies to get this turned around. I called Carl Andrews, the state senator from Brooklyn, and asked him to discuss the issue with the other Black state officials, known as the Black Caucus. Mayor Bloomberg didn't have a lot of Black people in his administration, but he did have a Black deputy mayor for education and development. I asked the deputy mayor if he could look into the issue. He called a meeting with McKissack and the head of the SCA and his staff.

In the meeting, I said, "We won this fair and square. And it's not until now that they want to do this financial check? But if this was part of the procurement, they should have done this in the beginning, instead of awarding us the contract. It's pure racism."

The deputy mayor looked at me and said, "I don't see anything racist here."

What?! You can't be serious.

I'm sure my bottom lip hit the table. *What in the world is he looking at?*

After that meeting, the SCA took the contract from us and gave it to a white firm, Parsons Brinckerhoff, run by a guy I knew named Gary Nunes. We didn't really hang out or anything, but I would see him occasionally at various gatherings of construction industry people. About a month after the meeting with the deputy mayor, I was sitting on the NYC subway, when Gary stepped onto the train. He sat down next to me. He was feeling very talkative.

"Cheryl, what they did to you was deplorable," he said. This was a guy who benefitted from the SCA move, but he was a decent man who knew the truth.

"Gary, they knew this would have made us bigger," I said. "They knew this would have taken us to another level and they just didn't want that to happen."

He looked me in the eye.

"Cheryl, they never asked us for our financials."

That one hit me in the gut. It confirmed everything I was thinking. I was so pissed, I decided I was going to get an attorney and lodge a formal protest against the SCA. They needed to know they couldn't treat us with such disrespect. I got a phone call from Carl Andrews, the state senator. I was eager to hear his take on the situation.

"Cheryl, they hear that you want to protest," he said. He paused. "But don't protest. This is not where you need to go."

I was listening, though I wasn't happy about what he was telling me. *Damn.* "Okay," I said. I called off the dogs. We weren't going to attack after all.

As Carl predicted, when an RFP came out a month later for

The Black Family Who Built America

staffing a much smaller project, we won it. The original project was somewhere around $50 million. This project was about $5 million, meaning we would be making a tenth of what we would have made.

The fight never ends.

CHAPTER 8

"It's Like We're in Heaven"

By 1975, the McKissack family had constructed more than three thousand buildings across the United States, a mind-boggling number. About two thousand of those were churches.

In 1971, three years after my father took over as chairman of the entire company, his brother Moses IV resigned as president of the construction company to take on the role of a traveling salesman and public relations director. His idea was to expand the construction company's reach beyond Tennessee—and he succeeded quite impressively. Among the many projects he secured in his travels in the Midwest and on the East Coast were New Garfield Baptist Church in Indianapolis; Calvary Methodist Church in Knoxville, Tennessee; and Mount Pleasant Baptist Church in Newark, New Jersey.

Under DeBerry's leadership, the firm provided the architectural

designs for the women's residence hall, the student union building, and the nursing home at Tennessee State University. At Meharry Medical College, McKissack designed the neighborhood health center, the mental health center, and the outpatient clinic. DeBerry was awarded a plaque of appreciation by the president of Lane College in Jackson, Tennessee, for his outstanding architectural planning of the school's student union building. He also designed Lane's seven-story women's residence hall.

Most of these campus structures were built with the help of federal monies, which meant that the same company could not act as architect and contractor. While the architecture company was designing all these campus structures, McKissack's construction arm was mainly concentrating on religious buildings. In 1973, the construction company partnered with Hardaway Construction of Nashville to build the $2.2 million coeducational residence hall at Fisk. This was McKissack's first time partnering with a white construction firm. It became necessary because McKissack was encountering a lack of skilled Black craftspeople.

While the McKissack architects had been designing major structures for years, the Fisk project was the largest for McKissack & McKissack Construction Company up to this point. The company's previous projects had been focused on churches, military barracks, and private homes. DeBerry believed that the leaders of the construction company would acquire the skills, working with Hardaway, to be able to handle bigger projects moving forward, which is exactly what happened.

Under DeBerry's leadership, the company moved with more intent into property management. After designing and

constructing College Hill—the 216-apartment complex that was built on McKissack family property under a governmental loan extending over a thirty-year period—the McKissack corporation's stockholders decided to purchase College Hill in 1973. The company also constructed government housing projects at Lane Garden and Union City in Nashville.

Clearly, the family business was in good hands under the stewardship of my father.

When it came time for me and Deryl to think about college, we knew that we would be going into a field related to building. My father, the Howard grad, had this to say about our college plans: "Y'all can go anywhere you want—but I'm only paying for Howard."

That might sound harsh, but it worked for me. I had been going to the Peabody Demonstration School since kindergarten, swimming in a sea of white folks. It was time for me to be around some Black kids.

In fact, Howard was the only school I applied to, which in retrospect was not very wise. But Howard had long occupied a special place in my imagination. Our older sister Andrea lived in Washington, DC, with her husband, Dr. Charles Franklin, and we had been staying with them every summer since we were about twelve. We were coming from Nashville, but Washington felt like a big city to us. And best of all, it seemed to be totally Black—DC wasn't called Chocolate City for nothing.

Both Andy and Charles were Howard alums, so we spent a lot of time on campus and going to Bison games. Deryl and I knew exactly what we were applying to when we put a stamp on the envelopes and sent in our Howard applications—imagine that,

The Black Family Who Built America

sending in a college application through the US Postal Service. Seems so quaint.

We were nervous when we got the letters back from Howard that spring and held them in our hands. Did we get in? We were so excited and relieved when we tore the envelopes open to see that they contained acceptance letters. When it came time for the drive to DC, it was a route we knew well because our parents drove the ten and a half hours every summer to bring us to Andy. My mother was sick that week, so it was just me, Deryl, and Dad in the car.

Walking on the campus for the first time as a Howard student in the fall of 1979 was magical. I was overwhelmed by the beauty of the buildings, the campus square—and the beauty of the Black men. Everywhere Deryl and I turned, we saw nothing but gorgeous guys.

Oh my God, it's like we're in heaven! I told myself.

We lived in a triple with a girl named Sharita from Miami. Compared to us, Sharita was more of a homebody. She was fun, but we had different interests. On the weekends, Deryl and I were focused on one thing—partying. Sharita didn't hang the way we hung. And we were hanging hard, honey. Real hard.

The first thing I had to do was get rid of my boyfriend, Darrell. We had a cousin, Mel Dixon, who was in his first year at the Howard University College of Dentistry, so he was four years older. Four years makes a big difference at that age. He was living in a house with three or four different guys, all good-looking and a lot of fun. Of course, we spent a lot of time at their house. But then Darrell started showing up on campus unannounced.

117

I had another cousin nearby who also watched over us. We called him Junie. I reached out to him after Darrell showed up again.

"Junie, you're gonna have to come over here and talk to my boyfriend and get rid of him," I said. "He's cramping my style."

Junie showed up and had a talk with Darrell. I have no idea what Junie said to him, but that was the last time I ever saw Darrell. I heard recently that Darrell passed away. I believe he stopped selling weed and continued working at a factory, laboring on a hard nine-to-five job for all those years. I pray he had a fulfilling life.

After our father dropped us off at Howard, our mother came up two weeks later to check on us. We complained to her that it was hard for us to find liquor, so she opened a tab for us at the liquor store down the street from campus, Central Liquors. It should be noted that the drinking age was eighteen at the time.

"I know your daddy taught y'all how to drink before you went to college," my mother said. "So if you girls just want a little drink, I'll open an account at Central Liquors."

She met with the owner and told him, "Listen, when my daughters call, be sure and let them have the alcohol."

After that, it didn't take long for our room to become the party spot. The following year, we got an off-campus apartment, which made it even easier for us to get liquor and host our friends. Everything was going great until our mother showed up on campus for a surprise visit. The year before we had been storing all our empty liquor bottles at a friend's apartment, where we built a little shrine to Jack Daniel's, which was our drink of choice then. We would stack up all of the bottles in fun, interesting arrangements—we were architecture students, after all. After we got our own apartment, we

The Black Family Who Built America

moved all the bottles to our new place. When our mother surprised us, we quickly stashed the bottles in a cabinet, out of sight. But she wanted to be nosy and decided to open the cabinet. All the bottles came crashing out of the cabinet. She turned to us with a shocked look. She marched right down to the liquor store and canceled our account. We kind of shrugged it off—it was good while it lasted.

My first two years at Howard were very easy academically, I think because of the preparation I got at Peabody. Deryl and I took the same classes every semester, working on degrees in both civil engineering and architecture. We were taking as many as seven or eight classes a semester, Monday through Friday. But eventually the grind started catching up to me. I knew I really wanted to be an engineer, but I didn't have as much of an interest in architecture. However, I was scared to tell that to my father. The hours for architecture majors were terrible—drawing in the studio until late at night. Deryl and I had good study habits, a work ethic instilled in us in high school, so our grades were always stellar. Right after class I'd make sure my notes were straight and I'd go over what we'd just learned and do whatever homework was needed. By 7:00 p.m., I was ready to hang again.

At some point, since we were taking the same classes, we realized both of us didn't need to attend every class. We would split it up and then teach each other what we missed in class. It turns out there's no better way to learn the material than to teach it to somebody else.

Our daddy was sending us an allowance of $40 a week, which we felt was not enough. We eventually got him to raise it to $60 a week. We brought our cash with us one weekend to Atlantic City. Deryl was dating an older guy named Lobo, who had a cute little

Mercedes. We drove to Atlantic City in his car, and lost all of our little bit of cash playing blackjack. But my God, we had so much fun.

Lobo had his own apartment and he had a friend named Hank, who was part owner of a nightclub called the Foxtrappe. After I started dating Hank and I went down to the Foxtrappe practically every night. The other spot was the LA Café. If you were looking for me, you'd find me at one or the other. One night I fell down the steps at the LA Café and realized my heel had broken.

"I don't need shoes!" I said, laughing. And I went back upstairs in my bare feet and proceeded to have a good time.

Speaking of bare feet, sometimes after our nights hanging out, Deryl and I would go to Hains Point at the edge of East Potomac Park—which, by the way is the best place to see the cherry blossoms—and race each other barefoot, still wearing our sexy club gear. Of the two of us, I was the one who ran all the time, so I would always win. One time when we were racing I lost the Nefertiti chain that my father had given to Deryl—he gave one to each of us; I don't know why I was wearing hers. The chain was so big and I was so little that it fell over my shoulders. She was so mad.

If we wanted to play with guys and also collect beers, I would put on these tight little short-shorts and go jogging on a Saturday afternoon. Deryl would follow behind me in the car, collecting all the beers guys would offer me as they ogled my butt.

We really felt like we were living in the heart and soul of America, where everybody wanted to be. One time when we were out, we saw President Ronald Reagan and First Lady Nancy Reagan drive by in the motorcade near the Fourteenth Street Bridge. I went to visit the offices of the US senators from Tennessee,

The Black Family Who Built America

Howard Baker and Jim Sasser, and Representative Bill Boner. It was exciting to be so close to the centers of power. I think my time there really solidified in my mind that I wanted to be a part of something big, which led me to New York City after graduation.

Lobo had another friend named Eugene Bogan, who lived in New York. Gene and I liked each other; I started taking the train to New York to see him.

After a couple of years of crazy, overloaded schedules, we appealed to our mother to let us drop architecture as a major. She agreed, which freed up our schedule considerably—enabling us to do even more partying. Howard truly felt like the Black Mecca. Concerts, poetry readings by Nikki Giovanni and other greats, speeches—it was a great place to be. I met people there with whom I would remain connected for the rest of my life. Interestingly, Kamala Harris, former vice president of the US, also attended my beloved Howard. Although she was a few years behind, we would eventually meet when we both received the Trumpet Award in 2014 given to us by Wynona Redmond. Thereafter, we remained close acquaintances due to our recognition, and shared connection with Howard and business.

While I was at Howard, I thought my career path would lead me into academia. One of the engineering professors, Dr. Broome, took me under his wing and was very encouraging. He started talking to me early about pursuing a master's degree in civil engineering. The engineering came very easy to me, so I thought a master's degree was a good idea. The economy was tough in the early 1980s; a lot of graduates were having a difficult time finding jobs. Deryl, who was more interested in business, applied and got into Columbia

Business School. But she deferred and never attended, deciding instead to take a job with a civil engineering firm, Dames & Moore.

When it came time for us to graduate, my parents planned a big bash for us in DC. My mother came up a few days before my father to help set everything up. My father was supposed to come on Wednesday. When we got up on Wednesday morning, my mother told us that we couldn't forget to call Dad to remind him that he needed to bring up some financial documents. We were going to move into a new apartment and they needed paperwork from us before we could sign the lease.

When we called him, he was making a weird guttural sound on the other end. It was like he was trying to talk but words weren't coming out.

"Daddy! Daddy!" I shouted into the phone.

My mother grabbed the phone. "Dear, what happened?!" she said. But she couldn't make out anything either. She called Avon and Joan Williams, who had been partying with him the night before. Joan told her he was fine when they left him at about midnight.

"Well, he's not fine now," my mother said. "Please get over to the house and find out what's going on."

Joan called back a bit later and said something was wrong with him. When they finally got him to the hospital, it turned out that he had suffered a stroke. Suddenly, what should have been one of the best weeks of our lives turned dark and tragic. Our precious daddy was seriously ill.

"Before I went to Washington, I could tell that something wasn't right with him," my mother recalls. "His energy was totally different. The one thing we had in common, what we loved to do together,

The Black Family Who Built America

was work in our yard. We could work all day on the weekends, on Saturday and Sunday. Then we'd go out to dinner afterwards. It just felt so good. Sometimes we'd forgo church and just work in the yard to get it like we wanted. He loved that. Then I noticed one day in the yard that he put his foot on the spade, then he took his foot off the spade. I'm thinking, *What the hell is that about?* I asked him, 'Dear, are you all right?' He said, 'Oh, I'm fine.' But he would never admit to the fact that he was having all this stuff going on. He wouldn't tell me because he knew he'd have to go to the doctor. And he was afraid of doctors. Most of our friends were doctors because of Meharry. I would have to trick him and have one of them come over to visit us in order to examine him."

Before my mother had left for DC, my father had given her a bunch of presents to give to his friends. She asked why he didn't just bring them himself when he made the trip, but he insisted that she take them. As if he sensed that he wouldn't be making the trip himself.

My mother rushed back home after Dad was admitted to the hospital. She was told that he had suffered a massive stroke. Mom felt that she immediately knew the cause: cigarettes. My father was like a human smokestack, smoking several packs a day.

We went back to Nashville later that night and missed our graduation so we could be with our father. Three days after she rushed home to be with Dad, my mother had to walk into a meeting of the McKissack board and announce that she was taking over the company. In an instant, she went from being a mother and housewife—who hadn't worked in nearly two decades—to president of a multimillion-dollar company.

CHAPTER 9

What It Takes

My parents said they would continue to pay my rent and keep me afloat while I was in grad school. However, the stipend they were sending me was never enough. I decided to get a job at a clothing store in Georgetown called Britches. It was quite high end, in a brand-new retail mall, and they allowed me flexible hours; I mostly worked nights and weekends. I was a pretty good salesperson for them and got quite a few raises. I was making about $10 an hour, which was good money for retail back then. Because of its location in trendy Georgetown, sometimes we would get well-known people in the store. One day I looked up to see Prince walk in.

Mind you, this was about 1985, not long after the release of *Purple Rain*. In other words, there wasn't a bigger music star in the world at the time. As you can imagine, I was thrilled. He was

certainly a beautiful man, but I couldn't get over how little he was. His hair was a little strange, like there was some perm in there. Before I could take a step in his direction, the white woman who was the store manager pounced on him. She was leading the conversation with him while I was running and getting sizes. At one point I handed him a piece and he gave me a little wink. I thought I had been transported to heaven. *Oh my God, I love him!* I thought. We didn't get his autograph, but he said he would give it to us when he came back to pick up his stuff. Instead, he sent someone else to pick it up for him.

I waited on Ethel Kennedy, the wife of the late US attorney general Robert Kennedy, one afternoon near Christmas when she was buying a bunch of sweaters for family members. She bought so many sweaters that she made my week saleswise.

I was having a difficult time in my master's program with my advisor, Dr. Broome. I would go far down a particular track on my thesis, thinking I was getting somewhere, and then he would have me change course and go in a different direction. It felt like he kept moving the goalpost on me. In retrospect, I wonder if he was having me do research for *his* projects. Either way, it didn't matter to me because he was a prominent professor and I was happy to be under his tutelage. I finally got my mother involved. She had a conversation with him, telling him that I needed to be done. He agreed to let me move on. The only thing remaining was for me to defend my thesis.

I applied to about four or five different engineering firms in New York City. I had a good friend, Brad Perkins, who is still a renowned architect in New York, and he told me that he was going

to help me find a structural engineering job. He introduced me to several firms. I went on a bunch of interviews; they would put me in a room and have me take a test. One firm offered me a job for $15,000 a year; another offered $15,500. Weidlinger Associates offered me $17,500. That was a no-brainer for me—I'll take more money, thank you. It was 1986, but $17,500 still was paltry, especially in New York. After taxes, my check was about $600. But it wasn't so bad because I wasn't paying rent—I was living with a guy.

While I was in DC working on my master's degree, a friend of mine told me he wanted to introduce me to one of his buddies from New York. He was a Howard grad coming to DC for homecoming. "I want you to show him around," my friend told me. At the time I was living with Deryl and her boyfriend in a town house and having a ball. When Michael showed up, he was a nice-looking Black guy who talked a mile a minute, like a typical New Yorker. I had never met anybody who dressed like him and acted like him, plus he was from my beloved New York. He sort of swept me off my feet. When I moved to New York for my job, I moved in with Michael in a fourth-floor walkup loft in Jersey City, New Jersey, right across the water from Manhattan.

I went back to Washington to defend my thesis, which was the scariest day of my life. They can ask you any question on any subject you've studied over the past six years, plus questions on your thesis. I sat there in front of a firing squad that consisted of anybody from the engineering school who wanted to listen to my thesis defense. For almost three hours, I felt like I was being indoctrinated, hazed, like I was pledging the AKAs or the Deltas. There were a couple of

The Black Family Who Built America

questions that I couldn't answer, so they actually put me on hold. They told me I had to come back and do it all over again. And it wasn't like I could come back in two weeks; I had to wait six months to defend it again. I was so upset. I felt like I had been abused. *How can these Black men put me through all this?* I thought. My mother set me straight, though.

"Listen, Cheryl, this is Howard," she said. "They're gonna make sure you know your stuff. When you graduate from here, you're going to earn your master's. So you just need to roll with it. They want you to come back, you come back. And make sure you know all those questions."

I felt humiliated going back to Weidlinger and thinking everyone knew I had failed. After the torture of waiting six months, I made sure there was no way I was going to fail a second time. I finally got my master's degree in engineering.

In Jersey City, we lived downtown on Washington Street, right near the water. Our street was in the midst of gentrification, so there was a lot of unsavory activity going down. Our apartment was newly renovated, but at night we'd hear shootouts at the other end of the block. Sometimes I'd be walking home at 3:00 a.m. from the Exchange Place station on the PATH subway line that went into Manhattan and I'd be thinking, *What am I doing living in this ghetto?* There was trash everywhere and scary-looking dudes on the sidewalks. But after about six months I had learned to become a New Yorker. You figure out that you need to buy novels and read them on the train so that it's easier to not pay attention to anybody around you. You board a train that's full but yet there's an empty

seat—you only need one time to sit down and realize the seat is empty because the dude next to you is bugging out. At first you smile to yourself, thinking, *I got a seat!* Then you look over to your left and see some guy talking to himself.

It was the mid-eighties in New York City, and crime was rampant. I heard stories of people having their purses snatched on the subway; a few folks were even pushed onto the tracks. There was a little bit of danger to it all, but as many others will tell you, the freedom and excitement of untamed New York was incomparable. I loved it! You truly can get used to anything. It didn't take long for me to feel comfortable boarding a subway train in the wee hours. Hey, it was the easiest way to get around. There was no Uber then, and a taxi at that hour was hard to come by. That was life as a New Yorker. I loved the Halloween parade in Greenwich Village, the West Indian Day Parade in Brooklyn on Labor Day. I was living the life. We would go to Martha's Vineyard for a week with a bunch of other couples at the end of August, then go to the US Open tennis tournament when we got back. It was such a great way to kick off the fall.

When I decided to get married to my first husband in 1986, my colleagues from Weidlinger came to the wedding. That's how close to them I was. My husband—who liked to refer to himself in the third person as "The Big Man"—sold software to the Wall Street banks and investment houses, so most of his friends were Wall Street guys, working for companies like Salomon Brothers and Goldman Sachs. They were all making a lot more money than we were. We would have impromptu parties at our place at 11:00 p.m. or 12:00 a.m. Eventually, we bought a condo on

The Black Family Who Built America

Barrow Street in Jersey City, which gave us more room. It was a fun time. Until it wasn't.

Big Man was an *interesting* guy—and I use that word in place of a few others that come to mind. He would always be throwing out the saying, "I pay the cost to be the boss." But I soon discovered that Big Man wasn't paying nearly enough costs. He was barely covering our bills. In addition, he was running a head trip on me on the subject of West Indians versus Black Americans. His family was from Grenada, and he needed me to know that West Indians were superior. He wasn't very impressed with my family's business. He actually told me I come from a "nigger business" that's not worth anything. He didn't have much good to say about my profession either. "Oh, you're an engineer? Everyone else is into making money." He would tease me about my nappy hair—he loved Puerto Rican girls and their straighter hair. If you're not ready for a duel to the death, you better not tease a Black woman about her hair.

It really was verbal abuse. But I was only twenty-five, still a kid, and he was a whole decade older than me. In response to the abuse, I would act out and do crazy stuff. I would be thinking, *I got a nigger business? All right, fuck you! I'm going to go hang out with this dude tonight with my girlfriends. We're going to party and have a good time, while you do your thing with the guys, or whatever.* This was not a recipe for a successful marriage.

Since my paycheck was so paltry, I was trying to find other streams of income in addition to my day job. I wasn't stressing over money, especially since I thought my husband was handling most of the bills, but I wanted more walking-around cash. I knew some people in Nashville who had developed and patented a formula for

quick-dry nail polish. I became their Northeast saleslady, going around to different nail salons and selling the nail polish. That was my side hustle for about a year and a half while I worked at Weidlinger.

The work at the firm was fascinating. I was the only Black person in sight at the company. Paul Weidlinger had hired a woman named Eve Hinman a year before me, and he treated the two of us like his protegés. At the time, the firm's big project was to design a structure that could withstand a bomb. This was several years after 241 American troops were killed by a massive suicide bomb in Beirut. A truck filled with twelve thousand pounds of TNT had crashed through the gates of the Marine Corps barracks in October 1983 and into the Battalion Landing Team Headquarters building, prompting an enormous blast that lifted the building from its foundation in what was described as the largest non-nuclear explosion since World War II.

We had a defense contract to design barracks that would withstand such bombs. I had top-secret security clearance—but I didn't like the work at all. We had to read reports on the effects of massive bombs and look at these painfully gruesome pictures of what bombs could do. This was in the middle of our Cold War nuclear arms race with Russia, so it was all a bit scary and unnerving. We used nascent computer technology to design silos for these missiles that were in the middle of the desert out in places like Utah and Arizona. They would move the missiles around, so we never knew the actual locations, and they would test the missiles. It was very top-secret stuff.

The Black Family Who Built America

We used the famous Cray-1 supercomputer at Los Alamos—which was the famed site where Robert Oppenheimer developed the atomic bomb—to do our calculations. We would write our programs on cards that we would run through a card reader before we left the office at night, and we would have our results back from the computer when we got in the next morning. We didn't even have keyboards yet. It's unbelievable to me how much we've progressed when I think back on those days. You learned that you'd better be efficient at spotting mistakes before you put the cards through the machine because you would lose a whole twenty-four-hour period if a comma was in the wrong place.

Paul was a big proponent of education, so he made me start on a PhD at Columbia University. Most of my professors were actually working at the firm; after class, they were right there at the office, which was convenient if I had issues or questions I needed to work through. But I hated it. I was no more interested in doing a PhD than I was in going to the moon. I had labored through that master's; I wanted to be free of school. But they insisted that my master's was not enough. And, as if the PhD wasn't enough, I was interested in the fledgling computer technology so I also began an IT program at New York University. It was a lot.

Around this time, my husband the software salesman came home with this enormous contraption that he said was the first portable computer. Huge and heavy, it had a small screen displaying white letters on a black background. It was pretty awful, but that's all we had. I felt like I was on the cutting edge of IT, with my own computer in the house. Since we had our own computing

system at work now, we didn't have to send stuff to Los Alamos. Instead of the process taking overnight, we could now calculate our programs in two and a half hours. And we actually had keyboards now instead of the cards. The pace of technological advancement really began to take off.

I appreciated the lessons I was learning at Weidlinger about being reliable and consistent—but I still wasn't making any money. I had met one of the Black executives at Turner Construction, Hilton Smith, and he told me I should come work for Turner. I had an interview and got offered a position with this major construction firm for considerably more money. I went from $23,000 to $35,000—I thought I had hit the lotto. It was a difficult decision to leave Weidlinger—where I had made so many friends and learned so much—for more cash, but the money won out. Also, working at Turner would get me closer to the work of my family business, though I wasn't really thinking of that at the time.

I started at Turner in the estimating department, which was a great learning environment. I believe that's the reason I'm in construction management today, because of what I learned doing estimating for Turner. Estimating teaches you how to construct a building on paper. You create a line item for every piece of equipment, every supply item. You have to make sure all the quantities are correct and everything is verified. It's about detail, about being thorough, checking and rechecking. We would go through all of these procedures before we put in a bid. Because a bid can make or break you. We worked really hard. As a newcomer, I started out with the small stuff—toilet accessories, doors, and doorknobs. I would have to go out into the market and get the door suppliers and

The Black Family Who Built America

installers to give me their bids. Then I would level the bids, making sure everybody was including the same items in their bids so that we were comparing apples to apples. Eventually I worked my way all the way up to drywall and all the interior trades. You couldn't tell me anything—drywall was the big league.

Technically we didn't need to be at work until 8:00 a.m., but the unwritten rule was we should be in our seat by 7:00 a.m. We'd work all day into the night, till 8:30 or 9:00 p.m., then our boss, John McGordy—who was one of the icons in New York when it came to bids—would take us to dinner. Sometimes we'd be there until midnight. If we had a bid going in, we'd have to be there to go through every detail with John. Sometimes he would make me go back out and try to negotiate a lower bid from a few of the bidders. Then he would go into a room with the CEO of Turner and they would massage the numbers to come up with an overall bid to present to the client. It might be as large as $300 million. A lot of the time we would just be sitting there waiting on the client to get back to us; we were at their beck and call.

I instituted the things I learned at Turner when I built my construction-management business at McKissack. After the bid goes through our estimating department, then it goes to my EVP, then it goes to me and another EVP, then we sit down and review the bid before we submit it. If something goes wrong in this process, there will be hell to pay. I had a bad bid almost put me out of business in 2015 in Philly. We had a bunch of projects where we didn't go through that process, where I did not go through the final bid, and the dollars needed to complete the job were more than what we had in the job. Couple that with a client who didn't have money and, to

Cheryl McKissack Daniel

make matters even worse, a bad architect who had submitted documents that were not complete and not detailed. If the architect's documents aren't complete, it leaves room for a lot of error in estimating costs. We fell into that trap with several projects in Philly, and they almost took us under.

I did estimating at Turner for about two years. I would have been rotated out soon to a different department, but I got a fateful phone call one day at my desk. It was from my mother.

"Cheryl, you're quitting your job today," she said. "Pack up your things. You're going to start coming to Nashville and working for me."

"What?!" I couldn't believe what I was hearing.

"I've already talked to your boss," she said. "It's all taken care of."

I could have refused her and told John, my boss, that I was going to stay with Turner. But a part of me was feeling like maybe Mom was right. My eyes were beginning to open, and I could see the glass ceiling at Turner. I had a colleague in estimating, a Black man named John Hall, who had been there for five years and had grown very disgruntled. We were the only Black employees in the department. John took on a mentoring role with me, taking me out to lunch, doing little things to keep my spirits up. But he was angry with Turner over his lack of advancement. He told me if I wasn't an Irish male, I would go only so far in the company. I looked around at senior management and realized he was right. There was no way I was going to catapult over all the white boys to get to senior management. I didn't have all the experience that I would have liked to be able to run my own business, but maybe it

was time for me to move on and control my own destiny. Though I certainly wasn't pleased about it at the time, I have to thank Mom for making such a gangster move and calling up my boss. Thirty years later I might have become a VP at Turner, but I surely wouldn't be controlling my own destiny. Mom put me on the track of business development—and that's what I've been doing ever since.

CHAPTER 10

Family Business

When Mom got home from DC after finding out my father had had a stroke, she had no idea what kind of condition she would find him in. He was not in good shape. He was incapacitated, he couldn't speak, and his left side was paralyzed. As he lay in the hospital bed in intensive care, she had to make some quick decisions about the family business. Her first idea, which she discussed with her lawyer, was to find somebody who could come in and help run the company. She had already gotten calls from three major architectural firms looking to buy McKissack & McKissack. However, she soon decided she would run it herself, because as she put it, she wanted to "keep it for my babies."

Right before Mom's first meeting with the board, less than a week after his stroke, I walked into Dad's office and saw her downing a little airplane bottle of scotch that he had stashed away.

"What are you doing?!" I asked, shock and judgment edging my tone.

"What does it look like I'm doing?" she answered curtly. "I'm getting fortified."

There wasn't much I could say. In her mind, she was about to walk into a room with a table full of men who saw her as the boss's wife, nothing more. They were vultures and she was a carcass they were poised to devour. If she needed a bit of liquid courage, who was I to argue?

Those men on the board and the executives with the company soon found out how much of a force of nature my mother is. She was not somebody you wanted to challenge. She didn't know much about the business at first, but she was a very smart woman with a strong personality and confident persona. After all, she had a bachelor's degree in math and a master's in psychology, which she said helped her in dealing with the craziness.

"They were disrespectful," my mother says. "They would disrespect me with whatever they were commenting on. Yeah, they were good employees for him, but they weren't gonna work for me. They thought he was going to come back, but that just wasn't happening."

One of the vice presidents actually threw a stack of papers at her during an argument. The man who was in charge of the construction arm of the company was particularly rude to her.

"He said, 'Look at you. One day you're a housewife. And the next day you're running all these companies,'" Mom remembers. "I told him, 'Well, don't talk about it—try to help me out.' He didn't like me and I didn't like him. I didn't trust him."

One day he showed up with a wad of cash that he handed over to my mother. "This is your cut of it," he told her. She was incredulous. That was not how business was supposed to be done—dudes showing up with wads of cash. It didn't smell right at all. I don't think we were connected to the mob or anything like that, but there probably were some kinds of payments being made under the table. My mother eventually decided to sell the construction business to this guy, as a way of getting rid of him.

"It took me a year, but I got rid of all of them. I fired everybody who had been working for my husband," my mother says. "Because they were not competent. They didn't have enough sense to recognize the fact that this woman was gonna be there—I wasn't going anywhere. I said, 'I'm not trying to be an architect. I don't want to be an architect. I'm just going to be in charge of all of this. And if you don't like it, you can get some flying shoes and get the hell out of here.' It took me a little while, but I really toughened up.

"We had a carport in our house and we lived on a hill. When I would back that car out, put it in drive, and head downtown to the office, I would say, 'Thank you, Lord, that I got someplace to go.' Because after I quit teaching when the girls were little, I hadn't been working at all."

After his stroke, my father was able to get back most of his mobility and his speech. To take some of the pressure off Mom, I offered to look after him in DC. He stayed with me in my one-bedroom apartment for several months. I got him a speech therapist who worked with him three times a week, and his speech began to improve.

"The first night he was gone was my first real good night's

The Black Family Who Built America

sleep," Mom says. "He had a pacemaker and I was always afraid that it would stop."

My father returned to Nashville in much better shape. In fact, he wanted to get behind the wheel again, so my mother bought him a new car. Sometimes he would take it out and get lost, scaring the hell out of everybody. My mother would rush home from the office when she got word that nobody knew where he was. A family friend who was a doctor lived around the corner from us and he frequently brought my father back home when he was lost.

"I found Dee out there roaming around again; he didn't know where he was," he'd say when he brought Dad back into the house.

Once he was gone for three long, nerveracking days. When he finally returned, he was holding on to tickets from gambling on dog races in Arkansas—and was wearing a big smile.

While we all stuck around for a while after Daddy's stroke to help Mom, my sister Andrea, who had been working with Dad after she graduated from Howard, stayed the longest. When she began looking around, Mom saw all the many things that my father had been juggling. Not only did he have the architecture business and the construction business; he also managed the College Hill apartments and another complex called Devonelle.

"With Devonelle, which he invested in with two other people, I realized the other people weren't doing anything," my mother says. "No wonder he had a stroke—he was basically doing all of it."

Because Mom wasn't an architect or an engineer, she had to lean heavily on the architects. That was a major weakness in her management of the company because she couldn't do things herself. She was great at business development; she could go out and

139

cultivate relationships and get more business—but she was reliant on the architects to make sure the company could implement.

The architects running her offices in Nashville, Memphis, and Montgomery were basically in control. They could take advantage of her in ways they couldn't with my father. I believe the architects outside of Nashville used Mom to retain an income while they built their own businesses. When Mom would go visit them, they'd have the McKissack shingle outside. Then when Mom would leave, they'd put another shingle outside for their own business. They were making agreements with subconsultants and clients that Mom didn't know about, and then they would do side contracts with their own companies.

"I ended up firing all of the employees except two—and they were both women," my mother recalls. She took one of the women, Claudette Howell, who had been handling specs and typing memos for the company for twenty-five years, and put her in charge of the books, right underneath her.

"I said, 'Can you handle the money? I will go out and get the work,'" Mom recalls.

Eventually Mom had some health challenges and realized she needed more help. That's when she called up to New York and told my boss I quit.

My father walked me down the aisle at my wedding in 1986, a proud moment for us both. Two years later we all gathered in DC for him to receive a distinguished award from Howard's school of architecture. He made it to the awards banquet, but he didn't make it back home. He died in the room at the DC hotel where they were

The Black Family Who Built America

staying. His funeral service was held in the University Chapel at Fisk. He was just sixty-two.

I began to fly to Nashville on Mondays to work with Mom, then fly back to New York on Thursdays to spend the rest of the week with my husband. Mom and I would get in her car and drive to see her clients throughout the South. The whole time we would have a ball. When I flew home on Thursday, Mom would walk me all the way to the gate and we would have drinks at the bar before I got on the plane. It was a fabulous time for us to grow even closer. And I got to watch her work her magic up close.

We were doing a lot of work at Tuskegee University, restoring two dormitories that my grandfather had built. One day Mom and I were walking across the campus with the president of the school, Dr. Benjamin Payton. She pointed to a building in the center of campus that was being used to store equipment.

"I think you should be living there," she said. "I think that should be the president's home."

He frowned. "Are you kidding me?"

"No, I'm not kidding," she responded.

Mom wasn't an architect, but she had vision. She was able to conceive things that others couldn't see. She went back to the campus with McKissack architects and had them draw up a plan. When she showed the plans to Dr. Payton, he said, "Absolutely!" Now it's the president's house, and it's a beautiful building.

Mom would do that sort of thing with her clients all the time. She would give them ideas about how to add value. And you couldn't shut her up. She was going to tell you what she thought;

she doesn't care who's listening. In those years we did everything: residences, dormitories, K–12 schools, churches, academic buildings. At Meharry, they wanted to build a new hospital—so Mom went to Congress and testified to get the money. Then she told the administration which construction company she wanted to build it, a company named Bovis.

We would get into her late-model Cadillac—she only drove Cadillacs, and she got a new one every three years—and drive through the South, visiting clients. On the way back home we would write letters to the people we had visited—well, I would write the letters on a yellow legal pad while Mom drove. When we got back to the office, I would hand Claudette a stack of six or seven letters to type up and send out. That's how we operated. It's interesting because I found a book full of carbon paper that contained copies of letters that Uncle Calvin and Moses III had written to clients many decades earlier. Mom and I were doing the exact same thing.

For some reason, the stretch of highway between Nashville and Memphis always presented problems for us. The police would be out in force trying to snag speeders. But my lead-foot mother would not be deterred. On one occasion when Mom was speeding, a police car pulled onto the highway behind us with lights flashing. But instead of slowing down and pulling over, Mom slammed her foot down on the accelerator and went faster.

"What's wrong with you?!" I screamed. "What are you doing?"

"No, no, no," she said, her eyes focused ahead. "If I can cross this bridge, I'll be in another county."

"Mom!" Suddenly we had become Bonnie and Clyde. "Have you heard of a radio? What if they radio ahead?"

The Black Family Who Built America

But she was right—the cop car stopped following us on the other side of the bridge. She looked at me with a knowing grin, like she had done it before. I could only shake my head. Never a dull moment with Mom.

When the city of Nashville finished the plans for a new airport and didn't choose any Black firms for design, construction, engineering—nothing—my outraged mother got together with other Black companies and they sued the city. It created some discomfort for her in dealings with the city for a while, but Mom was never going to back down.

"I had been talking to them and they had been nice to me, but when it came time to actually select the architect for the airport, that's when they cut off talking to me," Mom says. "When I sued the city, I told them, 'It's not anything against you; it's against the city. They have got to start using Blacks. Our firm has been in business for almost ninety years; we got employees in Washington, DC; in Memphis; all over the place. And you mean to tell me . . . ?' It wasn't fun because you have to go to court. I was just a wimp when it came to all this stuff, but I had a good lawyer. I go to work one day and there are nine white lawyers standing outside my doorway waiting to get in. They were there early in the morning. I thought, *Oh my God!* But that's what I had to do. I didn't get any work out of it, but it opened the door for another Black friend to come in and get some work. So that was better than nothing."

My mother likes to say that my father, DeBerry, was part of the good-ol'-boy network. She was not. He got a lot of jobs without having to market the company or answer RFPs. She said he got more business this way than a lot of white firms. Everybody liked

143

him and respected him, so when a project opened up, the name McKissack was always in the mix.

"At heart I'm not a Republican or a Democrat," my father used to say. "I'm an Africrat!"

But all of that handshake business disappeared overnight when my mother took over. She had to work hard for everything she got.

One of the more prominent projects Mom secured in those years was the National Civil Rights Museum in Memphis. McKissack was chosen to design the museum that was constructed next to the Lorraine Motel, where Martin Luther King had been killed in 1968. Though it was prominent, the firm didn't make any money on that one—in fact, it cost the company money. But it was important to Mom to memorialize Dr. King, whom she had met once at the airport in Atlanta.

Mom established a McKissack office in Washington, DC, where she would work her magic on senators and congressmen from Tennessee, including Harold Ford, Al Gore, and Bill Frist. Gore and his wife Tipper loved my mother; Gore even came to the house in Nashville. After he and President Clinton were elected, we visited him at the vice president's residence at One Observatory Circle in DC. My father had taught her the art of currying favor with politicians.

"I asked him, 'Why is it that when somebody's running for office, you always end up going to the celebration party of the winner?'" my mother recalls. "He said, 'Baby, I play both sides—so you can't lose. I learned from my father that you just got to put some money in this one's pocket and put some money in that other one's pocket, and then just act like you love them both.' He told me, 'Honey, I've had really big Republicans not knowing I'm a Democrat.'"

The Black Family Who Built America

As hard as it is to believe now, women couldn't even get a business loan on their own in many states when my mother took over the company in the 1980s. A woman in business needed to have a man cosign the loan for her. This wasn't changed until Congress passed the Women's Business Ownership Act of 1988, which eliminated discriminatory lending practices. It was signed into law by President Ronald Reagan. It blows my mind that when I was out there doing "Da' Butt" to the E.U. song, I wouldn't have been able to get a business loan by myself. I should add that despite the ridiculous law, my mother could still march into the bank by herself and somehow come out with a bank loan anytime she wanted.

My mother brought me with her to a memorable meeting with the late Gentry Crowell, the former Tennessee secretary of state. When we walked into his office, I was so nervous I'm sure I was trembling. He was sitting behind his desk and he didn't even look up when we entered. I stared at his face, which was so weathered it looked like a road map. My mother wanted me to make the presentation instead of her, but I was terrified. She gave me a withering look that said, *You're gonna do this and you're gonna do it now!* I was more afraid of her than I was of him, so I took a deep breath and began talking. I told him my name, though I was so nervous that I could barely remember it. I started talking about what our company does, our history. But all the while I'm thinking, *This dude is so prejudiced; clearly he can't stand us.*

When I was done, he rose from his chair. "Come over here, little lady," he said.

I didn't want to get anywhere near him. But I willed one foot in front of the other until I was standing in front of him. He lifted

up his head to look at me, and he grabbed my hand. His hand was so big, it swallowed mine.

"I'd love to do business with you," he said.

I was shocked. As we left the office, I couldn't believe what had just happened.

"You can never judge a book by its cover because you don't really know what people are thinking," my mother told me when we got back to the car. "You should run up and tell everybody who you are and what you do. Because you never know how it's going to be received. Don't ever be afraid of that."

I never forgot those words. I have seen their truth shine through so many times in subsequent years.

We actually wound up getting quite a bit of work from the state because of our relationship with Gentry Cowell. But a few years later, in 1989, he killed himself after he was involved in a corruption scandal and had to testify in front of a federal grand jury, though he wasn't indicted.

Watching my mother in action during those years, I never thought I could be like her. One time when we were at Tuskegee, they wanted me to give a speech. I was in my late twenties at the time; I just didn't think I could do it. Mom said, "I'll take it."

With no paperwork, no notes, no nothing, Mom got onstage and talked for about thirty minutes straight. I was amazed. Because she had been a schoolteacher, she knew how to put her thoughts together on the fly. She just wasn't afraid. Over the years, I think I have grown into my own version of her. I'm not sure I have the strength she has, but I am very strong. She taught me how to do business development in her own way—by having confidence in

The Black Family Who Built America

what you're saying and knowing that you're an expert in your own company. Mom had been through so much that she had a belief that things were going to work out. And in the end, they always did.

In 1990, this former housewife, who reluctantly had taken over the reins of her husband's company in an extreme emergency, was named National Female Entrepreneur of the Year by President George H. W. Bush. In 1994, President Bill Clinton presented her with the Presidential Design Award. More recently, in 2021 she was inducted into the Nashville Entrepreneur's Hall of Fame.

In 1991, after two years of commuting back and forth from New York to Nashville every week, I told my mother that I couldn't do it anymore. My marriage was already going off the rails and the travel grind was wearing on me. I incorporated McKissack in New York, but I needed something to bring in income while I got my business off the ground. I took a job as a consultant with the Nettleship Group, a program management company, working on a project overseeing management of a contract with the Metropolitan Transportation Authority (MTA), the agency that ran the city's vast transportation network. Nettleship was owned by a woman named Tish Nettleship, a beautiful blond business maven with a captivating personality. She reminded me of Ivana Trump. She taught me a lot about marketing a business in New York and introduced me to important networking events like the New York Building Congress dinners and Engineering News-Record (ENR) Man of the Year dinners.

As I got my business going, moving to Philly and transitioning into construction management, Mom was still doing well in Nashville. But by 1997, she had begun to struggle. Things were

closing in on her. She called me one day and told me the going was rough—she owed money to subconsultants and she was having a hard time making payroll. In my view, her architects were taking advantage of her. They were telling her there were no contracts coming in, but in reality they were taking the contracts for their own businesses.

In the end, my ex-husband stepped up and paid off one of her loans for about $70,000. My company paid off another $150,000 or so in loans. Then I helped her procure another loan for $500,000 to start the process of closing down everything else; we paid back that loan over a period of ten years.

By 2001, McKissack in Nashville was done and absorbed into The McKissack Group in New York. It was an inauspicious ending to a very long era. My family had been building in Tennessee for nearly 150 years, since Moses II moved to Spring Hill to work for William McKissack II. Though we'd started out as someone's property, we had cemented the McKissack name into the history books. McKissacks were instrumental in creating the infrastructure of this complicated, fascinating Southern state.

Now it was over.

My mother was seventy when I told her I thought it was time for her to retire, to let go of the daily headaches of running a sprawling business. At first she objected, telling me I couldn't fire her.

"And then I heard my inner voice say, *Shut the shit down*," my mother says. "And I said, 'Oh yes, honey. Thank you so much.' It was a very big relief to me because my health wasn't getting any better and the pressure was sky high."

Mom became a consultant for my reestablished firm and

The Black Family Who Built America

I appointed her to my board. She moved into a condo in the mid-eighties. Eventually Mom and I expanded her unit into a luxurious four bedroom, four bath apartment with a sprawling balcony. It currently displays all of her amazing artwork—in a building that sits high on a hill overlooking Nashville. She did a lot of traveling, visiting her daughters, having a great time taking advantage of a relatively carefree retirement. And now, at age ninety-four, she's still telling me what to do.

CHAPTER 11

Sisterly Love

In the late 1990s, there were rumblings in Philly that the city was going to be building a new stadium for the Philadelphia Eagles football team, replacing the old Veterans Stadium that the Eagles and the Philadelphia Phillies had been using since 1971. I really wanted McKissack to be on the construction team for this high-profile project. We were working our way up to being part of a significant joint venture—I figured it was time for us to get at least 30 percent. We were in a good position because the City of Philadelphia was basically being run by African American politicians—city councilmembers Augusta "Gussie" Clark, Marian Tasco, and John Street, who would soon become mayor. In order to get in on this project, I would once again need to go through Turner Construction—which seemingly has played a big role in each step of my career.

The Black Family Who Built America

Turner had a close relationship with the NFL; the company had a piece of many NFL stadium constructions around the country, giving them vital relationships in the NFL ecosystem. Turner was accustomed to being the lead contractor; in Philly they were required to use local contractors. They brought on a local contractor, Daniel Keating, who had never built a stadium—but he was a Philly guy. The city mandated 25 percent MWBE on the project, so that's what I had my eye on. But Turner and Keating did not seem to want us to participate. There were other minority firms that also were angling for a piece, so they had options. I got Gussie Clark and Marian Tasco on the phone and asked if they could help. They advocated to Mayor Rendell and his chief of staff, David L. Cohen, and we got chosen as the construction managers for the stadium project.

Because of Turner's method of accounting, we actually found ourselves in a deep hole at the end of the project. McKissack ended up with a larger-than-expected tax bill, which we would have been unable to pay if we did not work with Turner to reduce our tax liability to zero. Those were difficult and stressful times for McKissack. My grandfather and great-uncle never had to worry about these sorts of entanglements because they never got a chance to partner with these large white firms. And when they finally got such opportunities, the white firms were not reporting their earnings to the stock exchange. But this definitely fell under the category of "be careful what you wish for. . . ." We were experiencing the ugly downside to being a major partner on these enormous deals.

I learned a valuable lesson from that ordeal: Make sure as part of

your payment schedule you receive the money you need for taxes in the same year that the taxes will be owed. Don't wait until the end of the project, when the numbers have gotten scary and unwieldy. I also learned that I need to be asking more questions about tax implications at the beginning of the project, so that my tax situation doesn't get entangled in the larger firm's tax situation. That's what experience is—knowing what questions to ask. Because most likely the other party isn't going to help you out, even if they know you're walking into a storm. They're going to stand by silently and watch you get struck by lightning.

After we partnered with Turner to build the new structures on the campus of Medgar Evers College in Brooklyn, we decided to enter into another partnership with Turner to pursue the School Construction Authority's new emergency services building. Turner president Jim McKenna had a great relationship with the president of the SCA, Bill Goldstein, which made this feel like a near sure thing for us. We were looking at a 60 percent–40 percent split, with Turner taking the lead. I had attended the preproposal meeting, so I was just waiting for the SCA to officially release the RFP. When the RFP finally came out, it was time for us to jump. When I called McKenna, I got a shocking bit of news.

"Jim resigned today," his secretary, Camilla, told me.

"What?!"

"They escorted him out with security guards and they took his cell phone and computer," she said. "You have to call him on his daughter's cell phone."

I was stunned. What was going to happen with the SCA deal if he was gone, since his relationship with the SCA was a crucial part

of it? When I finally got Jim on his daughter's phone, he laid out the whole story. He had resigned from Turner to start a new company, which he was calling Hunter Roberts. As if that wasn't enough to incite the ire of Turner brass, Jim was taking with him more than a dozen senior Turner managers. Thus the security escort. Jim was paying the highest salaries in the city to lure talent. This was the rough-and-tumble world we lived in.

"I just can't believe they reacted this way," he told me. But once I found out about his gambit to hire away Turner's senior management, it made sense. McKenna had partnered with Bob Fee, who had been my boss at Turner, to start this new company, backed by a billionaire named Jeff Records.

When I asked him about the SCA project, he said, "Well, Cheryl, I still think we can do this. I just have to do it under Hunter Roberts."

"But no one knows Hunter Roberts," I said.

"Just trust me," he said. "I've already talked with the folks at the SCA and I think we're good. We just need McKissack to be the lead because you guys attended the preproposal meeting. We're going to make it fifty-one McKissack and forty-nine Hunter Roberts."

Wait, we're going to be the lead? Absolutely! I thought to myself. This would truly be a unique position for us. We were the lead on paper for Medgar Evers, but not in reality. But this would be a game changer if we won the project. I figured I might as well take a chance with this new company and be the lead rather than try to find a new partner and be back to minority status.

Jim was right—we were good. We were ecstatic when we got word that we had won the SCA contract. That turned out to be the

first job for Hunter Roberts. Twenty years later, Hunter Roberts does almost a billion dollars a year in business—significantly more than the $50 million or so McKissack does. Whenever Jim and I do presentations together now, he always tells people, "Our first project was through McKissack." It never fails to make me smile.

I should add here that companies like Hunter Roberts use a different method to determine their revenue than McKissack. They hold all the contracts of their subcontractors and count it as part of their revenue, even though it then gets disbursed. That greatly inflates their revenue numbers, as the subcontracts are just passing through their books. We might hold the subcontracts for a few projects that we manage, but for the most part our revenue is true revenue. Anytime you have that much cash passing through your account, you can play games and make money off of it. But there are many more risks attached. They can also offer their subcontractors default insurance, which is an additional way for them to make money. It's all a big game—but one that's easier to play when you have a billionaire backing you. High risk and high reward.

I'm still waiting for that phone call from a billionaire offering to back McKissack and help us get bigger. Y'all know where to find me.

I'm joking. Kinda. My goal had always been to grow organically, because that allows me to retain control. This company has been in my family for so many generations, I have to be real careful with how much risk I'm willing to take on as I steer the ship.

After the SCA project, McKissack went Ivy League—namely, the University of Pennsylvania. We partnered with a larger white firm, Driscoll Construction, and won the contract to build the University of Pennsylvania Perelman Center for Advanced Medicine.

The Black Family Who Built America

It really made sense for us to do all these projects in academia, considering McKissack's history in the South. But this was our first time working in the hallowed halls of the Ivy League. I have to give considerable thanks to City Councilmember Jannie Blackwell for our attachment to the University of Pennsylvania project. Penn was in her council district, and Jannie—who succeeded her husband Lucien Blackwell when he was elected to Congress—was a strong supporter of MWBE.

I learned quickly that the University of Pennsylvania project was going to be fascinating because of the involvement of a singularly enthralling character—architect Rafael Viñoly. A world-renowned talent, Viñoly designed soaring structures around the globe featuring his dramatic glass enclosures that produced striking exteriors and shimmering interiors. The Uruguay-born socialite was also exceedingly charming, with a taste for expensive French wines and a flair for entertaining, particularly at his Long Island property, where the classically trained pianist gave recitals in his music pavilions on one of the nine pianos he owned. *The New York Times* described him in a 2003 profile as "a black-clad wraith with a madcap nimbus of silvery hair" who "could run a charm school in his spare time, if he had any."

When you walked into the eccentric Viñoly's office in a beautiful Manhattan high-rise, you were greeted by a lovely grand piano. It was appropriate that one of his best-known designs was the home of Jazz at Lincoln Center overlooking Central Park. Interestingly, because he was from Uruguay, my understanding is that Viñoly registered his firm as a MWBE, though he looked white to me. To me, his case pointed out the difficulty of upholding the integrity of

the MWBE program, which was vulnerable to such manipulation from the start. I think many people were surprised in the beginning by the extent to which people who appeared to be white would go to claim they should get MWBE designation.

The University of Pennsylvania project ran into difficulty right at the start because of Viñoly's ambitious design. He wanted to put an eight-story-tall oculus on the front of the building that added $30 million to the project's cost. When we all came together to discuss how to make the building constructible and come up with a budget, Jack Donnelly, who was president of Driscoll Construction, said, "Well, we can't afford that. I think we should take this oculus and chop it off right here."

He pointed to a much lower point on the drawing, many floors shorter than eight. Viñoly became practically apoplectic.

"Huh? Huh?"

You would have thought Donnelly was proposing to chop Viñoly's body in half. He got up and stormed out of the room. "We'll see about that!" he said on his way out.

Viñoly wasn't playing—he went to the wealthy board members of the university and he raised the money for his beloved oculus. That's the type of person he was—he wasn't going to be deterred by a no from a construction guy trying to chop his vision in half. That was a signature Viñoly move—to use his charm, debonair, and sexy voice to woo his wealthy friends. The man could sell winter coats in Miami.

The construction at Penn was proceeding at a promising clip; the structure was clearly going to be beautiful. Then one day in 2009, as we were approaching the end, we got word that Driscoll

The Black Family Who Built America

was being purchased by a New York company called Structure Tone Construction. Structure Tone had a very different view of the MWBE program; they didn't use many MWBE firms. Some companies had latched on to the need for the programs; most companies were indifferent. Other companies fell somewhere in the middle. At the time we were struggling with cash-flow issues, so we were counting every penny coming in. We had been unable to build a big cash cushion; in those years we were always seeking new lines of credit. As I got more info about this coming acquisition, I started to get nervous. We were owed about a half million dollars, and I was worried that our money would fall through the cracks as they dealt with the thousand issues that needed to be hammered out in a complicated deal. I got an idea—it was time to deploy my secret weapon: Mom.

"Mom, I need you to come to Philly and go in there and ask this man for my money," I told her. "You have to charm him."

Then I called up Jack Donnelly. "Jack, my mother's coming to town and I'd like for you to meet her," I said.

Jack was an old-school gentleman, who came to the construction office every day in a fancy suit, complete with a pocket square. Not your typical construction attire, not even for the boss. He said he would love to meet my mom.

Before we went into the meeting, I gave Mom a pep talk. "You got to do whatever it takes—we can't walk out of there unless I know I'm getting a check that day or the next day."

In the meeting, Mom talked her butt off, laying on all of her charm. She had this old white Philadelphia gentleman eating out of her sweet Southern hand. Jack decided to take us on a tour of

his whole office. As we were walking with him, Mom lowered the boom.

"You know that project that you all were working on with Rafael Viñoly? Don't you owe my daughter a lot of money on that?"

He stopped walking. "Yeah, I've been thinking about that," he said. "You know, we're being acquired by Structure Tone. I really don't want your daughter caught up in that, because he couldn't trust I would receive dollar for dollar.

He looked at Mom and then at me. "We're gonna get her check by Monday," he said.

He was a man of his word—I had my check a few days later. Right after that, Jack resigned. The timing proved to be perfect; if we had waited a few days, our money would have been caught up in the acquisition, which would have been awful for us. In those situations, contractors are known to go to their subs with horrendous proposals—"We know you're owed $500,000 but we're gonna give you seventy-five cents on the dollar." Or even fifty cents on the dollar. And there's virtually nothing you can do about it. That's the nature of this construction beast.

I must say, the glass-encased Perelman Center for Advanced Medicine turned out beautifully. It was awarded the International Architecture Award for Best New Global Design by the Chicago Athenaeum, the Design Award of Special Recognition by the Society of American Registered Architects (SARA) PA Council, and an Honorable Mention in the Healthcare Sector by World Architecture News (WAN). In addition to that, we have continued to work on projects at the University of Pennsylvania; they have been a very good client for McKissack.

The Black Family Who Built America

After working on a series of joint ventures, I was feeling pretty good about where McKissack was situated in the construction ecosphere. It was time for us to run an entire project by ourselves, with no partner. And there was no better place for us to start than Harlem in New York City, the longtime symbolic home of Black hopes and dreams. Ever since the Harlem Renaissance had blossomed in the 1920s and 1930s as African Americans fled the Jim Crow South and made a home in New York, Harlem had been seen as the epicenter of Black arts, culture, and progressive thought. Though the area had succumbed to the devastating crime and degradation wrought by the epidemics of heroin and then crack, it was reemerging in a new renaissance of sorts by the 2000s, helped along by organizations like the Harlem Children's Zone and people like its president, Geoffrey Canada.

The New York State Dormitory Authority put out an RFP to rebuild Harlem Hospital. At a price tag of $225.5 million, the modernization and expansion would enable Harlem Hospital to improve its physical and therapeutic environment and offer more state-of-the-art services to Harlem and its surrounding neighborhoods. It was a project that got considerable attention before a nail was even hammered. "When finished, Harlem Hospital will be among the most technologically advanced hospitals—public or private—in the city," Mayor Bloomberg said.

Before any constructing could be done, the first project consisted of the demolition of three old hospital buildings that had fallen into disrepair. As part of the demolition, the project called for the removal and preservation of important WPA murals—by artists Charles Alston, Elba Lightfoot, and Vertis Hayes. These nearly

one-hundred-year-olds murals, which were painted onto cement walls, had to be safely removed and stored away so that they could be installed in the new buildings. Taking down the walls with the murals intact was probably the riskiest part of the job.

There were other Black firms teaming up with the big boys, like TDX Construction, Turner, and Skanska, to get the demolition job, which was about $40 million. But we decided McKissack would go after it alone. To understand the lay of the land and put the company in a good position, I spent endless hours in Harlem going to community board meetings. I also met with several of the neighborhood coalitions in the area. With names like the Mid-Bronx Desperadoes, Positive Workforce, Harlem Fight Back, and United Hispanic, these groups were all over Harlem, showing up at construction sites and threatening contractors unless they gave construction jobs to coalition members. We hired a woman named Aissatou Bey-Grecia, who met on a regular basis with the heads of the five major neighborhood coalitions operating in the area. We ambitiously called a meeting of all five coalitions, naively thinking that we just needed to get everybody in the same room to find a workable alternative to the shakedowns. Our plan was to do a round-robin, where we would hire someone from one coalition, then the next job would go to a second coalition, then the next job to the third coalition, and so on. That was our idea for using a systematic way of bringing people onto the job. It sounded great on paper, but we failed to get buy-ins from everyone in the room. Two guys started loudly arguing in the back of the room, and the argument escalated into a fight. Our security guards, who were armed, quickly escorted us outside.

The Black Family Who Built America

The larger contractors had begun bringing in the New York Police Department to keep the coalitions away. They would arrest everybody and just shut down the job, which wasn't a great solution either. It was an untenable situation. Friends had told me stories of being at a site when a coalition showed up, threatening everybody at gunpoint. In one instance, a friend told me she saw them dangle a superintendent on the job by his feet out a window on the thirteenth floor. The coalitions would get especially angry and aggressive if they showed up to a site and saw mostly New Jersey license plates on the cars, which let them know that the workers on the site likely weren't from the area. In Harlem, people were actually paid to picket a site, in some cases pocketing tiny fees of $10 a day.

Though the competition was tough from the other companies vying for the hospital demolition, we won the project. We submitted an exceptional proposal, and our presentation was second to none. As far as I was aware, it was the first time a Black company had been chosen as prime on a major construction-management job. I know our political contacts and showing up at all those meetings also had a lot to do with us winning that contract. Once we got started, we opened up a workforce development office in Harlem, to try to bring in more local workers onto the site. Even if a MWBE company is prime on a contract, we are still subject to the MWBE provisions. If we bring in a number of other MWBE companies, we could make the entire project an MWBE workspace.

After we won the Harlem Hospital demolition project—including the safe removal and preservation of the WPA murals—we teamed up with TDX Construction to try to win the contract to construct the new hospital. By this time we were close to the executive director of

Harlem Hospital, Dr. John Palmer, and we had a relationship with all the local politicians who supported MWBE firms and understood the minority ecosystem, which is why TDX wanted to team up with us. We won the contract to build the new hospital.

We were gaining momentum now as a company. That's when I heard about the Barclays Center project, on the heels of the Harlem Hospital project. I told the story of that whole saga in Chapter 1. As I said, the work we did on Atlantic Yards to prepare the ground for the Barclays Center was a huge step for us. We took whatever was left over on the project, in this case moving the rail yard, and we made it work. I jokingly said that we'll take your leftovers and make them taste good; we could turn the chitlins into a gourmet meal.

In the midst of the Atlantic Yards project, we decided we would pursue another project with the MTA, managing the agency's capital program. Managing the capital program would consist of monitoring the MTA's billions of dollars' worth of design and construction projects for compliance with construction and project-management, budget, schedule, safety, and quality requirements. We didn't expect to have much competition for the job because the company that manages the capital program is banned by state law from working on the projects in the capital program; that would be a conflict of interest. Since most firms wanted to work directly for the MTA, which meant potentially more lucrative projects, we knew they wouldn't be much interested in this contract. Getting the contract would be a strategic way of solidifying our transit business. When you're based in New York City, with its more than 470 stations and 660 miles of track, having transit experience can be a real moneymaker.

The Black Family Who Built America

However, there was one potential impediment standing in our way: In the RFP, the MTA required national transit experience. Our only transit experience was working on Atlantic Yards, which we had just started—and was not exactly national in scope. Our solution was to find a partner that met the national criteria. We teamed up with a Canadian company called Delcan Corp., which had decades of experience in the transit sector. They took the lead, with 51 percent to our 49 percent. We had to go outside the country to find a firm with transit experience that was willing to forgo the possibility of one day getting an MTA project in the capital program. The US firms with transit experience were either already working for the MTA or wanted to be working for them in the future.

One of the Delcan executives flew down from Toronto for our presentation to the MTA board. There had been a push to make the MTA board members more diverse and representative of the city. The twenty-three-member board is comprised of members from New York City and the seven surrounding counties. After our presentation, I happened to run into a couple of the board members around the city. One of them was a Hispanic woman who told me she was really proud of the work McKissack had done. She and I eventually became good friends. The other member, a white woman, told me that she was a strong proponent of bringing more diverse companies into the MTA fold. I was feeling very good about our chances. We were ecstatic when we got the call that we had won the contract. It potentially was a seven-year contract—three years, with the possibility of being extended four more years.

In 2014, when we were in the third extension phase of the contract, Delcan was purchased by a California-based company

named Parsons. Because Parsons was already working directly for the MTA, Delcan had to bow out of our partnership. We took over the management of the capital program by ourselves. At the end of the seven years, we had to recompete to get another seven-year contract. By then we had been running the program by ourselves for the previous two years. We weren't sure if we would win it again, but Governor David Paterson—the state's first Black governor, who took office after Governor Eliot Spitzer was embroiled in a sex scandal—was keen on keeping a Black firm in charge of the program. So, we got another seven-year run. But four years into the second seven-year term, I got the idea that we should try to go for one of the projects in the capital program, which would mean we'd have to step down as prime and become a sub. We were more familiar than anyone with the scope of the capital program, which was now something like $52 billion. I thought it'd be real nice to get a piece of that enormous pie. Over the last three years of the contract, we devised a strategy to transition from prime to sub. We partnered with a company called Baker Engineering. We would compete for another seven-year contract with Baker as prime and McKissack as their sub.

A Black female friend of mine, Aleksandra Chancy, who owns a company called DACK Consulting Solutions, told me that she wanted DACK to be the prime on the project—meaning she was going to be one of the companies competing with Baker and McKissack. During the whole fourteen years we had run the project, DACK had been a sub working under us.

"Cheryl, I just think it's my time to do what you did," she told me.

The Black Family Who Built America

"Alex, I hear you, and I know how you feel—but the stars are not aligned for you right now. We proved we could run this contract for two years without any major prime working with us. What happened to us is not what's happening for you. You've been a sub for fourteen years, but you're not gonna just take it over." I truly understood Alex's desire to be a prime because that's the ultimate goal. After all, she runs a well-established business, but I knew this was a risk because her firm's experience could not compete against others. If I were in her shoes, this is not a risk I would have taken. But I guess McKissack makes it look easy.

But Alex didn't listen to me. She moved forward with her plan to compete against us to be the prime. And she lost. In May 2023, Baker and McKissack were once again awarded the contract. DACK would no longer be a sub. As we were going through the transition and her four workers were being moved off the job, she called me up.

"What can I do?" she asked. She said she couldn't afford to lose those four slots.

"Alex, there's nothing I can do," I said. "I'm not even the prime anymore; I'm the sub."

I had warned her that it was not a good idea to go against us, but she didn't listen. I would never purposely steer anybody in the wrong direction, especially another Black woman. I even told her that if she stuck with us, we would give her more positions. But she wanted to shoot her shot—and wound up with nothing.

My grand plan worked out very well for us. Now freed up, we started competing on contracts directly with the MTA. In the summer of 2023, in partnership with a London-based company called Turner & Townsend—they are the prime and we are the

sub—we were awarded a contract to manage project controls for the MTA. We are also competing for other extremely lucrative MTA contracts.

Interestingly, Alex partnered with our former COO, Mike Kaleda, when she unsuccessfully competed against us on the MTA contract. Several years back, Mike had left McKissack and gone to work for a company called HAKS Construction, run by a man named Husam Ahmad. Husam was an arrogant guy whose company had partnered with us on a project with the State Dormitory Authority, with HAKS as our sub. His company was growing extremely fast, which was just adding to his brashness. I decided I didn't want McKissack to partner with him anymore, but we couldn't undo our arrangement. We ran into an issue with the Dormitory Authority because Husam was charging the authority a multiplier that authority officials deemed too high. They told him he had to lower his multiplier—the amount he was charging them for each HAKS staffer on the project—but he wouldn't listen. As a result, the authority decided they wouldn't pay HAKS. For this, Husam blamed McKissack. I recall whenever I would see him at a public event, he would shout out to me from across the room, "Cheryl! When are you gonna pay us? You owe us all this money for this project!"

"When we get paid by the client, then you'll get paid," I responded.

But that's the type of person I found him to be—aggressive and uncouth. He seemingly became obsessed with poaching my staff. Michael Tolliver, who was our head of business development, came to me one day and told me he had been approached

The Black Family Who Built America

by Husam, who said to him, "Whatever Cheryl's paying you, I'll pay you ten percent more."

I wasn't pleased. "I don't get into a bidding war with people outside my company," I said. "Now, if you had come to me and said, 'Cheryl, I need an increase or whatever,' I could have entertained that. But you're coming to tell me Husam says whatever I pay, he's gonna pay 10 percent more. So then whatever I offer you, he's gonna pay 10 percent more. So you probably need to go ahead and work for him."

I let Tolliver go to HAKS—and he took one of our interns with him. On the heels of the Tolliver mess, I had another internal conflict that ultimately involved Husam as well. After joining McKissack to help us win the Barclays Center/Atlantic Yards project, Mike Kaleda did fine work with us and was appointed chief operating officer of the firm—just one step below me. A few years into his tenure, he approached me with a proposition. He said that his wife, Meryl, who was an attorney specializing in human resources, was looking for part-time work.

"Do you think we could bring her in?" he asked.

I met with her and we hit it off. I thought it was a win-win. Mike had become a major asset in many aspects of McKissack, so it would be great to keep him happy and at the same time beef up our HR services within the company with a competent person. Meryl came in first as a part-time human resources staff member, and then went full-time. She was eventually promoted to general counsel of the firm.

One day when I was talking to one of my employees, Aissatou, who runs our Harlem community outreach office, she delivered

167

some disturbing news. Aissatou and I have a special relationship; she can tell me anything.

"You know, Cheryl, the Kaledas are a problem," she said. "Most of the company works for Mike. And Meryl is their HR director and legal counsel. So if they have a complaint against Mike, how are they going to tell you about it? How are they going to tell HR about it?"

It turned out that many people had a problem with Meryl. They thought she had a tendency to be short and somewhat rude to people. Aissatou told me that she felt that the interactions were exacerbated when she was dealing with people of color—as you might guess, we had many of those at The McKissack Group. My eyes widened. *This was all going on without my knowledge?*

When I brought Meryl in, she denied that there was a problem, which I expected she would. Around this time, a new issue of our internal McKissack newsletter came out. As it was being passed around the office, it was filled with so many articles about Mike and Meryl that a few of my employees joked that we should be called "Kaleda and Kaleda" instead of McKissack & McKissack. I was busy doing business development and hadn't even seen the newsletter until somebody pointed it out to me. They had a point: My name was barely in there. I gritted my teeth, but I didn't say anything. I should add that HR was in charge of creating the newsletter.

I recall that the final straw was when Meryl had an encounter with my executive assistant, Haynes, my right hand. She reportedly demanded that Haynes do something Haynes didn't want to do. She claimed that Meryl got short with her and they exchanged a few cross words. It then seemed like Meryl proceeded to start sabotaging her in the office in instances that could be taken as little microaggressions.

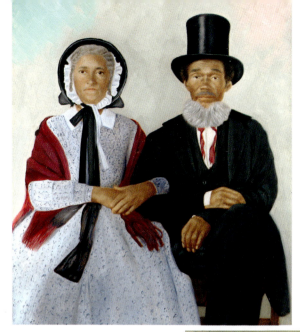

All photos courtesy of Cheryl McKissack Daniel unless otherwise noted

Moses McKissack I (enslaved brickmaker) and wife, Miriam McKissack, 1822 Comissioned by McKissack & McKissack

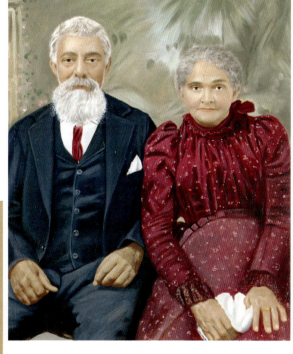

Gabriel "Moses II" McKissack (enslaved brickmaker) and wife, Dolly Maxwell McKissack, 1867 Comissioned by McKissack & McKissack

Moses McKissack III, America's first Black licensed architect, License # 117, 1922

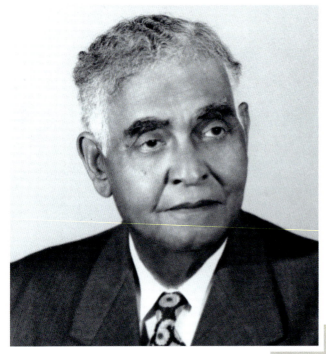

Moses McKissack III, cofounder, McKissack & McKissack, 1905

Calvin L. McKissack, cofounder, McKissack & McKissack, 1905

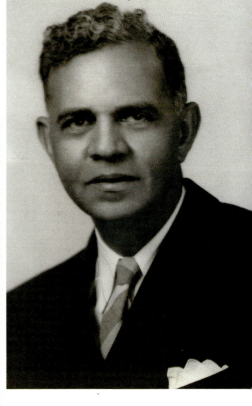

Calvin McKissack, America's second Black licensed architect, License # 118, 1922

William DeBerry McKissack, president and CEO, McKissack & McKissack, 1968

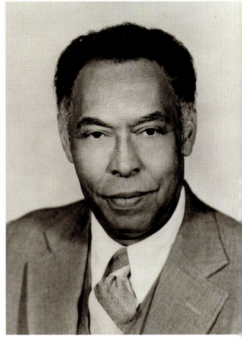

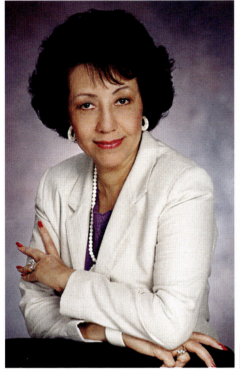

Leatrice Buchanan McKissack, president and CEO, McKissack & McKissack, 1983

Meharry Medical College

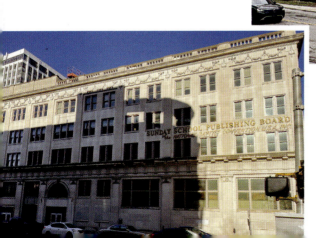

Morris Memorial Building

Capers Memorial CME Church, completed in 1925

Pearl High School, once considered the finest school for Black students in the South, had an art deco design that included terrazzo floors on the entry level.

Following Moses III's 1952 death, Nashville named McKissack Elementary School on 38th Avenue North in his honor.

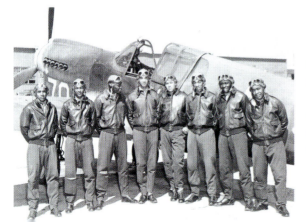

McKissack & McKissack was hired in 1942 to construct the 99th Pursuit Squadron Air Base at Tuskegee, Alabama.
United States Air Force Photo Archive

McKissack is a key partner in delivering the $11.5+ billion New Terminal One at JFK, leading design, construction, and community outreach. Spanning nearly 3 million square feet and containing twenty-three gates, the new international terminal will set standards in sustainability and customer service. As a leader in project management and MWBE engagement, McKissack is shaping the future of air travel with cutting-edge innovation and inclusive development. Gensler

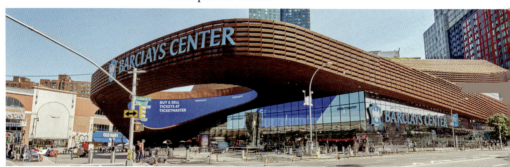

McKissack provided construction management for the $500+ million Atlantic Yards project, which included constructing a temporary rail yard, demolishing and rebuilding the Carlton Avenue Bridge, and creating a new West Portal rail link. Additionally, McKissack managed the critical infrastructure upgrades for the Barclays Center Arena, the environmental impacts, and New York City Transit Barclays Center subway connection project.

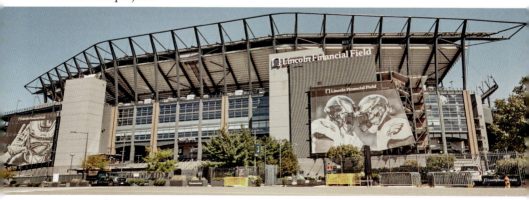

As part of a joint venture, McKissack & McKissack provided construction-management services for the $388 million NFL stadium for the Philadelphia Eagles.

McKissack & McKissack served as a major subconsultant providing construction-management services for the Oculus, the new World Trade Center transportation hub in Lower Manhattan, for the Port Authority of New York and New Jersey.

As the lead partner in a joint venture, McKissack & McKissack provided construction-management services for the Medgar Evers College School of Science, Health & Technology in Brooklyn, NY.

Shirley Chisholm Recreation Center, Brooklyn, NY. McKissack & McKissack is providing construction-management services for a $141 million recreation center of approximately 65,000 square feet to house programming for all ages.

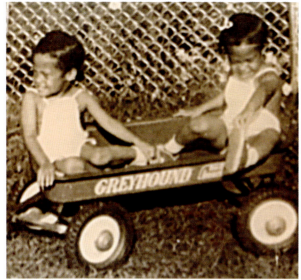

Cheryl and twin sister Deryl in their Greyhound wagon.

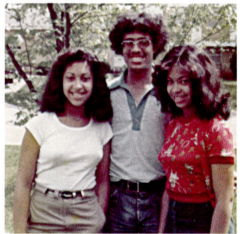

Cheryl with cousin Harold Buchanan and Deryl.

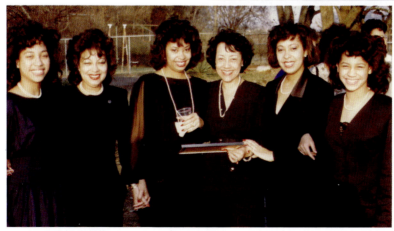

William DeBerry McKissack's funeral, December 1988.
Left to right: Shareth (Shari) Franklin Smith, Andrea McKissack Kruski, Deryl McKissack, Leatrice B. McKissack, Cheryl McKissack Daniel, Michelle Franklin.

For over fourteen years, McKissack served as the Prime Independent Engineering Consultant (IEC) to the MTA, overseeing major capital projects across its five agencies, including New York City Transit, Long Island Rail Road, Metro-North Railroad, and Bridges and Tunnels. In this role, McKissack provided expert reviews and recommendations on cost, scheduling, and risk management, helping to enhance project execution for the $54 billion MTA Capital Program. Notable oversight projects include East Side Access ($11 billion), Second Avenue Subway Phase I ($4.2 billion), and the LIRR Expansion ($2.6 billion). McKissack continues to support the MTA, leveraging its expertise in infrastructure development and project management to ensure efficient and effective delivery of the region's most critical transit initiatives. Frank Mendoza

Cheryl with her two daughters. Left to right: Deryl Felder, Cheryl McKissack Daniel, and Leah Felder.

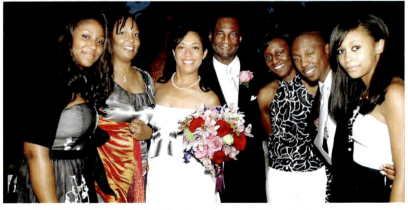

Cheryl with Dr. Samuel Daniel (husband) and children. Left to right: Deryl Felder, Joy Daniel, Cheryl, Sam, Nicole Daniel, Jerry Daniel, and Leah Felder.

The Black Family Who Built America

Things heated up to the point where one day Meryl reportedly rudely snatched papers out of Haynes's hand. I brought both of them into my office. If one of them had to go, it wasn't going to be Haynes.

"Meryl, this is a problem. I think it's time for you to consider moving on to another location," I told her.

I asked my board to help me handle this delicate situation. When we finally released Meryl, I recall that Mike came to me and said he was relieved because the stress of them working together was starting to affect his marriage. That's what he told me, but I didn't really believe him. I could tell he wasn't pleased that I had to let her go. I knew Mike's days at the firm were numbered, too.

When Meryl left McKissack, she was hired as general counsel by Husam at HAKS. I guess I shouldn't have been surprised that Husam would snatch her up. I still didn't quite understand why he was so obsessed with everything I did. Mike Tolliver called me about six months after he started working with Husam.

"Hello, Mike. How's everything going?" I said.

"Well, you know, Husam just walks into a room at a presentation and he may not have prepped before or anything," Mike said. "And the New York City DEP [Department of Environmental Protection], the DDC [Department of Design and Construction], the SCA [School Construction Authority]—they just give him projects on a silver platter."

It was clear to me that Mike, who wasn't pleased with how I had let him go, was trying to rub this in my face.

"Oh, that's nice for you, right?" I said. "Because everything I do I have to work hard for; I have to prep. I gotta work like a week before the presentation. So if he's getting it easy like that, good for him."

Well, a few years later, Husam and HAKS hit the news in a story that shed some light on how he did business. In May 2019 he pled guilty, along with his CFO, to bribery charges related to efforts to gain municipal water infrastructure contracts. A year earlier, Manhattan District Attorney Cyrus Vance had announced the indictment of a former New York City Department of Environmental Protection (DEP) manager and executives at nine engineering firms—including Husam at HAKS—on business fraud, bribery, and other charges. Vance said Husam was part of a vast scheme in which the design firms won contracts between 2007 and 2016 to maintain and expand the city's water system with information illegally obtained from the DEP manager. Prosecutors contended that the DEP manager gave the firms confidential information, such as upcoming contract schedules, nonpublic cost estimates, and details about selection committee members during contract bidding. In return, the executives allegedly gave the DEP guy $7.5 million in contracts to firms owned by his family and friends, in addition to pricey gifts to him and jobs to his relatives.

That's the world I was doing battle in, where my rivals appeared to use bribes and deals under the table to gain hidden competitive advantages. I was never going to engage in those tactics. I valued integrity, honesty, and transparency too much. As a Black woman in a white, male-dominated industry, I wanted to stay as pure as the driven snow. And I had seen over the years that the dirty players eventually either got caught or karma came along and kicked them in the head (or worse).

CHAPTER 12

The Right Kind of Monument

As I sat in the meeting and surveyed the room, I was overwhelmed by the blinding procession of white male faces. It was 2004, just three years after that horrific day when the Twin Towers fell, and we were gathered to discuss plans to build a new structure on the World Trade Center site—a giant oculus that would tower over the skyline in a breathtaking tribute to the fallen buildings and the thousands who'd fallen with them. But the room looked nothing like the city in which we sat. New York City is one of the most stunningly diverse places on earth—America's vibrant exemplar of the so-called melting pot. In this big room, there were a couple dozen white men, all heads of the biggest construction firms in the city. And there was me—the only woman and the only person of color. It all gave me a bad feeling in my stomach. This

was such an important project for the city and for the country. The room should have looked different.

Turner Construction and Tishman Construction Corporation—the company that built the original World Trade Center—had brought everyone together for a project that was sure to be many billions of dollars. I was eager for McKissack & McKissack to be on the team, but I had a difficult time figuring out how to slide my way in. Everything seemed so private, like all the decisions were happening behind doors that were closed to me. But I kept making my case to my friends at Turner. Finally, they said, okay, McKissack should be a subconsultant on this project.

I was relieved—until I found out that I would also have to convince Tishman, since it was a joint venture. We met with the people at Tishman and sold ourselves all over again. Finally, we got a thumbs-up. Our job on the project was to oversee the supplier diversity program. The goal was for 20 percent (or 30 percent) of the companies hired to build the Oculus to be MWBE firms. On a $2 billion project, that meant we were responsible for bringing in $400 (or $600) million worth of MWBE companies, which was an extremely daunting task. To pull it off, we put some of the onus on the subcontractors. If we were hiring a drywall contractor, we would tell them they had to give 20 percent of their work to MWBE companies. McKissack would then be responsible for vetting those companies to make sure they were legitimate. There were quite a few companies that had certification as WBEs, meaning women-owned, but I often found myself questioning their certification. When I looked closely, all I saw were white men.

The Black Family Who Built America

Some of the MBEs, the minority-owned companies, were the same way. I would have a hard time hiring an MWBE company that clearly was a front for white men who were the true owners. But even though they had the state certification as an MWBE, sometimes it was hard to figure out what was really going on. In a lot of cases, even though I was suspicious, I would have to live with it to get the work done.

I have to say that the certification process got a bit more rigorous after Kathy Hochul became governor of New York in 2021. She created an office for whistleblowers to report on companies that were violating the intent of the program. It's a great idea—although I'm sure most people in the industry would be afraid to call that number. You might not be eager to blow the whistle on a concrete company doing $500 million worth of work, because you can't be sure that you won't wind up wearing concrete shoes at the bottom of the East River.

In 2016, a jury convicted Larry Davis—CEO of the Canadian-based steel company DCM Erectors, which had won almost $1 billion in contracts to work on the World Trade Center—of wire fraud and conspiracy for using two companies—one headed by an Ecuadorian man and the other by a woman—to show he was subcontracting work to minority firms when David's company was actually doing the work.

Preet Bharara, US Attorney for the Southern District of New York, said in a statement after the verdict was announced, "The construction work awarded to Davis came with the obligation to employ minority- and women-owned businesses, an obligation that

Davis shirked and then lied about. We cannot allow major public projects—particularly ones on the sacred World Trade Center site—to be built on a foundation of fraud."

We were pulled into the controversy a bit, and had to turn over emails. But that's where McKissack's involvement ended.

Whereas there is a natural vetting process that occurs in fields like architecture and engineering—where getting a college degree is one of the basic barriers to entry and which adds a level of professionalism to most proceedings—construction doesn't have any of that. Anybody can start a construction business and make money. While that fact means that the field is open to anyone willing to do the work, it also can mean that the industry naturally attracts shady characters looking to take shortcuts and use whatever schemes they can conjure up to get ahead. And there are so many ways to make money on the side. We had an employee—he was not African American—who would go to the job sites on the weekends, gather all the scrap metal, and sell it. Eventually he got caught and we fired him. Getting caught and possibly going to jail is always a risk, but many of these guys are willing to take that risk.

New York's is probably the most regulated construction industry in the country, likely because of the longtime involvement of organized crime. All the owners of construction businesses have to undergo background checks and criminal checks; the results are stored on a central register called Vendex. A criminal record doesn't disqualify you from doing business with the city. You're required to disclose it, but you can still get contracts. I've had to interact with many unsavory characters over the years in this business, but I try to stay out of their way. I live by the motto, "Hear no evil; see no evil."

The Black Family Who Built America

And I have certainly seen a lot of evil. We were working on a major rebuild of the former North General Hospital in Harlem when I got a phone call late one Saturday night informing me that the construction site had been firebombed. On Sunday morning I skipped church and went to Harlem to visit the site. The target of the firebomb had been a brand-new crane, easily worth north of $6 million. The flames from the large fire had stretched four or five stories into the Harlem night sky.

When I came upon the head of the construction company that owned the crane, I was surprised by how chill he looked. If I had just lost a multimillion-dollar crane to an intentional firebombing, I would have been in a rage. But this beefy guy was walking around smiling and backslapping, like he didn't have a care in the world. He looked like the prototype of the wiseguy, as if he had just stepped off the set of a Martin Scorsese movie.

"Wow, this dude sure looks cool about losing all that money," I said to my project manager.

At the start of the project, we had encouraged the EDC to establish a community program so that Harlem residents would be able to get jobs on the site. But EDC officials rejected that idea. I guess they figured, *Hey, this is on East 121st Street, a prominent area near Marcus Garvey Park and a block from the 25th police precinct. The project will be in no danger of harm.* But we knew better. We had worked at Harlem Hospital, about fifteen blocks north. We knew what would happen if the community felt like it wasn't being included and employed—I had to have security escort me out of that hostile community meeting, the only time I'd truly felt threatened while doing my job.

Our involvement with the North General Hospital project actually came about because of my current husband, Dr. Samuel Daniel, a gastroenterologist who was president and CEO of the hospital at the time. The hospital was in grave financial trouble; it was a nonprofit whose financial model was no longer sustainable. Sam saw the hospital as a vital resource for the Harlem community, and he was desperate to figure out a way to keep it open. His idea was to team up with Mount Sinai Hospital, an exclusive, high-end hospital about twenty blocks away. Mount Sinai could send some of their Medicaid and Medicare patients to North General; North General could send some of their high-end patients to Mount Sinai. But that plan wasn't going to fly with Harlem leaders like Reverend Calvin Butts, the esteemed senior pastor at Abyssinian Baptist Church, the most important Black church in the city, who was chairman of Sam's board. They didn't want to sell this Black hospital to a white hospital, certainly not under their watch. The hospital had to close.

As CEO, my husband brought North General through bank-ruptcy and ultimately sold it to the NYC Health + Hospitals Corpo-ration. One day Sam came home and told me, "Cheryl, Bill Gilbane was in my office today. He wanted my staff to give him a tour of the building. Apparently, they're getting ready to renovate it or do something with it." He paused. "You need to get in contact with him right away."

It was one of those weird coincidences of fate that Sam even knew who Bill Gilbane was. Sam had been called in for jury duty; the case turned out to be some dispute between Gilbane Building Company and Deutsche Bank. Sam was able to get released from

The Black Family Who Built America

serving on the jury because he told the attorney that his wife did business with the defendant, Bill Gilbane.

I called up Gilbane to inquire about North General. The company had been started by the grandfather, Bill Gilbane the first; the Bill Gilbane I was talking to was the grandson, Bill Gilbane III. He and I already had a good relationship; we met on a regular basis down in Greenwich Village to talk shop. I enjoyed spending time with Bill, who is smart and funny and doesn't take himself too seriously.

"Yes, Cheryl, we got a tip from the EDC that they're going to renovate the hospital building and make it a long-term care facility, and then they're going to build a whole new building in the current parking lot," he told me. It was going to be a project in excess of $300 million.

"Well, Bill, we need a team, because my husband's going to be very influential on this," I said.

"Yes! Let's do a joint venture," Bill said.

We agreed on a 60 percent–40 percent split, with Gilbane taking the lead. As we were in the midst of putting together our team and writing up the agreement, a Gilbane exec named George Cavallo, who had previously run their Philadelphia office and now was in charge of New York, objected to the split. He wanted to give McKissack 30 percent instead of 40 percent. I had had a good relationship with him in Philly; we had worked together on several projects, such as building out several terminals in the Philadelphia airport. In Philly, we always got 30 percent; Cavallo wanted us to stay there. However, McKissack in New York wasn't the same as McKissack in Philadelphia. Firstly, I was a bigger player in New

York than I had been in Philly. Secondly, I knew that any joint venture competing on this project would likely only have 30 percent MWBE. If we wanted to distinguish ourselves and show a true commitment to diversity—something Harlem officials would be eyeing closely—we needed McKissack's number to be higher than 30 percent. I had gotten to know LaRay Brown, a brilliant Black woman who was one of the executives at New York City Health and Hospitals Corporation, which oversaw city hospitals, and I knew she was going to want a higher number than 30 percent for a project in the middle of Harlem.

George and I went back and forth over the number. I threatened to walk and go join the team Skanska Construction or Turner Construction were putting together to bid. I knew everybody wanted to work with us, so partnering with another firm wouldn't be a problem. But I wanted to work with Gilbane because they seemed to be most familiar with the EDC; after all, they had already toured the building. Finally, George relented and agreed to our 40 percent.

Gilbane assigned to the project one of their executives named Will DeCamp. Right from the start something about this guy rubbed me the wrong way. I didn't like him at all and I didn't think he had any interest in the MWBE program. It seemed like he knew he had to check the boxes, but he was not committed to it. From the start we were going at each other. Sam and I went to an event held by the New York Building Congress, a membership and advocacy group for builders in the city, and I couldn't believe that we were seated right next to DeCamp and his wife. It didn't take long for

The Black Family Who Built America

me and DeCamp to get into an argument once again, something having to do with the MWBE program.

"Cheryl, I'm friends with Black people," he said. "I served in Vietnam. I was in the hole with Black people—they protected my back!"

"Well, goddammit, we ain't in Vietnam!" I said with a snarl.

It got pretty heated. Everybody else at the table was looking a bit uncomfortable—though Sam knows me well and I'm sure wasn't surprised.

A short time after the Building Congress event, we decided to have a team kickoff dinner with Gilbane. A total of about thirty of us from the two companies got together at a restaurant in Manhattan. I was throwing back my usual martinis and feeling pretty good about the state of the world. I saw Will DeCamp also indulging in his drink of choice. Many times over. A few hours in, I looked up and realized that Will DeCamp and I were the last ones standing, along with my CFO, Kim Kules. We weren't ready for the night to end, so we headed to another bar. With our guards down, Will and I realized that we actually liked each other. This has happened to me with these white construction guys more times than I can count. When the walls come down, we can really see each other for the first time. I think there's a larger life lesson in there about the superficiality of difference—racial difference, ethnic difference, religious difference, you name it. We construct walls to protect ourselves, to act as armor when we encounter difference. But the walls usually do more harm than good.

After the firebombing of the crane, Will DeCamp, Bill Gilbane,

and I got called into a meeting with the project manager for the NYC EDC. We sat down, ready to have a discussion about the project—and were shocked when the project manager started cursing us out.

"What the fuck is happening up there?!" he said. "Why didn't you get all this straightened out?!"

"Hold on. Hold on," I responded. "We tried to do a workforce program, but EDC wasn't interested."

"I don't want to hear shit from you, Cheryl," he said. "Tell you what—your company is gonna be in the toilet if you don't fix this up. After all, you're just an MWBE."

My eyes bulged. The nerve! I wanted to leap up and grab this dude by the neck.

"Excuse me!" Will DeCamp abruptly leaped up from his chair. He pointed at the project manager. "You will never talk to this woman like that again." He paused. "Now, if you're going to continue in this vein, the three of us are gonna leave."

Pouting, the project manager said, "Well, you can leave."

The three of us turned our backs on him and walked out of the room. I was so angry, I was practically vibrating. But I was also grateful to DeCamp for standing up for me like that. Our relationship had come such a long way in a short amount of time.

When I was alone, I immediately called my political consultant, Walter McCaffrey, who was white. I told him what had transpired in the project manager's office.

"Walter, can you believe he just treated me like that?"

"Cheryl, you need to go above him," Walter said. "Talk to the deputy mayor that's over EDC. Let them know."

The Black Family Who Built America

Walter, who always gave me sound advice, unfortunately passed away two years later from injuries sustained in a car crash. He was just sixty-four.

I reached out to a coterie of folks, as did Walter, trying to make some headway with the EDC. I talked to David Kane, who was the project manager's boss at the EDC, but I could tell he didn't want to get involved.

Not long after our meeting with the project manager, the EDC got the message and decided to have a meeting with the local community board, which was overwhelmingly Black. The timing of the meeting couldn't have been worse for me. It was three weeks after I had had a surgical procedure; I wasn't supposed to work for four weeks. I could barely move, but I knew I couldn't miss this meeting. As I sat there, I was so bandaged up that I felt like I was in a straitjacket. But, honey, I'm so glad I went. The people in the audience were so upset that their community was not being adequately utilized on the site—as evidenced by all the Jersey plates they were seeing—that they lambasted the project manager as he sat on the stage. Those Black folks were really laying into him. He looked absolutely terrified. And I enjoyed every single second.

After the meeting, I got a phone call from the project manager. He apologized for cursing me out and treating my company like a bit player. Now he needed my help to put a workforce program in place. I'm always amazed by how often these things come back around. You treat a person badly and somewhere down the line you find yourself desperately needing them. Call it "karmic justice."

Because the contracts with the subcontractors had already been signed, we had a difficult time convincing them to hire from the

community. You can't go back in the contract and try to add more terms to it. As a result, McKissack wound up doing a lot of the labor on the job. That meant we had to join the union. We probably had about twenty-five laborers on the job, which is a huge expense, so we asked the EDC to cover the expense. They deposited a million dollars into our account, and we drew down on it to pay the laborers. At the end of each month we presented the EDC with an invoice showing how the money was spent. It was an unprecedented arrangement, but that's how bad the project manager, wanted to meet these goals of hiring from the community. (One of the laborers we hired was the guy who would steal the scrap metal and sell it on the weekend.)

During the project, the space we used as construction headquarters was my husband's old office at North General. It was crazy how close to home the project was for me. We pushed the construction at a rapid pace so that we could finish ahead of schedule. We did that as a favor to Mayor Bloomberg, who wanted it completed before his term ended so that he could do the ribbon cutting. In October 2013 he cut the ribbon on the new Henry J. Carter Specialty Hospital and Nursing Facility, just two months before he left office on December 31. Bloomberg had a big smile on his face for that one.

In my line of work, sometimes you have to be flexible and creative in order to succeed, because you never know what's coming at you around the next bend. One of those unexpected forces that came at us packed winds in excess of 150 miles per hour and went by the name of Hurricane Sandy. The largest hurricane ever recorded in the Atlantic, Sandy killed a total of 160 people in the

The Black Family Who Built America

United States and caused more than $65 billion in damage. In New York State, the storm caused 53 deaths, while Governor Andrew Cuomo estimated the storm's damage at $42 billion. About 100,000 residences on Long Island were destroyed or severely damaged, including 2,000 deemed uninhabitable.

And that's where we came in. Months after the storm disappeared into the Atlantic, the Obama administration was prepared to send billions in disaster aid to New York residents, but the state had to figure out whose homes were damaged enough to get checks. That job fell to the Dormitory Authority of the State of New York (DASNY), which was one of the state agencies best situated to make that determination and distribute the checks to those in need. They summoned all of the companies with which they regularly did business and asked us to get on a conference call. They told us they needed to have tens of thousands of property inspections done on Long Island and Staten Island, in upstate New York, and some in Manhattan. They asked which companies wanted to participate.

I immediately said, "We'll do it."

Brian Lyons, one of our executive vice presidents, looked at me and asked offline, "How the heck are we gonna do that?"

"I don't know, Brian, but we gotta get it done. You, me, and Albert." Albert Odjidja was another one of our executive vice presidents.

They told us that there would be a phone call every morning with the governor's office, where we all would be asked to give updates on how many inspections we had done. I hung up the phone and felt good about the call. Now we just had to go out and find inspectors.

183

The next morning I dialed into the conference call, still excited about the project. Working closely with the governor's office and getting recognition at that level was a good look for McKissack. What I didn't realize was that the other companies doing inspections had already had a two-week head start on us because they got the information before we did. And these were companies that had done this before, so they knew how the game was played.

The guy from the governor's office, one of Cuomo's top aides, started going down his list, asking each company how many inspectors they had.

"LiRo, how many people do you have out there doing inspections?"

The guy from the LiRo Group said, "Two hundred."

"URS, how many do you have?"

"Three hundred."

"McKissack, what about you?"

"Well, we just got our contract," I said. "We don't have anybody yet."

"You should be fired!" he said.

I was stunned. But there wasn't much I could say in response. It was time for us to get to work. In a hurry. Shaken by the nastiness from the governor's aide, I had Brian take the conference call the next day. Let him get yelled at instead of me—okay, not a profile in courage. We had been trying to mobilize some inspectors to work for us, but we were still trying to figure out the whole underground ecosystem of storm inspectors. On the call, when the aide asked about McKissack, Brian said we had ten inspectors—and that was an

exaggeration because we were including a few McKissack staffers. And we still hadn't completed an inspection yet.

"I don't know what you all are doing here, because you should be fired," the aide said. Again. The other companies began urging the governor's office to take inspections away from McKissack and give the inspections to them.

I knew that we couldn't come back on the third day with the same anemic response or we very well might get fired. We were an important addition to the team because they needed to have some kind of minority representation, but the aide didn't seem to care about that. The rest of that day and through the night, we hit the phones. We learned that there is a vast network of storm-recovery inspectors throughout the country, mostly located in Southern states like Texas and Louisiana that get a lot of hurricanes, tornadoes, major floods. We'd find five guys in Texas and get them to drive overnight to New York, then they'd tell us about ten more guys they knew who also do inspections, and those ten guys knew twenty more. They were like storm chasers. The other companies who were doing the inspections already knew about this ecosystem because they had done this work in the past. It was all new to McKissack.

We were also learning about the cutthroat nature of this little corner of the industry. The more inspections you got, the more dollars you would make. The other companies felt like the more business that was thrown our way, the less they would get. So they were trying to undercut us at every turn—bundling our inspections with their inspections, giving us the worst locations all the way in upstate New York.

On the call the third day, Brian was able to report that Mc-Kissack now had sixty inspectors in the field.

"Six?" one of the guys on the call said.

"No, sixty," Brian said. "Six oh." That shut everybody up real quick.

After a week and a half, we were up to three hundred inspectors out in the field. We took over a Marriott hotel in Union, New York, and rented out every hotel room, every conference room, and set up a war room that served as our headquarters. Brian was in charge of the operation. With his military background, he was the perfect person to get the troops working together smoothly. We even moved our accounting department out there so that we could get our invoices submitted efficiently and get everyone paid on time. It was supposed to be a two- or three-month assignment to do between six thousand and seven thousand inspections, but we wound up doing fifteen thousand houses—three hundred inspectors doing ten inspections a day. Our inspectors would verify the damage that the homeowners had claimed on their application and detail the things FEMA would pay for and the things FEMA wouldn't pay for. Governor Cuomo wanted to get money in the hands of residents as soon as possible. Many of them couldn't even live in their houses. There was a gubernatorial election coming up in 2014; I'm sure that had something to do with the urgency of the governor's office. The governor's aide running the show was a real taskmaster—mean and uncompromising.

At 7:00 a.m., Brian would give each group of inspectors their assignments for the day and they would disperse across Long Island and other parts of the state. He would tell them to check

The Black Family Who Built America

in at noon to chart their progress. For the most part, the operation went well, though there were some hiccups. Unfortunately, one of them involved Governor Cuomo's aunt. I mean, if you're gonna screw up, you might as well do it in the most high-profile way possible, right? One of our inspectors was a Black guy from the Deep South, I believe Louisiana, and his heavy drawl was not quite comprehensible to the average New Yorker. He was a country boy severely lacking in sophistication or home training. This guy was supposed to inspect the house of Cuomo's aunt. The first time he knocked on her door, he showed up late, which annoyed her to no end. When she let him in, he walked into her house with muddy shoes and tracked dirt all over her house. After they did inspections, the inspectors would go back to the war room at the hotel to write up the report on the estimating software—but if the report was missing something the software wouldn't allow you to submit it. This guy had to return to the aunt's house over and over because he kept forgetting stuff. The aunt was so incensed that she called the governor to complain.

In government, like many things in life, shit slides downhill, so the governor's outrage quickly got transferred to the governor's aide. He called down to Long Island and said he wanted McKissack & McKissack fired. We needed to fight back, but first Brian had to figure out what happened. He marched into the war room and started calling out the inspector's name, asking if he was there. This poor guy raised his hand.

"Let me ask you something," Brian said to him. "Did you do the inspection at this address?"

He gave the guy an address. The guy nodded his head.

187

"Did you go back to this house three different times?" Brian asked.

"No, sir, I did not," the guy said.

"Well, we got a report here saying you kept going back."

"I did not go back there three times, sir," the guy said. "I went back there twelve times."

Brian's head practically exploded. He asked the guy what happened the last time he went back. It took a minute for Brian to figure out what the guy was talking about, but when Brian finally did, he couldn't help but laugh out loud. Apparently, he needed to go in the woman's bedroom to find the dirt line and take a picture of it to show how high the floodwater had gotten. But when he tried to explain this to the aunt—that he needed to go into her bedroom and look at something dirty—she thought he was being inappropriately fresh with her. She promptly threw the guy out of her house and immediately called her nephew.

Oh my God, it was a hilarious story—but it turned into a big mess that I had to clean up. To assuage the governor's office, I had to promise to train our people in etiquette and customer service. The problem was, when you hire hundreds of inspectors overnight, your quality control flies out the window. We had one "disadvantaged business enterprise" (DBE)—a term that was created to give small businesses owned and controlled by socially and economically disadvantaged individuals a fair opportunity to compete for federal contracts—whose inspectors were doing an awful job. One morning in the war room, Brian had all the inspectors from that company stand up.

"You're all fired," Brian barked.

The Black Family Who Built America

As I said, he was running a military-style operation out there.

The other companies never stopped coming for us. At one point the governor's office told us that McKissack inspectors were getting the most complaints in calls to the governor's hotline. That didn't sound right to us, so we decided to do some digging on our own. Brian and his team figured out who was the person taking these calls and logging McKissack as the guilty party. They got the guy in a room and he eventually told them that he was employed by one of our competitor firms—and he was being told to check the McKissack box when the complaints were actually about his company's inspectors. Real nasty stuff. If you screw up long enough, you're going to get caught.

It was a challenging undertaking, but it was definitely worthwhile for McKissack. We turned a considerable profit with the storm recovery project. The governor's office created the Governor's Office of Storm Recovery (GOSR) to deal with this issue going forward. Because they were pleased with our work, we got the opportunity to compete against the larger firms for a major long-term contract to maintain these damaged properties. I had a meeting with Jamie Rubin, the guy who was put in charge of GOSR, to feel him out. Jamie was a smart, smooth operator, a man of few words, but someone I knew would be willing to listen. I told him the governor should do something different and innovative with this contract—such as have a minority firm as prime. He told me it was something worth considering. He said they would select four teams to do the work, and encouraged me to respond to the RFP that would be coming out soon. We submitted a bid as a prime and actually won the contract, beating out larger

firms who were vying for the prime position. It was an exciting moment for McKissack.

We were given all of Staten Island, about three hundred properties that we were to maintain. Once we demonstrated we could effectively handle those, we prodded them for more, so they started giving us properties on Long Island as well. It wound up being a lucrative contract for us that continued for years. Our role was essentially as a general contractor—hiring crews to do landscaping, pour concrete, whatever needed to be done to keep these damaged properties from falling into disrepair. It wasn't traditional work for us or any of the other firms. But it highlighted my firm's adaptability. We weren't one of the biggest firms, by any means, but we didn't shy away from any jobs—and we always figured out a way to thrive once we took them on. It's what we did at Barclays Center with the Atlantic Yards rail station, what we did in Harlem with both Harlem Hospital and the Henry J. Carter Specialty Hospital and Nursing Facility, what we did with the University of Pennsylvania Perelman Center for Advanced Medicine. I thought of it as a continuation of what my father, my uncle, my grandfather, my great-uncle, my great-grandfather, and all the other McKissacks had done as they built this family business over the decades. They had never built an airfield when they took on the project to build the Tuskegee Army Airfield for the Tuskegee Airmen in 1942, but they accepted the challenged and thrived—winning the prestigious Spaulding Award from President Roosevelt as the top Black business in the country.

Sometimes, though, despite your best efforts and intentions, a project turns into a perfect storm of misery. That's what happened when we were contracted to help build a new library for Hunter

The Black Family Who Built America

College in Manhattan. Hunter College is a prestigious public university in New York, part of the CUNY system, that has been around since 1870, when it was founded as a women's college. From the start the project had bad bones—a bad architect, a bad McKissack team, and a bad client. The architect had only done residential jobs prior to this. I'm not sure how he got this job; I think he probably knew the right people. Now he was tasked to design a state-of-the-art library for the college, which would be filled with a lot of cutting-edge technology. The architectural documents were very poorly crafted, which meant the project was starting out with a shaky foundation. I soon discovered the project manager we assigned to it was not up to the job. I don't know if he was an alcoholic or what his problem was, but he was a white guy who hadn't been working for us that long and he just couldn't seem to get it together.

And then there was Hunter College. They kept throwing shade at us, questioning our ability to finish the job. It got so bad that I had to call my old friend Jim KcKenna at Hunter Roberts.

"Jim, I need your help," I told him. "Do you think you could lend me somebody really good, just to come in and fix everything that my project manager is doing?"

The client felt better when the Hunter Roberts guy joined the team because there was now a big white firm acting as a backstop to us. What the Hunter Roberts guy told us confirmed what we already suspected—the job was a mess. Our estimate for our costs on the project turned out to be off by at least $700,000. We wound up losing $1 million on a $3 million project. You have to work really hard to do that. We were able to drag the project across the

finish line, but it sure as hell caused us a lot of pain. I always knew it was important to have the right project manager on a job, but that point was driven home with this one, kicking us in the head in the process.

The Hunter College library served as a symbol of a lot of things that were going wrong for McKissack during this period. We were securing contracts but somehow losing money. We had bad projects going in New York and even more bad projects in Philly. We lost money on a senior center that we were constructing in Philly; our contract was taken over by another contractor toward the end. We were embroiled in a lawsuit on another project in Philly. On top of that, I had an incompetent CFO who hadn't paid our payroll taxes, and we owed the IRS more than a million dollars. Everything was imploding at the same time.

I walked into an unpleasant meeting with my board in January 2014 and had to give them a report on our financials. We had more than a million dollars negative retained earnings—the amount of the loss exceeded the amount of profit—against revenues of $104 million. That was the highest our revenue had ever been, yet we were deep in a hole. One of my board members, David Oellerich, said something to me that day that I never forgot: "Revenues kill. Profits thrill."

It was a pivotal moment in the long, storied history of McKissack & McKissack. Would I be able to make moves to get us back on the right track? Clearly, growth isn't always a good thing if it's not managed right. How was I going to rescue this sinking ship? After more than a century in business, after more than two centuries of McKissacks building in America, I couldn't let this whole thing collapse on my watch.

The Black Family Who Built America

The meeting with my bank, Firstrust in Philadelphia, went about as well as I could have hoped. I was relieved that they didn't put us through a "workout," which means that the lender believes you may not be able to pay your debt and might even close your account and force you to find financing elsewhere. That would have been the worst-case scenario. Instead, Firstrust put us in a probationary status. When they do that, two things happen: They charge you more money for your money—a lot more money—and they make you hire a consultant to help you crawl out of the hole you've fallen into. So here we were in dire financial straits and my bank was requiring me to hire a $10,000-a-month consultant. That was painful. Even more painful was our decision to lay off sixty people. I let my executive VP in Philly, who had caused all the problems, leave McKissack and spin off into his own company, taking some of our projects with him. I felt he had made so many mistakes that it was a relief to get rid of him. It mirrored moves my mom had made years earlier when she was trying to save the company. In addition, I worked my ass off to bring in more work. That's the beauty of New York—it can be a tough place, but it's so big that there's always plenty of opportunity out there.

Over the next several years, our fortune slowly began to turn. With hard work and strong projects, we were able to put McKissack solidly back in the black. We had been more than $6 million in debt; we were able to get that number down to zero. In fact, Firstrust was so impressed by our turnaround that they made me their poster child for how to turn a struggling company around. They actually sent me out on the speaking circuit to talk about how we did it and to offer advice to others. When I think about the awful conditions

we faced in 2015 and where we are today, I'm frankly amazed at the turnaround myself.

But the intense effort to reverse the company's fortune did not come without a steep price. I paid those wages on a fateful day at the end of August 2016—a day that started like any other, but that would end "in infamy," to borrow a phrase from Franklin Roosevelt.

When I opened my eyes that morning, I had no idea what was coming my way.

CHAPTER 13

I'm a Survivor

The first thing I see is my husband Sam, his beautiful face resting on the pillow next to me, chocolate and chiseled. *Damn, he is fine,* I think to myself. *He has put up with so much over the last several years—dealing with his elderly mom, who doesn't even recognize him anymore as a result of her dementia, and helping me with my eighty-five-year-old mother, who truly considers him a son. I think my mom believes he's her personal doctor.* She had done battle with breast cancer, a TIA (transient ischemic attack, also called a *ministroke*) to the brain, and severe arthritis in her knee. In addition to the two moms, he had to grapple with the mental health challenges of our twenty-year-old daughter. But as I look at him this morning, my primary thought is that all the hardship is over now. *This is the end of our struggle. It's only up from here!*

It's still only 7:00 a.m. This should be an easy day for me. All I

have to do is get a physical, spend some time in the office, and go work out with my fine trainer, Tony. Everybody's still on vacation in the office. Hallelujah! That's why I love the end of August. It's the calm before the post–Labor Day storm.

As usual, Sam struggles to leave the pillow. But once he's up, he jumps out of bed with purpose. He leaves the bedroom and heads to the kitchen to make coffee. That's why I love, love, love this great man—he does all the cooking and pays all the bills and just takes great care of me and our family. At 8:45 a.m. sharp, Sam's driver is waiting outside to take him to work. Right on schedule. A graduate of Columbia University Vagelos College of Physicians and Surgeons (known to insiders as P&S), Sam is one of the top gastroenterologists in the city. I jokingly tell people, "Sam looks at assholes all day; I work with them."

"Cheryl, don't drink too much coffee today," Sam calls out to me before he leaves. "Don't forget—you have to get your blood pressure taken." He knows my routine—and my adoring relationship with my morning coffee. He made sure I have the best cardiologist in the city, Dr. Del Guzzo, one of his classmates from P&S. My appointment isn't until ten fifteen; I have plenty of time to get dressed.

I slip into my morning routine: meditate, pray, read the Bible. I get on my regular prayer call with my friend Raina. Thank God for Raina. Many years ago I prayed that God would bring me a Christian friend who was down to earth—someone I could relate to, who would not judge my actions, and who would see the good and the potential that God has placed within me. Raina was the perfect answer to my prayers. Also, a Christian who indulges in

The Black Family Who Built America

an occasional glass of wine wouldn't hurt either. I feel like I can talk to her about anything and everything. We usually pray every morning at 8:00 a.m. but because of her recent knee replacement we had made our time a little later. I was feeling pretty good about my health so we don't even include my physical in the prayers.

I stride into my closet to begin the process of getting dressed, which at fifty-five, takes far longer than it used to. The clothes coordination alone—the right underwear, outfit, shoes, bag—can be overwhelming. Then there's the makeup. While I'm getting dressed, I turn on CBS every morning to look to Gayle King for inspiration and intellectual stimulation. Sam turned me on to her. She gives me the real scoop on what's happening in the world—plus her clothes are impeccable. Thank God for Mark, my stylist, who has my wardrobe under complete control. He arranged my closet to be color coordinated, ordered in various color capsules, from dresses to suits to matching pocketbooks and shoes. Without any effort, I can walk into my closet, select an outfit created by Mark, and walk out looking like I stepped off the pages of *Vogue*. This year it's Gucci designed by Alexandro Michele—three-inch platforms and six-inch heels in nautical colors. Mark loves to use his creative mind to make my dressing every morning as effortless as possible.

I grab my beautiful purple Yves Saint Laurent dress because it will be easy to take on and off at the doctor's. Purple is a grand, royal color. I love matching the YSL dress with my Fendi two-tone red bag and purple Fendi sandals with a red-and-brown symmetrical heel and yellow straps. As I slip them on, I can hear Hanukah (Mark's nickname) calling out, "Simple and super chic. Mazel tov!" I would have to agree. I like what I see in the mirror. With my weave in

Cheryl McKissack Daniel

place, I don't look a day over forty-five. I consider myself extremely blessed not to be on any medications at my age. Sam always says if you make it to sixty-five without any major medical conditions, you are going to live a very long time. I think I'm going to make it over the hump. I am actually looking forward to the doctor visit so he can tell me how healthy I am.

I know I should eat some breakfast to balance out the coffee, but I don't have time. Personally, I think breakfast is overrated anyway. I would much rather use those calories on a martini tonight. I text Wade, my driver, to let him know I'm on my way downstairs.

"Good morning," I tell Wade as I slide into the car. I wonder if he took the time to look at my schedule to know where the hell he's going today.

"Okay, where are we headed this morning?" he asks.

That would be a *No, he didn't check*. I'm a bit annoyed—don't I pay him enough to at least look at my schedule each morning? Anyway, I don't feel like sweating the small stuff.

"Dr. Del Guzzo's office," I say.

I start answering my email as he drives, so I'm not paying attention to which way he's headed. When he announces that we have arrived, I look up.

"Oh shoot, it's the wrong location! Del Guzzo moved."

Del Guzzo had left Mount Sinai and moved to New York University, so his office location changed from Columbus Circle to 555 Madison Avenue—about twenty minutes away in New York traffic. What is wrong with Wade? All he had to do was look at my schedule to get the correct address. My assistant, Lola, is always on point. Now I'm going to be late!

198

The Black Family Who Built America

Why am I always running late? I hate it. I must have gotten it from my mother. Watching her as I was growing up, I noticed she would always leave at the time she was supposed to be there—and invariably blame something or someone for making her late. Then she'd say, "Damn, why am I always rushing? I can't stand to be late." The whole routine was always puzzling to me. How can you get somewhere on time if you're leaving at the time you're supposed to be there? And she truly hated to be late. When I was younger, I thought she was hard to understand—and now here I am doing the same thing. I've known Del Guzzo for years; he's known Sam much longer. He'll understand.

Oh my God, I'm sounding more and more like my mother.

As I walk into the new location on Fifty-fifth Street and Madison Avenue, I am impressed. What a beautiful building. NYU is on the move. If you have to go to see a doctor, this certainly is a lovely place to do it. I must admit, I feel terrific today. I don't recognize these new faces at the front desk. *Who are these people?* I look around. Okay, there's Carmen, Del Guzzo's assistant. I like Carmen—she and I have a lot in common. We both got tummy tucks from the same doctor, Karpinski on Fifty-Ninth Street. He did a terrific job; we're always comparing notes.

"Hi, Carmen, how are you doing?" I say, leaning over the reception desk. "It's been a while. I hope you like your new office. I think it's absolutely beautiful." The receptionist hands me a stack of forms. "I'll catch up with you in a few minutes, Carmen."

Why do you have to fill out the same basic information every time you go to the doctor? It's infuriating. I don't want to be bothered with all of this. Isn't all of this info on the internet somewhere?

I look around in the waiting room and play my usual game of wondering which patients have serious heart problems.

I'm relieved when I finally get to the examination room. "Cheryl, you look terrific!" Carmen says. "You look so young. And what a beautiful purple dress! I love it. We are matching today with my purple NYU outfit." She looks at me. "You know we got to take your weight," she says. I ask if I can do a urine sample first—anything to shed a couple of ounces before getting on the scale. Weight has always been a battle for me. For some reason today I feel particularly big.

I step on the scale when I return from the restroom. "I'm about 160," I tell her. But the scale reads 171.

"It must be the clothes! Can I take them off?"

Carmen chuckles. Of course I can't. But she always gets a kick out of me asking—she says she does the same when she goes to the doctor. Carmen takes my blood pressure on my left arm. She makes a face. I can tell that means it's not good.

"Let's try the other arm. Maybe you were a little nervous about coming to the doctor," she says. Again, she looks disappointed with the right arm. She says it's 160/100.

"I'll give you a few minutes," she says, leaving the room.

Dr. Del Guzzo walks in soon after. He's a handsome Italian man, wearing a crisp white shirt, an expensive tie, and, of course, the perfectly starched white doctor's coat. He has a warm bedside manner—polished, intelligent, highly competent. It's funny how far the Columbia degree goes in assuring me I'm in good hands. It reminds me of one of Sam's jokes. "What do you call a med student that graduated with all C's?" he asks. With a grin, he delivers the answer, "Doctor." Clearly, Del Guzzo isn't in that category.

The Black Family Who Built America

"Cheryl, you look terrific," he says. "You are getting younger looking each year." He knows just what to say. I'm hoping he means it—though I have to admit that with my new weave, flat-ironed straight as a bone, and my youthful skin inherited from Mom, I do look and feel younger than my age.

"I love that purple dress," the doctor continues. "You are color coordinated with NYU purple. And those shoes. But I wouldn't expect anything less from you."

I'm a bit startled by all the compliments. But this wardrobe cost a fortune—I better look like I'm bringing it every day!

After I answer a few of his routine questions, the doctor says, "Well, let's listen to your heart. How's that murmur?"

At the age of thirty, I was diagnosed with a bicuspid aortic valve disorder. The normal valve has three flaps to separate the aorta, but mine only has two flaps. At first this news was devastating, because it meant the possibility that at some point in my life my valve would require replacement. But over time, after yearly echocardiograms and no deterioration of the valve, I assumed—like most of my challenges in life—once again I was required to do more with less.

Del Guzzo comes close and listens to my heart.

"The murmur is still there," he says.

Darn, I was hoping it would miraculously disappear. I guess not yet. In God's perfect time.

"But it sounds like the functionality of the heart is good," he adds.

What the hell does that mean?

Building up the courage, I ask, "What does that mean?"

"The valve is closing completely, and blood is not leaking into the chamber. So I don't hear the swishing sound indicating blood is left in the chamber. Your bicuspid valve is operating efficiently—like a normal valve."

That was like a beautiful symphony to my ears. Producing more with less had become an art form for me—running a century-old Black- and woman-owned construction business in one of the most important cities in the world. Doing more with less—*I hope the same is true this week when it's time for payroll*, I think, chuckling to myself.

"You still need to schedule the echocardiogram just to make sure everything is good," Del Guzzo continues.

"Will do, Doctor!"

"Carmen can give you the EKG right now, followed by your blood work. But let's check out your blood pressure. Carmen indicated it was high."

Reluctantly, I hand over my left arm. As Del Guzzo approaches, that white coat makes me so nervous. All I can think about is the coffee Sam told me not to drink earlier that morning—and I drank it anyway. Damn, my blood pressure is 150/102. Del Guzzo tells me not to worry—come back next week and they can check it again.

"I'm sure you are fine," he says.

Carmen completes my EKG, which is perfect. After I give some blood for them to test, I rush out of there and head to the office. Thank God I am in good health. Now I can thoroughly kick some ass in the office.

On the way to the office, I exchange texts with my trainer, agreeing to meet him at six thirty at the gym on Sixty-Third Street.

The Black Family Who Built America

I get through the rest of the shortened day. By two minutes after six, I'm rushing out of the office, knowing I am going to be late. I slide into the back seat of the car. I have one more call on my log today—to tell Jeff that I have to reduce his company's role on our MTA contract. Not looking forward to that one.

Thank God Wade is in front of the building; one less thing to worry about. I stare at the car on the other side of seemingly hundreds of people barreling down the sidewalk blocking my way. Nothing like rush-hour sidewalk traffic in Manhattan—millions of souls trying to get somewhere with no regard for who they have to push out of the way to get there. To weave and push through them without getting knocked down, I feel like I need to be an NFL running back.

I finally get to the car without incident. I text Tony after I jump into the car.

Running 19 minutes late

Okay, he texts back.

Damn, I always hit the nine instead of the zero. I meant to say 10 minutes. Oh well, I certainly can use the extra time. I get on the phone with one of my employees, Aissatou—and realize calling her is a mistake. She's one of those people who can never hang up. At least twenty times she'll say, "Before I let you go, one more thing . . ." But I really need to speak to her to close the loop on our Camden client; I just have to plan my exit. During our discussion, I see I have another call coming in, from my assistant, Lola. Just in the nick of time.

"Aissatou, I have to take this."

As soon as I pick up with Lola, I regret taking her call.

"You received a very important call from the bank," she says. "They want to speak to you right away."

My body tenses up. My adrenal glands go into overdrive and I start feeling what I assume is the onslaught of a serious menopausal hot flash. An emergency call from my bank can't be good news. Unfortunately, bad news is the only kind I've been getting during the past year or so. I can hear my mother's words in my ear. "Cheryl, you gotta wear this business like a loose garment and not let it get to you." I can also hear the motivational speaker Brian Tracy telling me, "Don't procrastinate—do it now!"

I take the advice of both: I loosen my clothes, which had been tight as hell all day, and I call my banker. As the phone is ringing, sweat is building up on my forehead. I can feel the weight of all $5 million I owe the bank resting heavily on my shoulders. It was just too much to carry. I start my mantra: *God is good, He will never let me be ashamed. Cast your cares on the Lord and He will lighten your burdens.*

As I am talking to myself to calm down, I get my banker's voicemail. Hallelujah, saved by voicemail! I dodged that bullet for a few hours. All I have to do is try not to have a heart attack thinking about the inevitable conversation.

Wade and I are making good time up Sixth Avenue. Usually, it only takes fifteen to twenty minutes to get to my apartment—where I will change my clothes and walk to the sports club to meet Tony—so I have about ten minutes to finish the calls I need to make. All of them would easily take an hour, so I've got to prioritize. I fumble through my messages and decide I need to call Jeff and deliver the bad news about his contract with McKissack.

The Black Family Who Built America

As I talk to him and explain that I need to reduce his company's role, my arm drops. I try to lift it back up. It won't move.

I know right away what's wrong. I am having a stroke.

"Jeff? I got to go. I will talk to you later. Oh my God. Bye."

I call up to my driver, trying to keep my voice calm.

"Wade, take me straight to the emergency room at Roosevelt Hospital. Get Sam on the phone right now and tell him I am having a stroke. Oh my God! Oh my God! Please hurry!"

I text Tony.

Me: I can't move my arm and I have no feeling in it. I am heading to the emergency room.

Tony: OMG, which hospital? I will meet you there.

When we get to the hospital, we see that the traffic isn't moving heading to the entrance on Tenth Avenue. A truck is blocking the traffic. Wade drives down to the next street, but it's one way heading in the wrong direction to get us to the hospital. Wade doesn't care—he drives in reverse all the way down the street to the emergency room entrance. I get out and run into emergency in my high heels, with my arm hanging limply at my side. I am a regular at the hospital because I frequently bring in my daughter Leah.

"Where's your daughter?" the woman at the intake desk asks.

"It's not my daughter; it's me," I say. I tell her that I think I'm having a stroke.

"Oh my God—let's put you in a room," she says.

I can talk normally, but I can't move my hand. When they ask me to touch my face, I can't do it. When the resident comes in, he's already on the phone with a neurologist. She's telling him what questions to ask me, such as how it started and whether I can move

205

limbs. They want to give me the special drug to dissolve clots, like a Roto-Rooter, but my blood pressure is too high. If you take the drug when your pressure is too high, the vessels in your brain could burst. By now, my husband Sam has arrived. And it's a good thing because I am absolutely terrified. I'm trembling uncontrollably and I can't stop. They give me something to calm me down and lower my pressure. After about thirty minutes or so, they think my pressure might be low enough to take the clot-dissolving drug, but they're not 100 percent certain.

"What do you want to do?" they ask me. "Should we inject it now? Or do you want to wait longer?"

Sam and I look at each other. "Inject it," he says.

As they're injecting the drug, I'm thinking, *I'm really about to die, huh?* Then I feel a warmness flow down my arm. I could feel the drug entering my body. Slowly but surely, I am able to move my fingers, and then my arm. Within a minute, I have full recovery of my arm. It truly feels like a miracle; I'm in disbelief. Once they get me stable, they begin to run a bunch of tests. They do a CT scan and an MRI. We see the shower of clots that went to my head and caused the damage in my arm. They're small clots, which is why they only affected my arm.

It begins to sink in that I just had a stroke. I'm close to the same age as my father was when he had his stroke. Maybe I share a lot of his genetics.

Over the next three days, they're monitoring me to make sure I don't have another stroke and the clots are fully dissolved. As I'm lying in the bed, a beautiful Black woman sweeps into my room, wearing a gorgeous and stylish flowery dress. She is also wearing

The Black Family Who Built America

black lace gloves, which immediately drews my attention. *Wow, she's lovely,* I think to myself. Her name is Carolyn Brockington and she's the neurologist who had been advising the resident over the phone when I was first admitted. The words coming out of her mouth do not correlate with how she looks—she has the appearance of a wealthy woman going to a ladies' luncheon at Saks, not a doctor. She's actually the director of the Mount Sinai Stroke Centers. She explains to me everything that happened to my body and how they treated it.

They never got to the bottom of what caused the stroke, but I assume it was my related to bicuspid aortic valve disorder. Years later, I am now at the stage where the valve has to be repaired. That means open-heart surgery. They will have to open my chest and stop my heart. The thought is terrifying, but I know I'll deal with it. If there's one thing I've learned over the decades, it's that I'm tough. I'm a survivor. I'm a McKissack.

CHAPTER 14

Strange Bedfellows

It all started with a fairly innocuous call in midsummer of 2014, from a guy I had recently met named Michael. *Hmm. What could he be calling me about?*

"Cheryl, I have an opportunity for you that is out of this world! But you're going to have to trust me," he said.

Talk about an opening line. Immediately, I was intrigued.

"Okaaay. What's the opportunity?"

"Well, I work with Saudi Arabians," he said. "The company I work with is the largest construction company in the world. And they want to meet with you."

"Really?"

"The problem is, the meeting's in London," he continued. "In about a week. I can't tell you who you're meeting there. You just have to trust me."

The Black Family Who Built America

"You mean, I gotta drop everything and be in London next week?"

"Yes," he said.

I thought on it for a second. Michael was a young white dude who seemed pretty solid to me. I didn't think he would lead me astray. I agreed to go to London.

However, I didn't want to jump across the pond by myself, so I called my twin sister.

"Deryl, I would love for you to go with me to London to meet these people," I said. "I don't know who they are. I don't know what to expect. But I know one thing: If we go together, we'll have a good time!"

Deryl didn't even hesitate. "I'm going," she said.

At the start of the next week, we were on a plane to the UK. We stayed at a hotel in downtown London, but we found out the meeting was to be held in Hampshire, about an hour outside of London. They had a car pick us up; we relished the views of the lush, gorgeous British countryside on the way. Our meeting in Hampshire was taking place at the Four Seasons Hotel. When we drove up, the hotel looked like some grand castle from the Victorian era. There was a beautiful dog sitting out front, giving it all the appearance of a scene from *The Crown* or *Downton Abbey*. The place was dripping with high-end opulence, with a fleet of Mercedes Benzes and exotic cars lined up outside.

As we entered the hotel, Deryl and I still had no idea who we were about to meet. My friend Michael was leading the way, still tight-lipped about it all. Right before we walked into a random room, Michael turned to me.

209

"Now, Cheryl, you don't shake his hand unless he shakes your hand," he said.

What in the world?

"Who are we about to meet?" I asked again.

"Saad bin Laden," Michael said.

"Bin Laden? Like, *bin Laden*, bin Laden?"

"Yes. Osama bin Laden's brother," he said.

My head was spinning. I had a million questions, but no time to process any more thoughts because the door swung open. I saw several men dressed in regular Western business suits. One of them stepped forward with his hand extended. *My God, he's gorgeous*, I thought. He was immediately charming, greeting us with a warm smile. This was Saad bin Laden.

At the time, the Saudi Binladin Group, the business owned by the family, was the largest construction company in the Middle East and one of the richest in the world, with billions in contracts. The family's patriarch was Mohammed bin Awad bin Laden, who started the construction company in 1930 and grew it into a billion-dollar business after forging close relationships with the Saudi royal family, particularly Prince Faisal. When Faisal became king, he issued a royal decree awarding all future construction projects to bin Laden's company, allowing the business to eventually amass more than $5 billion in assets.

Before he died in 1967, Mohammed was married twenty-two times and had fifty-four children. His seventeenth child was the world-renowned terrorist Osama bin Laden, son of Hamida al-Attas, Mohammed's eleventh child, from Syria. According to Saudi custom, men are allowed to take up to four wives at a time.

The Black Family Who Built America

While Mohammed's first three wives largely remained stable, he frequently divorced his fourth wife and remarried over and over. He divorced Osama's mother shortly after Osama was born in 1957.

When Mohammed died, his son Salem bin Laden succeeded him as head of the family business. After Salem died in a plane crash in 1988, leadership of the company was turned over to another of Mohammed's sons, Bakr bin Laden.

The Saad bin Laden who greeted me that day at the Four Seasons was another of Mohammed's sons; he was the brother of Bakr bin Laden. Saad and Bakr had a different mother than Osama. According to published reports, Mohammed's wives all lived in separate homes with their children; Mohammed preferred to visit them in their homes. Saad likely hadn't spent much time around Osama growing up.

As we sat down, Saad was accompanied by one of his engineers, Zuhair Hashim, who was married to Saad's sister Sana. Zuhair, who we called Dr. Z, was Michael's connection to Saad. Dr. Z had graduated from Manhattan College in New York, and we knew a lot of the same people; he was familiar with the work of McKissack & McKissack. His presence was very calming for me and eased much of my anxiety. Saad felt a bit distant, almost untouchable, like he was Saudi royalty himself. He was a man of very few words; he sat and observed everything while rolling these beads around in his fingers. The beads were brown and looked almost like rosary beads. Saad didn't have to do much talking because Deryl, filled with nervous energy, did most of the talking for all of us. She was going on about all the things she had designed, all the projects her company had done.

Though I was the one who had been invited to the meeting, I told Deryl that if it amounted to something interesting, we could work together. While we had not had many collaborations in the United States, I figured it would be okay to work with Deryl on this venture. Besides, I felt like I needed backup at the meeting; I didn't want to be there by myself. And she did design while I did construction, so we weren't competitors. In fact, Deryl had her company pull together a beautiful glossy book showing off their work. This was the kind of fancy presentation architects did all the time. We added information about The McKissack Group construction projects to the book to look like we were a united front.

I could tell my sister was very tired, which I think somehow made her even more talkative. After she had gone on awhile, Saad turned to me.

"Okay, tell me about you," he said.

"Well, in New York, we—"

He cut me off mid-sentence.

"Ahh, New York," he said wistfully. "I miss New York so much. They won't let us come back. I can never go back to New York." He smiled at me. "If you come back here, just bring me anything from New York." (On our next trip, we brought him a New York Yankees baseball cap and a small replica of the Empire State Building.)

Saad and Dr. Z told us they were building eleven soccer stadiums for the 2022 World Cup that would be taking place eight years later in Qatar. Qatar is a small oil-rich nation just to the east of Saudi Arabia, whose vast land mass dwarfs all the other countries in the region. They were interviewing companies with stadium-building

The Black Family Who Built America

expertise to help the Saudi Binladin Group finish in time for the World Cup eight years later.

At some point during the two-hour meeting, Deryl—the DC resident—mentioned that she could use her White House contacts to secure a letter from President Obama. Saad liked the sound of that; the Saudis were excited about anything that could illustrate a strong bond with the United States.

When we got back to our London hotel later that day, Deryl and I were ready to do some damage in London. The place felt even more like New York than the last time I had been there, with great restaurants and exciting nightlife. We truly had a ball. A couple weeks after I returned home, I got a call from Dr. Z over the Labor Day weekend, telling me that he needed me to meet Saad in Dubai. In two days. I was not pleased, but I couldn't protest too loudly, especially if there was going to be big business for McKissack at the end of this odyssey. I called Brian Lyons, my senior vice president.

"Brian, you've got to come to Dubai with me," I said. "And I have no idea what's going to happen when we get there."

We caught a late-night flight and both of us slept for most of the fourteen hours on those fancy first-class seats that fold out into beds. When we woke up—me without makeup and Brian with his hair sticking up in crazy directions—I looked at him and smiled.

"Brian, you're the first employee I ever slept with." We both laughed.

After we arrived at our hotel, we were told that we would be meeting Saad at 10:00 a.m., which didn't give us much time to get ready. We got to the room where the meeting was to take place and

we waited. And waited. And waited. At one point Brian decided to go look for some flip charts to use for our presentation. While he was wandering around in the halls, he saw that there were other firms that also were waiting. He spotted a French firm and a Spanish firm.

"Cheryl, there are two other contractors in rooms down there," he told me when he came back. "I think we're all in competition."

"Whaaat?! We've flown all the way over here for this? This is ridiculous! Wait till I see Saad!"

After three hours of waiting, I called Dr. Z, but he didn't pick up. "He's not even gonna pick up?!" I exploded. I was done.

At about the five-hour mark, Dr. Z called me and told me it was time. He gave me their suite number upstairs.

When they answered the door, this time Saad was wearing the dishdasha, the fancy white robe favored by wealthy Saudis. If he'd had on Western clothes, like he had in London, it would have been okay for me to shake his hand, but the dishdasha meant that I, as a woman, couldn't shake his hand and I had to stand several feet away from him. As Saad sat back down, there were about five men standing behind him, all wearing the dishdasha except for Dr. Z, who had on a Western business suit. Saad looked like a king on his throne.

Saad described to us how he saw the stadium project unfolding and how McKissack fit into it all. He thanked us for flying all the way to Dubai on such short notice. He acknowledged that they were also talking to other international firms.

"But there's plenty of work to be done," he said.

That was it. We had flown halfway around the world—and waited for five hours—to hold a brief discussion about logistics. It was decidedly anticlimactic.

The Black Family Who Built America

After we left the room, Brian muttered to me under his breath, "I didn't know if I should kill that man."

I turned to him, more than a bit alarmed. "What?!"

"I just didn't know what to do," he said. "I hate the bin Ladens."

Brian's brother was a fireman who had perished at the World Trade Center on September 11, 2001. His brother had been on a rescue squad that went up in Tower Two—the first tower that fell—after the plane hit. He was on the fortieth floor, trying to get to a woman who was stuck in an elevator, when the tower collapsed. Brian actually went to the site after the buildings fell to look for his brother; he wound up working down there for a long time.

"It was pretty odd to be sitting five feet away from this guy," Brian recalls. "His brother killed my brother and now we're sitting there next to each other. It was a unique situation, almost like it was made to happen."

I told Brian that he was going to need to compose himself if we were going to do this project. I also said that they had different mothers and there were so many children that it wasn't like Saad and Osama were hanging out together when they were younger.

"I know, I know," he responded.

Brian was fine after that, though I'm sure it all was surreal for him, especially considering how much of his life he had invested in the aftermath of September 11. Brian is a businessman, so he was there to do business—though his feelings about Saad probably never changed.

At the meeting, several times they asked me about the presidential letter that Deryl had promised. When I had asked her where it was, she kept telling me, "It's coming, it's coming." I relayed to

them that Deryl was still working on the letter. (We didn't wind up getting that letter; rather a presidential message a year later.)

"We don't know if we want her involved," Dr. Z told me. You don't just offer up a presidential letter to the Saudis and not be able to procure it.

After the meeting, Brian and I stayed in Dubai for a couple more days. We drove around and saw many of the city's most popular sites. I was not impressed. I found the place to be so fake, a fairy-tale land constructed solely to impress visitors, like Disneyland in the desert. We visited the Burj Khalifa, the tallest building in the world—Turner Construction was the project manager—and went to the observation deck on the 124th floor. I looked up and saw vast emptiness in the forty stories above the deck. That emptiness felt symbolic to me, representing this superficial city built by exorbitantly wealthy people who had more money than they knew what to do with.

At dinner, Brian had to order for me, which was profoundly uncomfortable. As a woman, I felt like I couldn't sit at the bar by myself and have a drink. I was ready to go back home.

Our next meeting with Saad's team took place back in Hampshire, England. I happened to be vacationing in Bermuda when I got the call, so I had to fly from Bermuda to London, which was an easy trip because so many Brits vacation in Bermuda. Brian was there, as was Jack Kelly, who was running my Philadelphia office at the time, and twelve people from Saad's team. We spent about three days working through plans and designs; it was a productive working session. It was starting to become clear who would do what in the construction of these soccer stadiums. I flew back to the United

The Black Family Who Built America

States feeling good about the project, believing it would be quite lucrative for McKissack in the short term, and potentially make us a player on the international scene in the long term.

We learned that in order for us to do business over there, we had to hire a Saudi law firm. And the only way an expat could have a business in Saudi Arabia was to go into business with a Saudi Arabian. We were told that we could select from a list of people who were available to be business partners. They wouldn't have to do anything and they would get a portion of our fees. It was convoluted and uncomfortable, but we were sure the dollars were going to be big. We went along.

And then we were hit by some profoundly bad news, at least from the perspective of this project: The price of oil began dropping. That meant the Saudis saw their coffers dwindling. Suddenly they had less money available to lavish on a project like this. The viability of the project was now in doubt, and communications with Saad's team quickly dropped off.

At the end of July 2015, we got some horrifying news. Dr. Z, his wife Sana (who was Saad's sister), and Saad's mother Raja Bashir Hashim were killed when their private jet crashed as it was attempting to land at the airport in Hampshire. The family was coming from Milan, Italy, where they were attending a wedding. It was eerie—Saad's father Mohammed and his brother Salem both had been killed in private plane crashes; now his mother, sister, and brother-in-law as well.

Dr. Z was our primary connection to the bin Ladens and the construction project; once he was gone, the connection was gone. My friend Michael tried to pull together some other possible building

projects for us, but it all just fizzled out. It was terribly disappointing. But in the aftermath, as I was dealing with my regret, I had some conversations with principles at a couple other American firms and discovered that one of them was still owed something like $45 million for a project they had done for the Saudis. Perhaps it was a blessing that our project stalled out. I stored it all away as an adventure—a good adventure.

CHAPTER 15

A Whole New Ballgame

When Donald Trump was elected in 2016, I was deeply alarmed, like so many others in the country. I also wondered how his election might affect my business. It didn't take me long to find out.

In 2012, just as Obama was elected to a second term, we had won a lucrative construction-management contract with the New York State Office of General Services, which is New York's real estate, design, and construction arm. Along with a few other firms, we were responsible for helping OGS hire managers and engineers on their construction projects. We won the contract as a prime, which was a first for a minority firm. There were various other projects underneath that project—we performed well in all of them.

Right after Trump's election, it was time for us to recompete for the OGS contract. There were a total of eleven MWBE firms,

including us, that submitted to be prime—and the state selected none of us. We had already been doing the work for four years, and doing it well, but we could immediately sense a new attitude about MWBE firms, a backlash against them. The state could have hired four firms to do the work, but they only hired three. All of a sudden, in order to keep our staff on the job, we had to switch strategies and agree to become a sub to one of the white-owned firms that was now prime. I felt like it was a blatant effort to retaliate against firms like McKissack. Even though it was the administration of Governor Andrew Cuomo, a liberal Democrat, not everyone around him was a supporter of MWBEs—particularly in Albany, where these decisions were being made.

I complained to Alphonso David, a Black lawyer who served as Cuomo's chief counsel.

"Listen, this is so blatant!" I told him. "Eleven firms submitted and they only short-listed four or five majority firms. We've been working on it for four years—and we didn't even get a chance to do a presentation."

I guess his department looked into it; we got an offer to do a presentation. We did it, but all along we knew it was a waste of time. Albany sat in the middle of Trump country in upstate New York.

In New York City, the political landscape looked quite different. The city was in the hands of a liberal Democrat, Mayor Bill de Blasio, who was an ardent supporter of minority businesses. De Blasio was an intriguing guy. He had first come to my attention in 2013, as he was sitting in fourth or fifth place in that year's mayoral race, behind well-known New York figures like City Council Speaker Christine Quinn, former US representative Anthony

The Black Family Who Built America

Weiner, and 2009 mayoral nominee Bill Thompson, the former city comptroller. I attended a New York Building Congress event where de Blasio, a former city councilmember and citywide public advocate, was speaking; I thought he was brilliant. I was taken with his focus on inequality and his description of New York as a tale of two cities, the rich and the poor. But I knew he was trailing badly in the polls. That evening when I got home, I said to Sam, "Why can't good people win as mayor of New York?"

Sam said, "Well, number one, his wife wears dreadlocks."

"Wait—she's Black?"

Sam nodded.

I grinned. "Oh, I like him even more now," I said.

Shortly after, I got a call from Don Peebles, an exceedingly wealthy African American real estate developer. "Cheryl, I want to do a fundraiser for de Blasio," he said.

"I'm in," I said. "I like this dude."

He said he wanted to hold the fundraiser at McKissack's offices in midtown Manhattan. We got a good crowd, especially considering he was still in fourth place and it was on a Wednesday. I had a chance to get to know the candidate and I liked him even more. That Sunday when I showed up at my church, Christian Cultural Center in Brooklyn, de Blasio was there. I was invited upstairs to the pastor's dining room after service and I chatted more with de Blasio during the breakfast.

"Oh, you've already met him," Pastor Bernard said when he saw us talking.

"Yes, he was just in my office this week," I said.

Harry Belafonte was also dining with us that day. I thought it was

221

meaningful, providential even, that I was this close to de Blasio twice in the same week. In August, I was sitting on the couch watching television when a commercial filled the screen featuring de Blasio's fifteen-year-old son Dante, sporting an enormous, adorable Afro and talking about his father. *Time* magazine called it "The Ad that Won the New York Mayor's Race." After it ran, de Blasio was catapulted to the top of the polls and established a lead that he rode all the way to victory in November.

I found myself making frequent trips to Gracie Mansion during the early days of his term, establishing a strong relationship with him and his wife, Chirlane McCray. We were encouraged when de Blasio announced that he wanted the city government to double its number of MWBE contracts. Around this time, the city's Economic Development Corporation released a construction-management contract that could be worth millions of dollars. My chief operating officer at the time, David Kane, who had been one of the top executives at the EDC, told me he thought we should go after the EDC contract as a prime. Since he knew McKissack's capabilities, he knew the EDC well, and he still had many contacts there, plus we had a great relationship with de Blasio's people, I agreed with him that it was a good idea. In addition, when Maya Wiley, who unsuccessfully ran against de Blasio for mayor and was now serving as his counsel, called me seeking recommendations to run her MWBE department, I suggested she call Jonnel Doris, a Queens pastor who had served as chief diversity officer for the Governor's Office of Storm Recovery. I knew Doris as a solid guy; Wiley hired him to run MWBE for the de Blasio administration.

We had strong relationships around every corner. That helped

The Black Family Who Built America

us secure the EDC contract as prime. It's been a great project for us—as of this writing, it's been going on for more than seven years and we've done more than $200 million worth of work for EDC. Our strong relationships also helped us win a contract in a joint venture with Turner Construction to build Coney Island Hospital, a beautiful state-of-the-art $888 million hospital that we just opened in May 2023 with a new name—Ruth Bader Ginsburg Hospital.

I was giddy about how thoroughly McKissack had turned around our fortunes in recent years. Our streak of splendid blessings continued in 2019. The Port Authority of New York and New Jersey issued an RFP to rebuild the terminals at JFK Airport, which were badly in need of modernizing. As you might recall, Donald Trump famously trashed the state of New York airports during a Republican presidential debate in 2016 when he said, "You land at LaGuardia, you land at Kennedy, you land at LAX, you land at Newark, and you come in from Dubai and Qatar and you see these incredible—you come in from China, you see these incredible airports, and you land—we've become a third world country."

We knew the airport project was coming, but we didn't know which company would win the contract. We did some poking around, trying to decide which team we wanted to partner with in a joint venture. I called Jim Reynolds, founder and CEO of Loop Capital, who had partnered with Magic Johnson to form an investment firm called JLC Infrastructure. They were one of the big firms vying for the contract to build the new Terminal One at JFK, a project with a price tag of $9.5 billion. I was especially excited about this team because Reynolds and Magic were both Black.

Jim confirmed that the JLC team, which was partnering with Carlyle Group, was going after the terminal project. Then he said, "And we want you to be our program manager."

Just like that, with no RFP, no interview, no nothing. Just a pronouncement during a phone call. I'm sure this probably happens to white firms all the time, but it was the first time it had happened to me. That's the difference in having Black ownership. Jim Reynolds wanted to make sure that there was significant Black and Hispanic participation on this job from beginning to end and he brought us in early to make sure that happened.

Jim wanted me to meet with Amit Rikhy, who was the president of Carlyle Airport Group. At our meeting, Amit was quite charming.

"Absolutely! We want to make sure you're part of our team," he told me.

When it came time to do the presentation in front of the Port Authority of New York and New Jersey, Glenn Youngkin, who was co-CEO of Carlyle Group, stepped to the mic and delivered a spellbinding address. He said there were contractors outside the United States who could do the billion-dollar job by themselves, but we didn't have many of those in the United States. He wanted to make sure this whole project was done by Americans. This promise turned out to be bullshit, but Youngkin didn't know it at the time. I thought his presentation was amazing. I wasn't so impressed when Youngkin was elected governor of Virginia a couple years later and became Donald Trump lite, leaning especially hard into his banning of critical race theory—which wasn't even used in Virginia public schools. *The Washington Post* said Youngkin was "famous for being

PROLOGUE

just Trumpy enough to woo MAGA Republicans without alienating more moderate voters."

After we won the project, we had all sorts of challenges getting it off the ground. Carlyle had spent more than $300 million on architects, engineers, consultants, project managers, attorneys— but were still unable to satisfy the Port Authority's requirements with the current contractor. Eventually, Tishman was released and Carlyle issued an RFP to replace them. Carlyle said they didn't want to spend any more money; they wanted other investors like Loop Capital and Magic Johnson to kick in. They began cutting our invoices in half, telling us that our $600,000 shortfall represented our "skin in the game."

"If this project gets across the finish line, we will pay you back with interest," Carlyle execs told us. "But if it doesn't, you just lose your money."

We also had additional invoices to submit, putting the amount they owed us at about $3.2 million. It was profoundly uncomfortable, but at least all of us were rowing in the same direction. In May 2022, we got final approval from Port Authority; the project was ready to go. A windfall of money flowed in all directions to everyone who had put skin in the game. We were paid in full. Carlyle, JLC, McKissack—we all paid big bonuses to our employees. We gave our twelve employees more than $300,000 in bonus money. There was dancing in the streets. We officially broke ground on the terminal in September 2022. I can be seen in the ground-breaking photos grinning from ear to ear as I sank my shovel into the dirt, with Magic nearby towering over all of us.

Our work is ongoing as program managers in charge of the project's MWBE contracting, which was promised to exceed 30 percent. The 2.9 million-square-foot, state-of-the-art international terminal is slated for completion in 2026.

When the Empire State Development Corporation, which oversees economic development in the state, issued an RFP to develop the last site next to the Javits Center on the far west side of Manhattan, I heard the buzz in the real estate community. But I couldn't figure out how McKissack & McKissack might enter the fray. The big companies circling around the project, including Brookfield Properties and Silverstein Properties, didn't normally use McKissack. One day I got a call from a colleague, Cody, at CBRE Group, the real estate and investment firm. We had worked with them in the past.

"Cheryl, have you looked at this RFP?" he asked.

"Yeah, but it's not really in our wheelhouse," I said.

"Well, I think this would be an excellent opportunity for a company like Peebles to pursue," he said. "I think a hotel should be there—and that's what Don does. Do you know Don?"

Don Peebles, chairman and CEO of the Peebles Corporation, and the real estate mogul with whom I did the de Blasio fundraiser, has built successful properties all across the country. We had been moving in the same circles for years.

"Yes, of course I know him," I said.

"Can you introduce me?" Cody asked.

When Cody and Don got together, Cody found out that Don actually had already been looking at the Javits site. I was intrigued that CBRE had singled out Don as a potential developer because that

The Black Family Who Built America

company's expertise was identifying trends and taking advantage of them. It got my attention that they thought Don was the best person to grab this project. Don called me up and threw out a compelling proposition.

"Cheryl, we've always talked about you going into development," he said. "Why don't you be a developer with me on this project?"

I had recently turned sixty, and after decades of running a construction company, I was certainly ready to dive into my next chapter. But first I had to figure out what that chapter was. Perhaps real estate development was the ticket.

"Okay, fine," I said.

He told me he would give me 20 percent of the project—unless there was someone else I wanted to bring in to share my percentage.

"Well, I don't know what twenty percent amounts to, because I've never done a development like this before," I told him truthfully.

I decided to reach out to another colleague, Craig Livingston, board chair of New York Real Estate Chamber (NYREC), and ask him to become an investor with me. We each did 10 percent, while Don took 60 percent. The remaining 20 percent was handled by Steve Witkoff, another wealthy white developer in New York. We hired David Adjaye as the architect and he came up with a beautiful, mind-blowing design for the 1.2 acre site—a massively tall cantilevering tower that would extend farther out over Eleventh Avenue as it rose. The drawing looks like a building flipped upside down. Don wanted to do something transformative on the site, building a tower that would affirm that New York City is open for all people to do business. Of the more than three hundred skyscrapers

in Manhattan, it would be the first skyscraper built by a person of color. In 2024, I find that to be an outrageous statement.

In his concept for the building, Don talked about how, throughout American history, a large-scale building program has helped the country recover from a catastrophic economic event. Just as the Empire State Building helped the city recover from the Great Depression, he saw this project helping the city emerge from the COVID pandemic. We called it Affirmation Tower. It would house two hotels—a micro hotel and a luxury hotel—retail office space, a skating rink at the top. He convinced the NAACP to agree to place its national offices there.

We were very excited when we were short-listed. During the presentation, when the Empire State Development execs asked Don who would rent space from us, he told them he wasn't concerned about that because renting space in a Black-owned building would instantly earn a company Environmental, Social, and Governance (ESG) points. In an atmosphere where major corporations were desperate to receive favorable ratings when it came to their adherence to ESG issues, he figured that companies would be eager to rent space at Affirmation Tower. I thought it was a brilliant strategy. The timing was right.

The RFP had been issued by the administration of Governor Andrew Cuomo. Cuomo had been on a roll with respect to Black ownership and Black leadership, with projects like Terminal One at JFK Airport and several others. We thought he would be eager to get behind Affirmation Tower and grant our team the contract, which would be public relations gold for him. But Cuomo got yanked into a scandal in late 2020, when he was accused of numerous incidences

The Black Family Who Built America

of sexual misconduct. In August 2021, New York State Attorney General Letitia James released a report alleging that Cuomo had sexually harassed at least eleven women during his time in office. On August 23, 2021, after a decade in office, Cuomo resigned from the governorship and was replaced by his lieutenant governor, Kathy Hochul.

Hochul had to run for the full term the next year, so she was immediately thrust into a situation where she had to raise money and figure out how to keep the job. I'm sure she was getting advice from a dizzying array of people around her. While she may have been interested in doing something for the Black community, her priorities were likely in other places. While Cuomo had done many projects for white developers in New York, enough to keep them at bay if he granted us the contract for Affirmation Tower, Hochul didn't have any of that history with the development community. In addition, she was getting pressure from the local community board in Manhattan because our proposal didn't include any affordable housing, which we did not want to include in the building. On December 21, 2021, right before Christmas, we got a call from Hope Knight, acting CEO of the Empire State Development Corporation, telling us that the RFP would be reassessed to potentially include more housing. In other words, no to Affirmation Tower.

At that point we had spent more than a million dollars in developing the project. I was glad that I only had 10 percent instead of 20, meaning my stake was $100,000, not $200,000. I guess I found out the hard way what it meant to be a real estate developer. But we're not giving up on our dream of building a Black-owned skyscraper in New York. Maybe the stars need to realign to make it happen.

CHAPTER 16

Back to School

The year was 1990, and I had managed to procure my first architectural contract for McKissack & McKissack in New York City, designing a school (PS 190) for the newly formed New York City School Construction Authority. However, I had a problem: I had to pay my architect for his design work, but I didn't have enough cash on hand to do it. It would be weeks before I got my first payment on the project, and I needed him to start right away. So, I went to my friends.

I asked five of my friends, Wall Street guys and gals, including Joe Nunn, Wendy Van Amson, and Milton Irvin, to lend me $5,000 each so that I could pay the architect. Six months later, I was able to repay them with interest—I gave them $6,000 each.

This story provides the perfect illustration of why it's so hard for Black businesses to scale up and get big. To move beyond MWBE

The Black Family Who Built America

contracts. We just don't have access to the kind of money that we would need to grow and breathe more rarefied air. When Jim McKenna left Turner and started Hunter Roberts, he got tens of millions from billionaire Jeff Records as startup capital. My hope is that this starts to change as we get more Black billionaires and multimillionaires looking for investment opportunities with their own and we hear about Black entrepreneurs accessing real money to get bigger.

As I think seriously about retiring in the next five years, I have to consider the future of The McKissack Group. I dealt with years of fits and starts, but finally I feel like I have gotten the company to a stable place, where we don't have to worry about survival anymore. It's a great feeling. However, what happens next? What does the future look like for McKissack? And after more than two hundred years of McKissacks at the helm of this family company, am I the end of the family line? Does the remarkable string of McKissacks overseeing the company end with me?

When I think about my legacy, there are three challenges I must confront at the same time: How do I grow the business into other areas? How do I leave the company in capable hands? How do I nurture members of my family to make sure there are McKissacks among company leadership going forward?

For the first challenge, one of the ways I want to expand is to move our base beyond construction and construction management. Twenty years from now, I would like to see The McKissack Group DBA McKissack & McKissack as a very large construction firm that's operating nationally but based in New York City, that has Black leadership but is not dependent on MWBE to survive. We

have to dig deeper on the design-and-construction side and lean more into design build, which is the direction the industry is moving in. As opposed to hiring the architect separately from the contractor, the industry is now increasingly having the contractor hire the architect. It expedites the schedule, defuses controversy between the architect and contractor, and leads to greater efficiencies on the project—or at least that's the hope. It will mean taking on greater risk for the contractor, because design is a risk, but as a result, the contractor can charge more money for that risk. The owner doesn't have a problem with the higher payment to the contractor because they feel they're going to save money in the long run, since the job will get done faster.

We have bid on a few design-build projects recently, and it looks like they will bring in significantly more money to McKissack. This will allow us to build our balance sheet and move into new areas, such as development, like Affirmation Tower with Don Peebles, or into casinos, which is an industry I've been interested in but that requires equity. A more robust balance sheet will help the business become more sustainable and able to weather the storms that will come.

Even after I retire, I'd still like to continue doing work, perhaps chairing the McKissack board and delving into equity opportunities. I'd like to move away from the day-to-day management of these construction jobs, getting all the emergency phone calls when problems arise. I swear something is *always* coming up. I'd like to travel with my husband, who recently retired himself, and when I work, I'd like to be working on new deals. I want to figure out the most impactful opportunities for us, instead of managing people.

The Black Family Who Built America

For instance, owner of the New York Jets sounds pretty cool to me. Those are the kind of high-impact moves Magic Johnson is making. I'd like to borrow a page from his playbook.

I am blessed to have several skilled executives inside the company who are more than capable of overseeing the business after I step away. However, I am a bit disappointed at the scarcity of McKissacks who I believe are positioned to take on leadership roles in the company. I think in some ways companies like mine were hit by the same forces that took down many Black institutions after integration opened up new opportunities for ambitious African Americans. Starting in the 1970s, we had greater access to the Harvards, Yales, and Princetons, and from there we were able to go to the Wall Street banks like Salomon Brothers, Goldman Sachs, and Bear Stearns. That broadened people's perspectives on what careers were open to them, but it also made them look down on what we already had. Remember the buppies—Black urban professionals, flocking to the cities? Buppies didn't believe in working for a Black family–owned business; they believed in corporate America. There was a certain amount of shame in working for a Black business.

In the eighties and nineties, when people were running around bragging about their work for Goldman Sachs, I wasn't saying I work for my family's firm McKissack & McKissack and thinking I was doing something comparable. My friends had no desire to be part of the family funeral home or the Black-owned construction company. Hell, as you might recall, my ex-husband even told me that I was running a "nigger business." And he didn't mean it with an *a*. People wanted big, impressive jobs with white companies. But when I walked into these companies, I saw that there were very few

233

women and even fewer Black people. I understood early on that I needed to go to my family business to control my own destiny. I realized that it provided for a much more satisfying career path.

In the end, I feel like I won. In the beginning it might not have been an impressive career path, but comparing where I am now to where they are, I'd rather be sitting in my shoes. It's taken McKissack & McKissack one hundred years to become an overnight success and, in my case, thirty-five years to make it in the Big Apple. But we are now well-respected. When I tell people we've been in business for more than two hundred years, and that we're the largest Black-owned, female-owned firm in New York City, they're impressed. I run my own shop, so—unlike my colleagues—I wasn't going to be pushed out at age fifty-five because the shareholders say you're no longer any good and we need a younger president, or a taller president, or a white president. I'm going to leave on my own terms. There's a lot to be said for that.

There were a lot more male McKissacks during my father's generation, as he was the youngest of five boys. When you got to my generation, there were a lot more females. Many of them were a decade or so older than me—my sister Andrea, who started out as an art major at Howard and then chose a different route, as did my female cousins Dolly McKissack, Brenda McKissack, and Miranda McKissack. They didn't flock to the family business; they wanted to see what else was out there for them. As did many females in that era, they did not grasp being entrepreneurs, so their children grew up watching them in corporate America rather than watching them in the family construction business. I believe that has a major effect on the choices the children make.

The Black Family Who Built America

That brings me to today. I have two daughters who grew up watching both of their parents in construction but who don't have the same attraction to it that my sister and I did. I'm not sure why. My youngest, Leah, after dealing with mental health challenges throughout most of her twenties has turned her life around beautifully. She is now attending college and working for the company. Her sister, Deryl, works in the company; I'd like to spend some time focusing on her over the next several years—mentoring and showing her the ropes, just as my mother did for me. She works with the business manager, doing certifications and opening up new businesses. When they were young, I called them "my little presidents." Perhaps I was speaking their future into existence. After all, words hold power. I have a nephew who just graduated from architecture school with a master's degree, but he's not working for the company. I guess there's always a chance that one of my daughters, or nieces or nephews, or future grandkids, becomes interested in the family business. I pray that's what happens.

I'd be open to the business being sold but still maintained by the McKissack family, if the right situation came along. In the meantime, I'm trying to spend as much time as I can talking to and mentoring young people. I've been speaking a lot on college campuses, particularly the HBCUs, getting Black kids excited about design and construction. As I know, you have to see it to be it. I also have to get them excited about coming to New York, which can be a challenge. We're competing with places like Nashville, Atlanta, Dallas, Charlotte, and Houston. When I speak to these young people, I see that they desperately need mentors—someone they can go to when they hit those inevitable bumps. I relish that role.

I feel like I've put my everything into this business over the years. I've been the matriarch, the coach, the therapist, sacrificing always to keep the engine running, whether with my mother, my family, even with my sister. I have been a person of integrity and honesty, which isn't always easy to do in the construction industry, where shady enticements and sleazy propositions seemingly lurk around every corner. I don't need a team of praise dancers celebrating my every step, but I do believe the work I've put in is worthy of recognition.

In a nation that subjected my people to every indignity imaginable, that tried to deny us every opportunity, my family found a way to move on from cruelty to commerce. As a company, McKissack & McKissack survived Jim Crow, the KKK, the Great Depression, civil rights carnage, racist attacks, and bitter jealousy. Yet we are still here. Thriving. Growing. Expanding. Striving for greatness. Building America.

Here's to our next two hundred years.

ACKNOWLEDGMENTS

This book has been over a decade in the making—a labor of love that honors the enduring legacy of the McKissack family. My heart overflows with gratitude for the many people who helped make this dream a reality. To God be the Glory!

First, my deepest thanks go to Charlamagne tha God. You saw the vision and understood this story's significance—not just for my family but for America's collective history. Thank you for welcoming me into the Black Privilege Publishing family under your imprint with Atria Books. Since our first meeting, your support has never wavered, and I am forever grateful. Who would have imagined that a chance introduction at Taraji P. Henson's "Can We Talk?" mental health awareness conference and benefit dinner, in Washington, DC, in 2019, would lead to here? To my publicist Chandra McQueen of Moona Media & Management, thank you for making that introduction and for believing in this project from day one. Charlamagne's shout-out during Black History Month created unstoppable momentum, and I'll always be thankful for that.

Acknowledgments

Chandra, your persistence, creativity, and connections were essential in bringing this book to life. Beyond introducing me to Charlamagne, you connected me with my incredible writing partner, Nick Chiles. Nick, I cannot thank you enough for your brilliance, patience, and dedication. You invested countless hours listening to my stories, asking insightful questions, and traveling to Nashville to immerse yourself in McKissack history. You filled in the gaps, connected the dots, and helped shape this story into something extraordinary. Your commitment to honoring my family's legacy shines through every page.

To my parents, William DeBerry McKissack and Leatrice Buchanan McKissack, you are the pillars of this legacy. Dad, your teachings, love, and determination have guided my path. Mom, your courage and resilience in sustaining the business after Dad's debilitating stroke inspired me to step forward as the fifth-generation president and CEO. Your unwavering faith in me means everything, and I love you both beyond measure.

This story would not exist without the foundation laid by my ancestors. To my great-grandfather, Moses McKissack I, an enslaved Ashanti who brought the craft of brickmaking and construction to America, I owe everything. Your legacy flows through generations of builders, from Moses II to Moses III and Calvin to my father and now to me. Your principles—persistence, preparedness, perseverance, and productivity—the four Ps—have steered our family. And prayer, the fifth P, has sustained us through every challenge.

To my remarkable husband, Dr. Samuel Daniel: You have been our family's pillar and rock for several decades, and your strength and relentless pursuit of excellence set an inspiring standard. Your

Acknowledgments

support and dedication means everything to me. To our amazing children, Deryl and Leah Felder (whom I called "my little presidents' early on, hoping to speak it into existence), Nicole Daniel, Jerry Daniel, Kelsey Daniel Michel, and Joy Daniel, thank you for your endless love and support. All of you inspire me daily, and I am confident that this legacy will flourish in the sixth generation and beyond.

To Pastor A. R. Bernard, thank you for keeping me grounded in faith and purpose. To my prayer partner, Raina Bundy, your friendship and counsel have been precious gifts. To my twin sister, Deryl McKissack, you are my heart. We are one egg that split in two, and as you love to remind me, I may have escaped the womb first—but seconds later, we were together again. Life without you would be unimaginable. To my sister Andrea McKissack Krupski, whose remarkable intuition has guided me countless times—despite her playful claim that breaking a mirror at eleven (the year Deryl and I were born) brought seven years of bad luck—you've been nothing but a fountain of wisdom and a second mother.

To my incredible BFFs, including my Ride or Dies and Priscilla Simms Brown: Your steadfast presence through every chapter of this journey has lifted me higher than you'll ever know. Your friendship is a treasure I hold dear.

To my inner circle of friends and family—you know exactly who you are—your unwavering support has anchored me through every storm and celebration.

Finally, my profound gratitude goes to the McKissack team. Your exceptional professionalism and dedication make my role infinitely more manageable and created the space for this book to

Acknowledgments

come to life. Each of you brings invaluable expertise and commitment to our shared mission.

This book celebrates the McKissack legacy and honors everyone who has been a part of our story. Thank you for helping me share it with the world.

NOTES

Prologue

viii *"A master, however, could send his slave on an errand"*: James A. Padgett, "The Status of Slaves in Colonial North Carolina," *The Journal of Negro History* 14, No. 3 (July 1929): 300–27.

viii *The early 1800s saw a greater diversity in staple crops*: Alan D. Watson, "Impulse Toward Independence: Resistance and Rebellion Among North Carolina Slaves, 1750–1775," *The Journal of Negro History* 63, No. 4 (Oct. 1978): 317–28.

ix *the slaves of masters engaged in nonagricultural occupations tended to have more liberties*: Marcus Jernegan, *Laboring and Dependent Classes in Colonial America, 1607–1783* (Greenwood Press, 1980), 15–22

ix *hiring themselves out to rent houses*: Watson, "Impulse Toward Independence, 317–28.

x *"newspapers carried advertisements of slaves for hire"*: John Hope Franklin, "The Free Negro in the Economic Life of Ante-Bellum North Carolina: Part 1," *The North Carolina Historical Review* 19, No. 3 (July 1942): 239–59.

xi *sold poems to students*: "George Moses Horton, 1798–1883," Poetry Foundation, accessed January 6, 2025, https://www.poetryfoundation .org/poets/george-moses-horton.

xii *the empire had become a major player in the slave trade*: "Wonders: Ashanti Kingdom," The Slave Kingdoms, PBS, accessed January 6, 2025, https://www.pbs.org/wonders/Episodes/Epi3/3_wondr1.htm.

Notes

xiii *rate for the Africans crossing the Middle Passage*: Encyclopedia Britannica, "Middle Passage: slave trade," last updated November 18, 2024, https://www.britannica.com/topic/Middle-Passage-slavetrade.

xv *killing a Black or mulatto slave in Tennessee was actually deemed a murder*: William Lloyd Imes, "The Legal Status of Free Negroes and Slaves in Tennessee," *The Journal of Negro History* 4, No. 3 (July, 1919): 254–72.

xvi *the genesis of the Maxwell House coffee brand*: by Ophelia Paine, last updated March 1, 2018, "Maxwell House Hotel," *The Tennessee Encyclopedia of History and Culture*, October 8, 2017, http://tennesseeencyclopedia.net/entries/maxwell-house-hotel/.

ix *"It seemed after the war immaterial."*: W. E. B. Du Bois, *Black Reconstruction in America, 1860-1880*, (Harcourt, Brace & Howe, 1934), 131.

xxi *noteworthy Black businesses that emerged*: Bobby L. Lovett, *The African-American History of Nashville, Tennessee, 1780-1930, Elites and Dilemmas* (University of Arkansas Press, 1999), 107.

Chapter 3

39 *they would impress whites so favorably*: August Meier, *Negro Thought in America, 1880–1915: Racial Ideologies in the Age of Booker T. Washington* (University of Michigan Press, 1963), 35.

40 *"To promote racial loyalty"*: Jennifer Ritterhouse, "Daily Life in the Jim Crow South, 1900–1945," *Oxford Research Encyclopedia of American History*, May 24, 2018, https://doi.org/10.1093/acrefore/9780199329175.013.329.

42 *leading Du Bois to head an alumni movement*: Christopher Nicholson, "To Advance a Race: A Historical Analysis of the Intersection of Personal Belief, Industrial Philanthropy and Black Liberal Arts Higher Education in Fayette McKenzie's Presidency at Fisk University, 1915–1925," (PhD diss., Loyola University Chicago, 2011), https://ecommons.luc.edu/cgi/viewcontent.cgi?article=1152&context=luc_diss.

46 *"My object is to teach"*: Quoted in "'Art [and History] by Lightning Flash': *The Birth of a Nation* and Black Protest," Roy Rosenzweig Center for History and New Media.

47 *did "incalculable harm"*: "The Influence of 'The Birth of a Nation,'"

Notes

Facing History and Ourselves, last updated March 14, 2016, https://www.facinghistory.org/resource-library/influence-birth-nation.

Chapter 5

76 *The national Black unemployment rate*: Cheryl Lynn Greenberg, *To Ask for an Equal Chance: African Americans in the Great Depression* (Rowman & Littlefield, 2010), 31.

80 *"The trip down was"*: Charles River Editors, *The Tuskegee Airmen: The History and Legacy of America's First Black Fighter Pilots in World War II*, CreateSpace: 2023.

INDEX

A

Abyssinian Baptist Church (NYC), 176
Adjaye, David, 227
AECOM, 59, 60
Affirmation Tower (proposal; NYC), 226–29, 232
affordable housing, 11–12, 14, 229
African-American History of Nashville, The, 1780–1930 (Lovett), xxiii, 44
Ahmad, Husam, 166–67, 169–70
Albritton, Ahlyah (author's niece), 57
AMEC Publishing House (Nashville), 73
Amsterdam News, 89
Andrews, Carl, 5, 13, 111, 112
art deco style, 72–73
Ashanti Empire, xiv, xv
Association of Community Organizations for Reform Now (ACORN), 5, 11, 14–15
Atlantic Center (Brooklyn), 6–7
Atlantic City, N.J., 119–20
Atlantic Yards project, 8–9, 10, 12, 17, 162, 163, 167, 190

Aunt Francis (family friend), 91–92

B

Baker, Howard, 120–21
Baker Engineering, 164, 165
Barclay Center project, 1–2, 3–6, 7–10, 13–14, 66, 108, 167, 190
Atlantic Yards in, 8–9, 10, 12, 17, 162, 163, 190
delays encountered in, 10–13, 15–17
eminent domain issue in, 11, 16
50/50 proposal in, 11–12, 14
growing costs of, 10–11, 13, 14
neighborhood opposition to, 4, 11, 12–13, 16
opening of arena in, 17–18
Battalion Landing Team Headquarters (Beirut), 130
Becket, Ellerbe, 13–14
Beirut bombing (1983), 130
Belafonte, Harry, 221–22
Belize, Craig, 8, 9
Belle Meade neighborhood (Nashville), 44, 45
Bernard, A. R, 58, 64, 221

Index

Bethune, Mary McLeod, 78
Bey-Grecia, Aissatou, 160, 167–68, 203
Bharara, Preet, 173–74
bin Laden, Mohammed bin Awad, 210–11, 217
bin Laden, Osama, 210, 211, 215
bin Laden, Saad, 210, 211–16
bin Laden, Salem, 211, 217
Birth of a Nation, The (film), 45–48
Birth of a Nation, The: How a Legendary Filmmaker and a Crusading Editor Reignited America's Civil War (Lehr), 47
Black businesses, 32, 37, 44, 73, 81, 105
 Bloomberg's efforts in support of, 64
 "Buppies" as looking down on working for, 233
 challenges of expanding customer base for, 37
 in lawsuit against Nashville, 143
 limited financial access as obstacle for, 59–60, 230–31
 Mahalia Jackson's Fried Chicken, 88–89
 Moses III's investment in, 72
 movement pushing patronage of, 39–40, 45, 72
 in Reconstruction era, xix–xx, xxiii–xxiv, 37
 see also McKissack & McKissack
Black Cabinet, 78
Black churches, 43, 62, 176
 M&M's building of, 70, 71–72, 85–86, 114
Black community, 79, 80
 Birth of a Nation's damaging impact on, 45–48
 in Brooklyn, 4, 5, 6, 104, 105

in Depression years, 75–77, 82
elite class in, 20, 21, 23, 27, 28, 42, 44, 73
emphasis on economic path to progress in, 27, 38–40, 44, 45, 72
enslavement of, *see* slavery, enslaved people
Fisk University relationship with, 41–43
galvanizing support for Barclay Center project in, 4–6, 9
Great Migration of, 76, 159
in immediate wake of emancipation, xix–xxiv, 37, 39, 40
Jim Crow laws and segregation of, 42, 44, 79–80, 81, 82, 90, 236
M&M's employment of workers in, 39, 77, 85, 181–82
Mahalia Jackson's Fried Chicken as big deal in, 88–89
in Nashville, 19, 20, 21, 23, 29–31, 33, 38–40, 41–42, 44, 70, 72, 73, 91
in NYC, 54, 159, 181, 229
racial violence and intimidation against, xxi, xxii, xxiii, xxiv, 30, 31–34, 47, 58, 236
racism and, *see* racism
racist depictions and stereotypes of, 47, 48, 49
in Reconstruction era, xix–xxiv, 37, 39, 46, 47
restrictions on employment opportunities for, 40–41, 75–76
rise of middle class in, 70
in switch to Democratic Party, 76

Index

white resentment and hostility toward, xx–xxiii, xxiv, 40, 46, 236

Black Reconstruction in America, 1860–1880 (Du Bois), xx

Black schools, xiii, 38, 43, 45, 70, 77

 see also specific schools

Blackwell, Jannie, 155

Blackwell, Lucien, 155

Blaney, Cathy, 65

Blatstein, Bart, 54

Bloomberg, Michael, 5, 62–64, 111, 159, 182

Board of Registration of Architects, 74

Bogan, Eugene, 121

Boner, Bill, 121

Bontemps, Arna, 27

Bovis, 142

Boyd, Todd, 48

Breitbart, Andrew, 14–15

Britches clothing store (Georgetown), 124–25

Brockington, Carolyn, 206–7

Brookfield Properties, 226

Brooklyn, N.Y., 2–3, 6, 17, 111, 128

 Atlantic Center controversy in, 6–7

 Barclay Center project in, *see* Barclay Center project

 Black community in, 4, 5, 6, 104, 105

 Medgar Evers College project in, 2, 104–9, 152, 153

Brooklyn Dodgers, 2–3

Brooklyn Nets, 3, 4, 16, 17

Broome, Dr. (Howard professor), 121, 125

Brown, LaRay, 178

Brown, Dr. Roscoe C., 79, 81

Brush, Carlton, 49

Bryant, Ira T., 73

Buppies, 233

Burj Khalifa (Dubai), 216

Bush, George H.W., 147

Butts, Rev. Dr. Calvin, III, 176

C

Cameron School (Nashville), 77

Canada, Geoffrey, 159

Capers C.M.E. Church (Nashville), 71–72, 84–85

Capital One Arena (Washington, DC), 14

Carlyle Group, The (New York) 224, 225

Carmen (Del Guzzo's assistant), 199, 200, 202

Carmichael, Stokely, 91

Carnegie Corporation of New York, 43

Carnegie Library (Fisk University), 41, 44, 74

Carol's restaurant (Nashville), 71

Cavallo, George, 177, 178

CBRE Group, 226–27

Chancy, Aleksandra, 164–65, 166

Charlotte, N.C., xv, xviii, 18, 235

Chatham County, NC, xii, xiii

Cheekwood Estate (Nashville), 28

Christian Cultural Center (Brooklyn), 58, 221

Civil War, US, xvii, xviii, xix, 41, 47

Clansman, The (Dixon), 46

Clark, Augusta "Gussie," 150, 151

Clarke, Una S. T., 105

Clinton, Bill, 144, 147

CME Publishing House, 73

Cohen, David L., 60, 151

Index

College Hill development (Nashville), 82, 116, 139
College Hill Realty and Property Development, Inc, 83, 84
Colonial Revival style, 45
Colored Barbers Association, xxiii–xxiv
Colored Mechanics Association, xxiv
Columbia, S.C., 58
Columbia University, 131, 196, 200
Commerce Union Bank, 77
Coney Island Hospital, 223
Congress, US, 14, 15, 142, 145, 155
Conley, Booker, 78
construction managers, tasks of, 56–57
Cox, Jeff, 97–98
Crain's NY Business, 5
Cray-1 supercomputer, 131
Cross, Miss (DeBerry's coworker), 92–93
Crowell, Gentry, 145–46
Cuomo, Andrew, 183, 184, 186, 187, 189, 220
in sexual misconduct scandal, 228–29

D

DACK Consulting Solutions, 164–65
"Daily Life in the Jim Crow South, 1900–1945" (Ritterhouse), 40
Dallas Morning News, 82
Dames & Moore (engineering firm), 122
Daniel, Cheryl McKissack (author):
adolescence of, 36, 92–103

awards and honors earned by, 121
bicuspid aortic disorder diagnosis of, 201–2, 207
birth of, 19
childhood years of, 19–27, 29–36, 50, 71, 72, 88, 89–90, 91–92
Christian faith of, 196–97, 204, 221
chronic lateness of, 199, 203
DeCamp's contentious relationship with, 178–79, 180
in defense of thesis, 126–27
divorces of, 13, 54, 58, 69
domestic life of, 66–67, 68
drinking by, 67, 68–69, 94–95, 118–19, 120, 141, 179
family ancestry and background of, x–xi, xiii–xix, xxiii–xxiv, 18, 27–28, 37–38, 39, 41, 43–44, 45, 48–49, 59, 63, 70, 72, 74, 79, 82–84, 85, 86, 87, 114, 148, 190, 234, 236
father's death and, 140–41
father's stroke and, 122–23, 138–39
first marriage of, 128–29, 131, 140, 141, 147, 233
in first trip to NYC, 50
on fraudulent and unsavory characters in industry, 170, 173–75, 189, 236
Fred's controlling relationship with, 13, 67, 68, 69
Fred's wedding to, 58
girlhood and college boyfriends of, 97–101, 117–18, 120, 121
high blood pressure of, 68, 69, 200, 202, 206
at Howard University, 101, 116–22, 124, 125, 126–27

Index

Husam Ahmad's rivalry with, 166–67, 169

Jersey City apartments of, 126, 127, 129

at M&M, *see* McKissack & McKissack

mentoring of young people by, 235

MWBE backlash and, 219–20

at Nettleship Group, 147

in 1980s NYC, 127–28

non-construction or engineering jobs of, 93–94, 124–25, 129–30

NYU doctor's appointment of, 198–202

personal style of, 197–98, 200, 201

Philadelphia home of, 66

political relationships of, 5, 60–66, 105, 111, 120–21, 144–46, 151, 155, 161, 162, 221–22

post-grad job search of, 125–26

pregnancies and childbirth of, 54, 57–58

racism experienced by, 31–34, 111–13

rebellious streak of, 25, 26, 93, 97, 98–103

retirement contemplated by, 231, 232–33, 234

Saad bin Laden meetings with, 208–16

Sam's marriage to, *see* Daniel, Dr. Samuel

schooling of, 21–23, 52, 101, 116–17, 119, 121, 124, 125, 126–27, 131

stress experienced by, 67, 68, 204

stroke suffered by, 205–7

strong worth ethic and grueling schedule of, 66, 67, 119, 132, 147, 236

teenage jobs of, 92–94

in trip to Dubai, 213–16

at Turner Construction, 132–33, 134–35

at Weidlinger Associates, 4, 126, 127, 128, 130–31, 132

Daniel, Dr. Samuel, 176–77, 178, 179, 182, 195, 196, 197, 198, 199, 200, 202, 205, 206, 221, 232

Darrell (author's ex-boyfriend), 98, 99, 100–101, 117–18

David, Alphonso, 220

Davis, Benjamin O., 79

Davis, Larry, 173–74

DCM Erectors, 173–74

de Blasio, Bill, 220–22, 226

de Blasio, Dante, 222

DeCamp, Will, 178–79, 180

Delcan Corp, 163–64

Del Guzzo, Dr., 196, 198, 199, 200–202

Democratic Party, 76, 144

Design and Construction Department (DDC; NYC), 169

Develop Don't Destroy Brooklyn, 12–13

Devonelle housing complex (Nashville), 139

Disadvantaged Business Enterprise programs (DBEs), 60, 188

Dixon, Mel, 117

Dixon, Thomas, 47–48

Dixon, Thomas, Jr., 46

Donnelly, Jack, 156, 157–58

Doris, Jonnel, 222

Index

Dormitory Authority of the State of New York (DASNY), 104, 109, 159, 166, 183
Driscoll Construction, 154, 156–58
Dubai, 213–16, 223
Du Bois, W. E. B., xx, xxi, xxii, 27, 42

E

EASCO Boiler Corporation, 63
Eastmond, Arlington "Leon," Jr., 63
Ebbets Field, 2, 17
Elaine Massacre (1919), 47
emancipation, xix, 39, 40, 47
eminent domain, 11, 16, 82
Empire State Development Corporation, 226, 228, 229
Environmental, Social, and Governance (ESG), 228
Environmental Protection, Department of (DEP; NYC), 169, 170
estimating, estimates, 10, 56, 132–34, 191
Evers, Medgar, 104

F

Faisal, Prince, 210
Fee, Bob, 153
Felder, Deryl, 57, 66, 67, 68, 69, 235
Felder, Fred, 13, 54, 62, 65, 66, 68, 69
 background of, 58–59
 controlling nature of, 13, 67, 68, 69
Felder, Leah, 57, 66, 67, 68, 69, 195, 205, 235
FEMA, 186

financial crisis of 2008, 13, 14, 15
Firstrust, 193
Fisk University, 23, 27, 28, 29, 39, 73, 83, 84, 141
 Black community's relationship with, 41–43
 Carnegie Library project at, 41, 44, 74, 86
 new buildings built after 1950 by M&M at, 74, 86, 115
 seen as unwilling to fight Black oppression, 42
Fisk University Memorial Chapel, 87
Ford, Harold, 144
Ford, Harold, Sr., 43
Ford Greene School (Nashville), 77
Forest City Ratner, 6, 7, 11, 12, 13, 14, 15, 16
Forrest, Nathan Bedford, xviii
Four Seasons Hotel (Hampshire), 209, 211
Fourth Conference for the Study of Negro Problems (Atlanta; 1899), 39
Foxtrappe (Washington, DC), 120
Franklin, Andrea McKissack, 19, 24–25, 50, 69, 84, 92–93, 116, 139, 234
Franklin, Charles, 116
Franklin, John Hope, xii
Franklin Learning Center (Philadelphia), 55
Freedmen's Bureau, xxii
Frist, Bill, 144

G

Gehry, Frank, 13, 14
Geneva Circle neighborhood (Nashville), 23–24

Index

George Horton Middle School
(Chatham County, N.C.), xiii
George Peabody College for
Teachers, 21
Georgia, xii, xx, 48, 75
Germantown High School, 55
Ghana, xiv
Gilbane, Bill (grandfather), 177
Gilbane Building Company,
176–78
Gilbane, William "Bill," III,
176–77, 178, 179–80
Giles, Hannah, 14
Giles County Courthouse
(Pulaski), xviii
Ginsky, Marc, 52
Giovanni, Nikki, 121
Giuliani, Rudolph, 54, 63, 64
Goldstein, Bill, 152
Goldstein, Daniel, 12
Gone with the Wind, xi, 89
Gore, Al, 144
Gore, Tipper, 144
Governor's Office of Storm
Recovery (GOSR), 189, 222
Gravy, 88
Great Depression, 75–77, 82, 228
Great Migration, 76, 159
Great Recession (2008), 13, 14, 15
Green, Roger L., 5, 7, 105
Greenberg, Cheryl Lynn, 76
Greene, Darryl, 3–4, 5, 7
Griffith, D. W., 46, 47, 48

H

Hadley, Benjamin F., xxiii
Hadley Park (Nashville), 73
Hagan, Patti, 11
HAKS Construction, 166, 167,
169–70
Hall, John, 134

Hampshire, England, 209, 217
Hampton Institute, 83
Hardaway Construction, 115
Harding, Henry, xxiii
Harlem, N.Y., 159
Henry J. Carter Hospital project
in, 175–78, 179–82, 190
neighborhood resistance to
hospital demolition project in,
160–61
Harlem Hospital, 17, 108, 159–62,
175, 190
Harlem Renaissance, 27, 159
Harlem Workforce Development,
17, 161
Harris, Kamala, 121
Harris, Mitchell Jerome, xv
Harvard University, 27, 42, 59,
233
Harveys department store
(Nashville), 90
Hashim, Zuhair "Dr. Z," 211, 212,
213, 214, 216, 217
Hatch, John P., xxii–xxiii
Haynes (author's executive
assistant), 168–69
Helpern Architects, 52
Henry J. Carter Specialty Hospital
and Nursing Facility project
(Harlem), 175–78, 179–82,
190
Hentz, Caroline Lee, xiii
Hibbs, J.C., 74
Hinman, Eve, 130
Hochtief, 106
Hochul, Kathy, 173, 229
Holman, Joseph W., 74–75
Hooks, Benjamin L., 89
Horton, George Moses, xii–xiii
Horton, James, xii–xiii
Houston, William, xxiii

Index

Howard University, 4, 19, 25, 28, 43, 52, 83, 84, 103, 105, 117, 139, 140, 234
 author as student at, 101, 116–22, 124, 125, 126–27
Howell, Claudette, 140, 142
Howse, Hilary, 73–74
Hubbard, George W., 45
Hubbard House (Nashville), 45
Hughes, Langston, 27
Hunt, James B., Jr., xiii
Hunter College library project, 190–92
Hunter Roberts Construction Group, 59, 153–54, 191, 231
Hurricane Sandy, 182–83
 recovery project in wake of, 183–90

I

Imes, William Lloyd, xvii
In Hope of Liberty (Horton), xiii
Interior Department, US, 41
Irvin, Milton, 230

J

Jackson, Edison O., 104–6, 108
Jackson, Granbery, 38, 74
Jackson, Granbery, Jr., 74–75
Jacob Javits Convention Center (NYC), 4, 226
James, Letitia, 229
Jay-Z, 7, 16, 17–18
Jersey City, N.J., 126, 127, 129
JFK Airport project, 223–26, 228
Jim Crow, 42, 44, 79–80, 81, 236
 see also segregation, racial
JKRP Architects, 54
JLC Infrastructure, 223–24, 225
John Henry Hale housing projects (Nashville), 25–26

Johnson, Andrew, xxi
Johnson, James Weldon, 47
Johnson, Magic, 223–24, 225, 233
Jones, Thomas E., 42–43, 73
Junie (author's cousin), 118

K

Kaleda, Meryl, 167, 168–69
Kaleda, Michael "Mike," 8–9, 166, 167, 168, 169
Kane, David, 181, 222
Keating, Daniel, 151
Kelly, Jack, 216
Kennedy, Ethel, 125
King, Martin Luther, Jr., 32, 89, 91, 144
Knight, Hope, 229
Ku Klux Klan, xviii, xxi, xxiv, 33, 46, 47, 48, 236
Kules, Kim, 179

L

LA Café, 120
Lancaster Gazette, xiii
Lane College, 45
Lee, Rotan, 55
Lehman College, 108
Lehr, Dick, 47–48
Leonard (author's girlhood friend), 101, 102–3
Lewis, Bertha, 5–7, 11–12, 14–15
Lincoln, Abraham, 76
Lincoln Financial Field (Philadelphia), 16–17, 150–52
LiRo Group, 184
Livingston, Craig, 227
LL Cool J, 6
Lobo (Deryl's college boyfriend), 119–20, 121
Lola (author's assistant), 198, 203–4

252

Index

London, England, 208–9, 213, 214, 216
Long Island Railroad, 8
Looby, Z. Alexander, 30
Loop Capital, 223, 225
Lorraine Motel (Memphis), 144
Los Alamos laboratory, 131, 132
Lovett, Bobby L., xxiii, 44
Lyons, Brian, 183, 184–85, 186–89, 213–15, 216

M

Madison Square Garden (NYC), 16
Mahalia Jackson's Fried Chicken restaurant (Memphis), 88–89
Marcus Welby, M.D. (TV show), 25
Markowitz, Marty, 5
Marshall, Thurgood, 30
Maxwell House Hotel (Nashville), xvii–xviii
McCaffrey, Walter, 180–81
McCray, Chirlane, 222
McDonald's, 93–94
McGee, Charles, 79–80
McGordy, John, 133, 134
McKenna, Jim, 9–10, 106, 152–54, 191, 231
McKenzie, Fayette A., 42
McKissack, Almanda, xvi
McKissack, Brenda, 234
McKissack, Calvin
 (author's great-uncle), xxiv, 52, 70, 71, 72, 75, 77, 79, 83, 84, 85, 142, 151
 awards earned by, 81, 190
 death of, 20, 87
 as member of Fisk board of trustees, 28, 74, 87
 Nashville home of, 20, 21, 23

schooling of, 41, 43
in Tennessee licensing battle, 48–49, 53
see also McKissack & McKissack
McKissack, Calvin
 (author's uncle), 83
McKissack, Deryl, 57, 58, 67, 69, 121–22, 209, 235, 236
 adolescent years of, 92–97, 98–99, 101–2
 childhood years of, 19, 21–23, 24, 25–27, 29–30, 33, 34, 50, 71, 72, 88, 89–90
 at Howard University, 116–20, 122
 World Cup stadium project and, 211–13, 215–16
McKissack, Dolly
 (author's cousin), 234
McKissack, Dolly
 (author's great-grandmother), xvi, xxiv, 37
McKissack, Gabriel "Moses II"
 (author's great-grandfather), xiv, xvi, xvii, 19, 37, 38, 148, 190
 as building foreman, xvi, xvii–xviii
 McKissack Contractors founded by, xix, xxiii, xxiv
 in move to Pulaski, xix, xxiii
 notable buildings constructed by, xvii–xviii
McKissack, Geneva, 23
McKissack, Leatrice Buchanan, 19, 25, 26, 29, 32, 33, 34, 58, 64, 67, 69, 72, 88, 91–92, 94–95, 101, 102, 103, 117, 118–19, 142–43, 199, 201, 204, 235, 236
 author's education and, 21, 22, 23, 121, 125, 127

253

Index

McKissack, Leatrice Buchanan (*cont.*)
author's smoking of joint with, 95–96
awards and honors earned by, 147
charm and influence of, 3, 144, 157–58
DeBerry's courtship of, 28
DeBerry's stroke and, 122–23, 136, 138–39
elite family background of, 27, 28
Harveys segregated bathrooms fought by, 89–90
health issues of, 140, 148, 195
in leadership position at M&M, 3, 123, 134, 135, 136–38, 139–40, 141–42, 143–48, 193
mood swings and temper of, 96–97, 98
Nashville condo of, 149
political relationships of, 3, 144–46
retirement of, 148–49
strong personality and confidence of, 89–90, 95, 135, 137, 138, 141–42, 143, 146–47
McKissack, Lemuel, 83
McKissack, Miranda (author's cousin), 234
McKissack, Miranda (author's grandmother), 82
McKissack, Miriam, xiii, xiv, xviii–xix
McKissack, Moses (author's great-great-grandfather), x–xi, xiii–xiv, 18, 63
as building foreman, x–xi, xiii
death of, xviii–xix

mystery surrounding enslavement of, xiv–xv
wedding of, xiii–xiv
McKissack, Moses, II, *see* McKissack, Gabriel
McKissack, Moses, III (author's grandfather), xxiv, 20, 41, 52, 59, 70, 71, 75, 77, 79, 141, 142
awards earned by, 81, 190
birth of, 38
children urged to pursue architecture and engineering by, 82–84
Colonial Revival style favored by, 45
death and funeral of, 84–85
employment of Black workers by, 39
growing reputation of, 38, 41, 43–44, 72, 73–74, 81–82
as head of M&M, *see* McKissack & McKissack
investment in Black businesses by, 72
in move to Nashville, 38, 39, 44, 74
schooling of, 38, 43
in Tennessee licensing battle, 48–49, 53
McKissack, Moses, IV (author's uncle), 83, 84, 85, 114, 190
McKissack, Samuel, 83
McKissack, William, x–xi, xv, xvi
McKissack, William "DeBerry" (author's father), xv, 19, 21, 22, 26, 27, 29, 30, 34, 35, 71, 72, 78, 79, 85, 91, 93, 117, 118, 119, 120, 137, 144
author's childhood home designed and built by, 24

254

Index

author's rebellious behavior and, 99, 100, 101–2, 103
awards and honors earned by, 115, 140
in courtship of Leatrice, 28
daughters taught to drink by, 94–95, 118
death of, 140–41
as head of M&M, 87, 88, 89, 114–16, 139, 140, 143–44, 190
Leatrice's mood swings and, 96–97, 98
schooling of, 83–84
stroke suffered by, 122–23, 136, 138–39, 206
McKissack, William, II, xvi, xvii, 148
McKissack, Winter, 83
McKissack & McKissack, xi, 20, 27, 129, 233
Affirmation Tower proposal and, 226–29, 232
apartment complexes and housing projects of, 82, 116, 139
art deco style designs of, 72–73
author in move to, 134–35, 140, 141
author in reversing fortunes of, 193–94
author's envisioned future for, 231–33, 234–35
awards and honors earned by, 81, 115, 158, 190
bad bids of, 133–34, 192
Barclay Center project and, see Barclay Center project
Black churches built by, 70, 71–72, 85–86, 114
Black elite's support of, 73–74

Carnegie Library project of, 41, 44, 74, 86
DC office established by, 144
DeBerry as head of, 87, 88, 89, 114–16, 139, 140, 143–44, 190
in Depression years, 75, 77
Eagles arena renovation project and, 16–17, 150–52
EDC contract of, 222–23
in efforts to establish NYC presence, 51–53, 54, 62–66, 104, 147, 230
employment of Black workers by, 39, 77, 85, 181–82
"financial clearance" incident and, 110–13
financial struggles and cash-flow issues of, 77, 147–48, 151–52, 157–58, 166, 192–94, 230
Geneva Circle neighborhood built by, 23–24
Harlem Hospital project and, 17, 108, 159–62, 175
Harlem Workforce Development office of, 17, 161
Henry J. Carter Hospital project of, 175–78, 179–82, 190
historical legacy of, 4, 6, 51, 59, 63, 64, 190, 192, 234, 236
historical sites and markers of, 41, 45, 71
hospital projects of, 17, 86, 108, 159–62, 175–78, 179–82, 190, 223
Hunter College library project and, 190–92
Hurricane Sandy recovery project and, 183–89
internal staff conflicts at, 166–69

255

Index

McKissack & McKissack (*cont.*)
JFK Airport project of, 223–26, 228
in lawsuits, 143, 192
Leatrice as head of, 3, 123, 134, 135, 136–38, 139–40, 141–42, 143–48, 193
licensing obstacles of, 48–49, 52–53, 75
Mahalia Jackson's Fried Chicken built by, 88, 89
Medgar Evers College project of, 2, 104–9, 152, 153
Morris Memorial Building project of, 70–71
in Moses III and Calvin leadership era, 38, 39, 41, 43–44, 45, 48–49, 52, 59, 70–71, 72, 73–75, 77–78, 79, 81–82, 83, 84, 85, 141, 142, 151, 190
MTA contracts of, 162–66, 203, 204–5
National Civil Rights Museum project of, 144
neighborhood resistance to projects faced by, 4, 11, 12–13, 16, 160–61, 175
new World Trade Center project and, 171–73, 174
in 1947 split into separate entities, 84
OGS contract of, 219–20
Philadelphia building projects of, 2, 16–17, 54–57, 60–61, 150–52, 154–58, 177, 190, 192
Philadelphia office opened by, 53–54
public housing projects of, 81–82

racist resistance and obstacles faced by, 49, 53, 110–13, 143, 236
residential homes built by, 23–24, 44, 45, 74, 77
revenue earnings of, 108, 154, 192
rising reputation and growth of, 2, 4, 17, 38, 41, 43–44, 51, 72, 73–75, 81–82, 84, 86–87, 108–9, 114, 154, 162, 231–33, 234
SCA contracts of, 2, 9, 51–52, 109, 110–13, 152–54, 230
scaling up difficulties of, 59–60
school and college projects of, 2, 41, 44, 45, 51–52, 55, 70, 74, 75, 77, 86, 104–9, 115, 141, 142, 152, 153, 154–58, 190–92, 230
in transition from white to mostly Black clientele, 44, 70, 72
Tuskegee Army Airfield contract of, 77–79, 81, 83, 190
UPenn project of, 2, 154–58, 190
white architects and firms as creating obstacles for, 52, 53, 55–56
World Cup stadium project and, 211, 212–13, 214–18
McKissack Brothers Paint Shop, 83
McKissack Contractors, xix, xxiii, xxiv, 37–38
McKissack Elementary School (Nashville), 84
McKissack family, 36, 51, 72, 114
author's desire to keep M&M ownership in, 231, 233, 234–36

Index

Nashville home of, 24–25
Old Hickory Lake home of,
34–36
wealth and local prominence of,
19–20, 21, 22, 27, 28, 84, 148
McKissack Group, The, 4, 148,
212, 231
internal conflicts at, 166–69
see also McKissack & McKissack
McMillan, L. Londell, 7
Medgar Evers College, 2, 104–9,
152, 153
Meharry Medical College, 29, 45,
115, 123, 142
Meier, August, 39
Memphis, Tenn., 72, 86, 87, 140
Civil Rights Museum project in,
144
Mahalia Jackson's Fried Chicken
in, 88–89
Metropolitan Transportation
Authority (MTA), 8, 147
M&M's contracts with, 162–66,
203, 204–5
Middle Passage, xv
Minority and Women-owned
Business Enterprise (MWBE)
programs, 49, 53, 54, 59, 62,
63, 106, 107, 108, 109, 151,
157, 161, 162, 219–20, 222,
226, 230–31
new World Trade Center project
and, 172–74
North General Hospital project
and, 178, 180
post-2016 election backlash
against, 220
questionable certification and
fraudulent use of, 155–56,
172–74
white efforts in undermining or

dismantling of, 55–56, 178–79,
220
Montgomery, Velmanette, 5
Morris Memorial Building
(Nashville), 70–71
Moses, Robert, 2
Mount Sinai Hospital, 176, 198,
207

N

NAACP, 79, 228
Nashville, Tenn., 28, 35, 39, 43–44,
65, 73, 83, 84, 86, 123, 129,
134, 139, 140, 235
author's childhood and
adolescence in, 19–27, 29–36,
71, 72, 90, 91–103
Belle Meade neighborhood in,
44, 45
Black businesses in lawsuit
against, 143
Black community in, 19, 20, 21,
23, 29–31, 33, 38–40, 41–42,
44, 70, 72, 73, 91
Booker T. Washington in visit
to, 39–40
College Hill development in, 82,
116, 139
Fisk University in,
see Fisk University
John Henry Hale housing
projects in, 25–26
Leatrice's condo in, 149
M&M's apartment complexes
and government housing
projects in, 82, 116, 139
M&M's building of Black
churches in, 70, 71–72, 85
M&M's building of residential
homes in, 23–24, 44, 45, 74,
77

Index

Nashville, Tenn. (*cont.*)
 M&M's financial struggles and
 shutdown of office in, 147–48
 M&M's school and college
 building projects in, 41, 44,
 45, 74, 75, 77, 86, 115, 142
 Maxwell House Hotel built in,
 xvii–xviii
 McKissack family wealth and
 prominence in, 19–20, 21, 22,
 27, 28, 84, 148
 Morris Memorial Building in,
 70–71
 Moses III in move to, 38, 39,
 44, 74
 1968 riots in, 91–92
 racial violence and intimidation
 in, 30, 31–34
 segregation in, 90
Nashville Banner, 40
Nashville *Tennessean*, 70
National Civil Rights Museum
 (Memphis), 144
National Industrial Recovery Act
 (1933), 76
National Negro Business League,
 72
National Negro Conference, 39
National Park Service, 41, 71
National Register of Historic
 Places, 41, 45, 71
Negro Board of Trade, 72
*Negro Thought in America, 1880–
 1915* (Meier), 39
Neo-Classic style, 71
Nettleship, Tish, 147
Nettleship Group, 147
New Deal, 78, 82
New York, N.Y., 48, 50–51, 54, 69,
 72, 121, 171, 193, 203, 212,
 234

Affirmation Tower proposal in,
 226–29, 232
author's post-grad job search in,
 125–26
author's years in 1980s, 127–28
Black community in, 54, 159,
 181, 229
DEP corruption scandal in, 170
Harlem Hospital project in, 17,
 108, 159–62
Hunter College library project
 in, 190–92
JFK Airport project in, 223–26,
 228
M&M's EDC contract in,
 222–23
M&M's efforts to become
 established in, 51–53, 54,
 62–66, 104, 147, 230
M&M's growing reputation in,
 108–9
M&M's MTA contracts in,
 162–66, 203, 204–5
M&M's SCA contracts in, 2, 9,
 51–52, 109, 110–13, 152–54,
 230
new World Trade Center project
 in, 171–74
9/11 attacks in, 215
political landscape in, 220–22
see also Brooklyn, N.Y.; Harlem,
 N.Y.
New York Building Congress,
 178–79, 221
New York City Economic
 Development Corporation
 (EDC), 175, 177, 178, 180,
 181, 182
 M&M's contract with, 222–23
New York City Health and
 Hospitals Corporation

Index

(NYC Health+Hospitals), 176, 178

New York City School Construction Authority (SCA), 2, 9, 51–52, 109, 152–54, 169, 230
"financial clearance" incident and, 110–13

New York Jets, 233

New York Real Estate Chamber (NYREC), 227

New York State, 49, 108, 220, 223
highly regulated construction industry in, 174
Hurricane Sandy recovery project in, 183–90
M&M's licensing battle in, 52–53
MWBE program in, 53, 54, 63, 106, 107, 109, 161, 162, 172–74, 178–79, 180, 219–20, 222, 226, 230–31

New York State Court of Appeals, 16

New York State Office of General Services (OGS), 219–20

New York State Urban Development Corporation (NYSUDC), 3–4

New York Supreme Court, 16

New York Times, 89, 155

New York University, 131
author's doctor appointment at, 198–202

NFL, 151

Norman, Clarence, Jr., 105

North Carolina, xiii
early 1800s construction in, x–xi, xiii
slave laws in, ix–x, xii

slavery as practiced in, x–xi, xii–xiii, xv–xvi

North Carolina, University of, at Chapel Hill, xiii

North General Hospital rebuild project (Harlem), 175–78, 179–82, 190

NPR, 47, 48

Nunes, Gary, 112

Nunn, Joe, 230

O

Obama, Barack, 14, 183, 213, 219

Odjidja, Albert, 183

Oellerich, David, 192

O'Keefe, James, 14

Old Commercial Hotel (Nashville), 70

Old Hickory Lake, 34–36, 93

O'Malley, Walter, 2

Overton, Harriet Maxwell, xvii

Overton, John, Jr., xvii

Owens, Major, 105

P

Padgett, James A., x

Palmer, John, 161–62

Parsons Brinckerhoff, 109, 112

Parsons Corp., 164

Pataki, George, 64–65, 108

Paterson, David, 164

Payne Chapel (Nashville), 44

Payton, Benjamin F., 141

Peabody College, 21, 44

Peabody Demonstration School (Nashville), 21–22, 116, 119

Pearl High School (Nashville), 43, 77

Peebles, Roy Donahue "Don," 221, 226–27, 232

Peebles Corporation, The, 226

Index

Pennsylvania, University of,
 Perelman Center project at, 2,
 154–58, 190
Penny Savings Bank (Nashville), 72
Perkins, Brad, 125–26
Philadelphia, Pa., 47, 76, 193
 author's domestic life in, 66–67,
 68
 author's political relationships
 in, 60–62, 151
 Eagles stadium project in,
 16–17, 150–52
 M&M building projects in, 2,
 16–17, 54–57, 60–61, 133–34,
 150–52, 154–58, 177, 190, 192
 M&M's bad bids in, 133–34, 192
 M&M's opening of office in,
 53–54
 UPenn Perelman Center project
 in, 2, 154–58, 190
Philadelphia Eagles, 16, 150
Piano Lesson, The (Wilson), 20
Pittsburgh Courier, 76
Port Authority of New York and
 New Jersey, 223, 224, 225
Porter, James, 38
Prince, 7, 124–25
Prokhorov, Mikhail, 16
property inspections, 183–89
property management, 115–16,
 139
public housing projects, 81–82
Public Works Administration
 (PWA), 76–77, 82
Pulaski, Tenn., xxiv, 33, 37–38, 39
 Moses II in move to, xix, xxiii
Pulaski Colored High School, 38

Q

Qatar, 212–13, 223
Quinn, Christine, 220

R

race riots, 30, 47, 91–92
racism, 31, 37, 47, 58, 81, 236
 author's experience with, 31–34,
 53, 111–13
 in career advancement, 134
 encountered by M&M, 49, 53,
 110–13, 143, 236
 in media depictions of Black
 community, 47, 48
 in New Deal programs, 82
 in Reconstruction and in wake of
 emancipation, xx–xxiii, xxiv, 40
Raina (author's friend), 196–97
Randall, Alice, 88–89
Ratner, Bruce, 1, 3, 5, 6–8, 9, 11,
 12, 14, 15–17
Reagan, Nancy, 120
Reagan, Ronald, 120, 145
real-estate development, 226–29,
 232
Reconstruction, xix–xxiv, 37, 39,
 46, 47
Records, Jeff, 153, 231
Redmond, Wynona, 121
Rendell, Ed, 54, 60–61, 151
Republican Party, 14, 66, 76, 144
Request for Proposals (RFPs),
 104, 112–13, 143, 152, 159,
 163, 189, 223, 224, 225, 226,
 228, 229
Reynolds, Jim, 223–24
Rikhy, Amit, 224
Ritterhouse, Jennifer, 40
Riverburg Mill, 38
Roberts, Albert H., 77
Robinson, Jackie, 2–3, 17
Rock City Contractor, 74
Rogers, Isaiah, xvii
Roger Williams University, 45
Roller, Jerry K., 54

260

Index

Roosevelt, Eleanor, 78
Roosevelt, Franklin D., 76, 78, 81, 82, 190, 194
Roosevelt, Theodore, xviii
Roosevelt Hospital (NYC), 205–7
Rubin, Jamie, 189
Ruth Bader Ginsburg Hospital (Brooklyn), 223

S

Sam McKissack, Contractor, Inc., 83
Sanna, Bob, 7–8, 9–10
Sasser, Jim, 120–21
Saudi Arabia, 217
Saudi Binladin Group, 210, 213
School District of Philadelphia, 54–55
Schurz, Carl, xxi–xxii
segregation, racial, 81, 82
 Leatrice's battle against, 89–90
 see also Jim Crow
September 11, 2001, terrorist attacks, 215
Sharkey, Kevin, 107
Sharkey, William L., xxii
Sharpton, Al, 6
Silverstein Properties, 226
Simmons, William Joseph, 48
Skanska Construction, 109, 160, 178
slavery, enslaved people, xxiii, 35
 artisan training of, x–xi, xvi
 emancipation of, xix, 39, 40, 47
 growing opposition to, xvii
 laws for, ix–x, xii
 Middle Passage and, xv
 in North Carolina, x–xi, xii–xiii, xv–xvi

self-hiring and hiring out of, xi–xii, xiii
special liberties given to select groups of, xi, xii–xiii
weddings of, xiii–xiv
wide variance in treatment of, x, xi, xii
Small Business Administration (NYC), 63
Smith, Hilton, O., 132
South Carolina, xii, xix, 75
Spaulding, Charles C., 81
Spaulding Award, 81, 190
Spitzer, Eliot, 13, 164
Springfield College, 43, 79
staffing contracts, 110
"Status of Slaves in Colonial North Carolina, The" (Padgett), x
stock market crash of 1929, 75
Street, John F., 54, 61, 150
Street, Milton, 61
Streisand, Barbra, 17
Structure Tone Construction, 157, 158
Stuckey, James, 13
Student Nonviolent Coordinating Committee (SNCC), 91
Sumner, William, xxiii
Sumner House Hotel (Nashville), xxiii
Supreme Court, US, xx, 82

T

Taney, Roger B., xx
Tasco, Marion B., 150, 151
Taylor, Alrutheus Ambush, 27, 28, 43
TDX Construction, 160, 161–62
Techwood Homes (Atlanta), 82

261

Index

Tennessee, xvi, xx, xxii, 35, 65, 72, 75, 114, 148
architectural licensing law passed in, 48–49, 53
growing antislavery sentiment in, xvii
Old Hickory Lake in, 34–36, 93
William McKissack II's mansion in, xvi–xvii
Tennessee, University of, 32
Tennessee Historical Commission, 77
Tennessee State University, 21, 23, 25, 26–27, 43, 83, 84, 91, 101, 115
Texas College, 86
Thompson, Bill, 221
Time, 23, 222
Tishman Construction Corporation, 172, 225
To Ask for an Equal Chance (Greenberg), 76
Tolliver, Michael, 166–67, 169
Tony (author's trainer), 196, 202, 203, 204, 205
Tracy, Brian, 204
Trimble, George, xxiii
Truman, Harry S., 81
Trump, Donald, 54, 219, 220, 223, 224, 225
Tulsa Race Massacre (1921), 47
Turner & Townsend, 165
Turner Construction Company, 8, 9, 59, 60, 109, 152, 160, 172, 178, 216, 223
author's job at, 132–33, 134–35
Eagles stadium project and, 150–52
McKenna's resignation from, 152–53, 231

Medgar Evers College project and, 105–8, 152
Turner Normal and Industrial School for Negroes (Shelbyville), 45
Tuskegee Airmen, 78, 79–81, 190
Tuskegee Airmen, The (Charles River Editors), 79, 80
Tuskegee Army Airfield, 77–79, 81, 83, 190
Tuskegee Institute, 40, 79, 83
Tuskegee University, 141
21 Club (NYC), 65

U

Union army, xviii, xix, 37
Union City (Nashville), 116
Universal Life Insurance Company (Memphis), 72, 87
US Colored Troops (USCT), xxiii

V

Vale Rolling Mill, 38
Van Amson, Wendy, 230
Vance, Cyrus, 170
Vanderbilt neighborhood (Nashville), 44
Vanderbilt University, 21, 38, 44
Vann, Albert "Al," 5
Vann, Robert Lee, 76
Vendex, 174
venture capital, 59–60
Viñoly, Rafael, 155–56, 158
Virginia, xii, 105, 224

W

Wade (author's driver), 198, 203, 204, 205
Washington, Booker T., 27, 39–40, 42, 72
Washington, DC, 116, 138

Index

author's college and grad school years in, 117, 120–21, 122, 124–25, 126–27
M&M office established in, 144
Washington Junior High School (Nashville), 77
Washington Post, 224–25
Weidlinger, Paul, 130, 131
Weidlinger Associates, 4, 126, 127, 128, 130–31, 132
Weiner, Anthony, 220–21
Wells Fargo Center (Philadelphia), 13
Wiley, Maya D., 222
Wiley Hall (Texas College), 86
Williams, Avon N., Jr., 21, 30, 31, 33, 89
Williams, Avon, Sr., 29, 31, 32
Williams, Charles E., 51, 109–10, 111

Williams, Joan, 22, 29, 31
Williams, Joseph, xxiii
Willis, A. W., Jr., 89
Wilson, August, 20
Wilson, Woodrow, 47–48
Wind Done Gone, The (Randall), 89
Winter McKissack Architects, 83
Witkoff, Steve, 227
Women's Business Ownership Act (1988), 145
Works Progress Administration (WPA), 76–77, 159, 161
World Cup stadium project, 211, 212–13, 214–18
World Trade Center, 171, 172, 215
World War II, 77–79, 83

Y

Yearwood, Trisha, 89
Youngkin, Glenn, 224–25

ABOUT THE AUTHOR

Cheryl McKissack Daniel is the president and CEO of McKissack & McKissack. She serves as principal-in-charge and project executive on numerous high-profile projects, including major work in the commercial, healthcare, education, and transportation sectors. She serves on numerous corporate, charitable, and community boards, and has been honored by the National Liberty Museum as a "Hero of Liberty" for her support of humanitarian initiatives and for promoting the responsibilities of a free and diverse America. She has also received a Legacy Award from the Women's Builders Council and has been named to the City & State New York Construction Power 50 List. Born in Nashville to architect William DeBerry McKissack and teacher Leatrice Buchanan McKissack, Cheryl represents the fifth generation of the McKissack family's century-old business, the oldest minority- and woman-owned professional design-and-construction firm in the nation.